VISUAL ABUSE

JIM BLANCHARD'S
GRAPHIC ART
1982-2002

Written and designed by Jim Blanchard
Introduction by Jim Woodring
Editor and associate publisher: Eric Reynolds
Production: Paul Baresh
Publisher: Gary Groth

FANTAGRAPHICS BOOKS INC.
7563 Lake City Way NE
Seattle, Washington, 98115

ISBN 978-1-60699-938-7
Library of Congress Control Number: 2016945228

First printing: October 2016
Printed in Hong Kong

CONTENTS

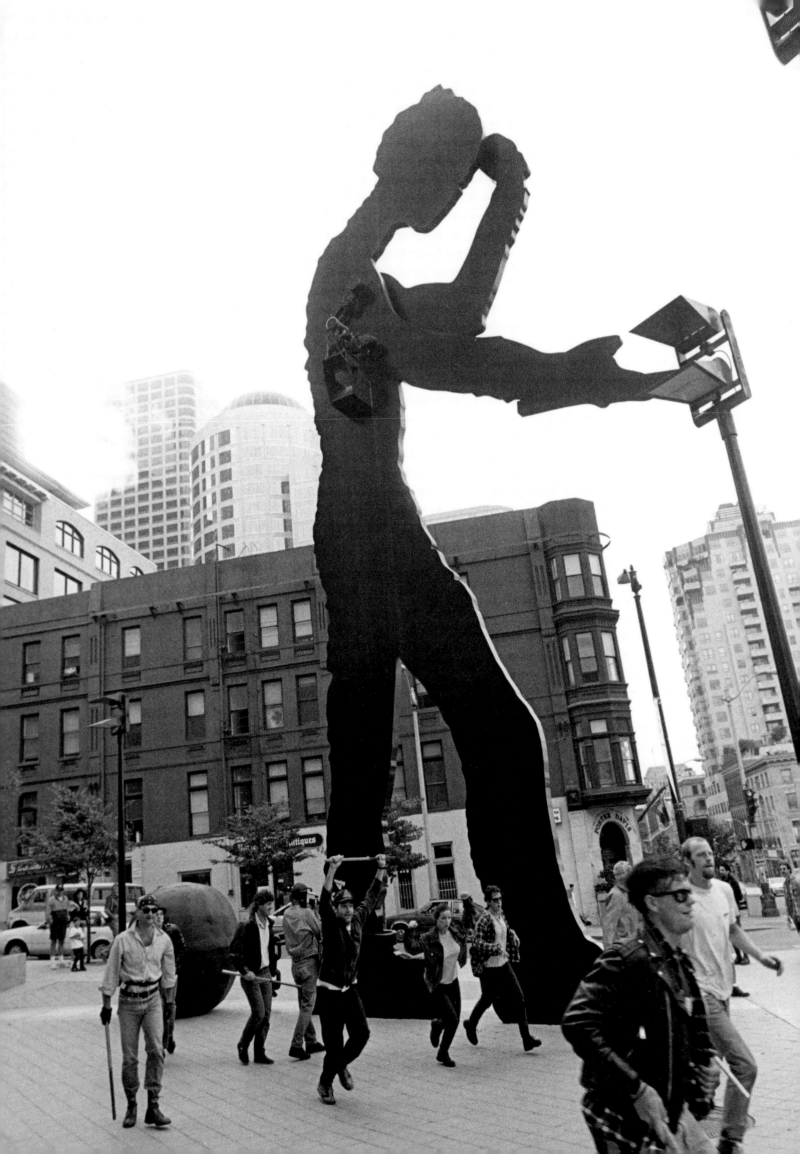

INTRODUCTION

BY JIM WOODRING

If psychedelia had not existed before he came along, Jim Blanchard would have invented it. The realm of the expanded mind is his natural habitat. His work has the sharp-edged intensity of revelation regardless of what form it takes. From his sometimes hideous cartoons to his intellectually complex existential comics to his phenomenal pen-and-ink drawings to his dead-on and innovative portraits, Blanchard is an inspired original whose work succeeds perfectly on its own iconoclastic terms as well as in the larger world of visionary art. You can't say fairer than that.

Blanchard is a serious guy. He's serious about being weird and creepy and he's serious about being funny and he's serious—real serious—about exploring the fabric of reality. He doesn't make it easy on himself; he's one of the most exacting and meticulous draftsmen working, and if he has ever produced anything clichéd or trite, I missed it. You can almost feel him dismissing ideas one after the other until the right one—charged, personal, unprecedented, subtle—comes along.

I discovered his work as a participant in the zine/cassette phenomenon that filled so many mailboxes during the '80s and early '90s. Most of the stuff that came my way was either silly and whimsical or contrivedly and unconvincingly dire. Jim's book *Blatch* was one of the rare exceptions. It consistently delivered the *mysterio autentico*, always on its own terms, never hesitating to rub the reader's nose in something interesting for the sake of heightened experience. I loved it.

Living in Seattle for most of the past 25 years I've seen Blanchard's work regularly, in material released by Fantagraphics Books, at art shows, on *Stranger* covers and diverse other venues. It always startles me when I see it, always wakes me up a little, always makes me wonder how the hell he manages to make such perfectly executed drawings.

But what I like most about Jim's work is that I'm never...quite...able... to get my mind around it. There is always something ineffable, something unreachable, something beyond what my mind knows and understands. I can never extract the last measure of meaning from his work, which means I'm never quite done with it, never able to file it away and consider it resolved. To me, that's the goods.

OPPOSITE PAGE: **ATTACHING BALL AND CHAIN TO JONATHAN BOROFSKY'S HAMMERING MAN**- Jim Blanchard (center, arms raised) as a member of Jason's Sprinkle's guerilla art crew Fabricators Of The Attachment. Seattle Art Museum, Labor Day, 1992. Photograph by Steve Gilbert.

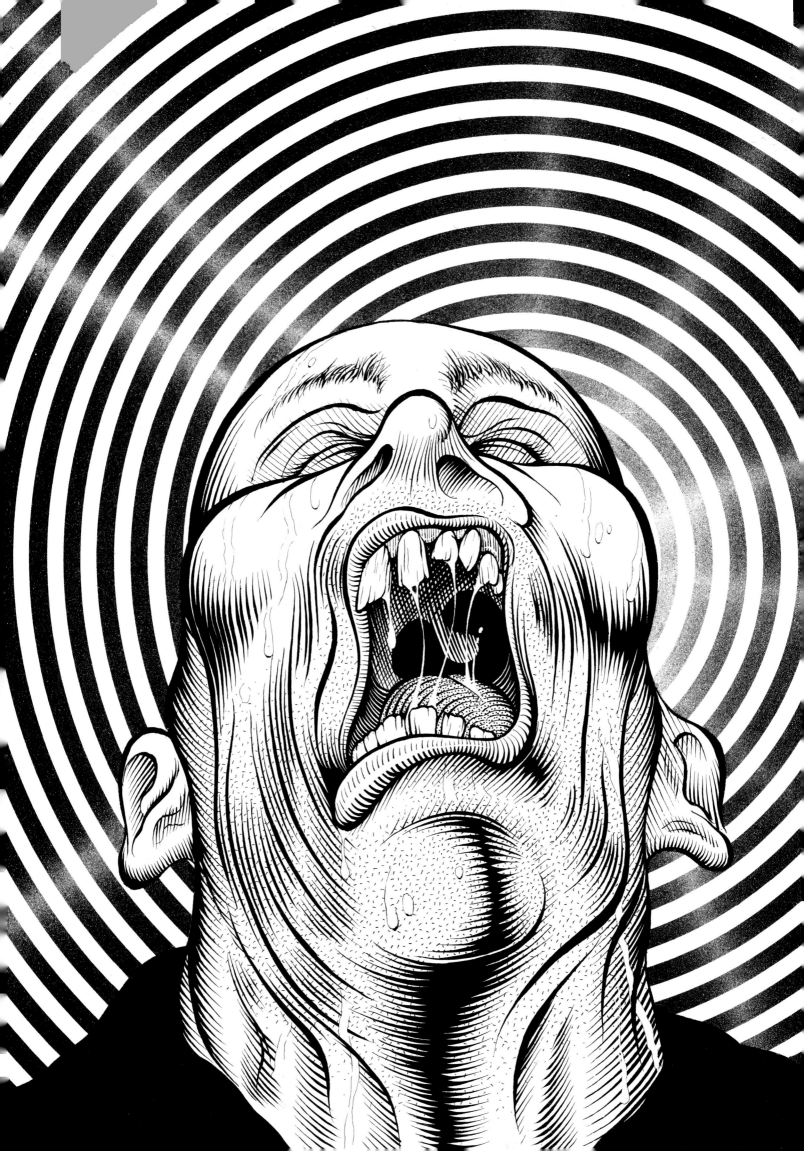

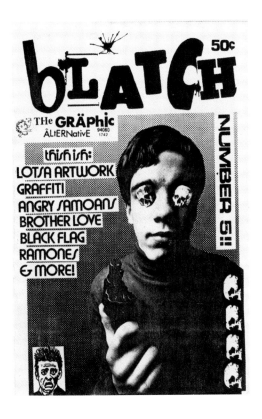

ROCK ART

I was entranced by "hard" rock the first time I heard Jimi Hendrix' wailing distorted guitar in 1970, at age 5, on a reel-to-reel tape compilation recorded for my father by a long-haired "hip" co-worker. The same reel-to-reel comp was also my introduction to The Who, Grand Funk, Jethro Tull, and Bob Dylan, and my brother and I played it over and over until we had committed it to memory. At a very early age, I was under the spell of hedonistic, drug-fueled rock and roll.

My brother and I continued to fetishize my parents' few rock LPs and reel-to-reels throughout the early to mid-1970s, and eventually we began to acquire our own records. Early ones were by The Beatles, Elton John, Alice Cooper, Led Zeppelin, The Rolling Stones, The Who, Jimi Hendrix, and Black Sabbath—all the usual suspects!

I discovered punk rock in the late '70s/early '80s, and it seemed like a natural progression at the time: The Ramones, The Sex Pistols, The Damned, The Stranglers, and The Clash being a logical "next step": faster, angrier, and more urgent than their groovy predecessors. *Never Mind The Bollocks* by the Sex Pistols blew my mind in 9th grade and wiped the rock slate clean. I was living in stodgy Bartlesville, Oklahoma, which made punk rock all the more important as an emotional outlet.

When the American "hardcore" punk scene reared its head in the early '80s, the music got even faster and harder. I was 16 in 1981, and my teen body chemistry was perfectly tuned to receive the new hardcore punk gospel. Hearing Black Flag, Fear, The Circle Jerks, Bad Brains, and Minor Threat for the first time was a revelation, and provided an ideal soundtrack for a hyper, vandalizing wiseacre, who felt out of place in squeaky clean Bartlesville, OK. Seeing hardcore bands play live sealed the deal. Some shows were epiphanic, and I left them feeling spiritually cleansed and energized.

In the summer of 1982 I made a punk rock pilgrimage to the San Francisco Bay Area on a Greyhound bus. I hooked up with my brother and two of his college friends and in the space of a week I saw Black Flag and the Dead Kennedys in San Fran-

OPPOSITE PAGE: **PSYCHOSIS**- detail from LP cover art for Coffin Break, 1990. THIS PAGE, ABOVE: **BLATCH #5**- cover for self-published punk zine, 1983.

cisco, and the Circle Jerks in Berkeley. I got all my hair cut off and bought a big stack of punk LPs and 45s at Rough Trade Records on Sixth Street in SF. I came back to Oklahoma a full fledged hardcore punk convert.

The visual culture that accompanied the '80s hardcore scene had "upped the ante" gnarl-wise from the '70s new wave era, and was harsher, more primitive and more extreme. It was an aesthetic rife with shocking xeroxed imagery and crude "rub-down" or crappy typewriter text, definitely a consequence of the do-it-yourself nature of the scene. Punk bands were putting out their own records, and people were publishing magazines and fanzines themselves, sometimes with no idea how to do it. Figure it out! When I saw handmade Tulsa xerox punk zines like *No Fashion*, *Pure Hype*, and *Dry Heave*, I knew I could do it, too. It was a call to action, powered by the intensity and revolutionary quality of the music and the complete void of coverage in the mainstream media. So my insertion point into the pop culture landscape, albeit only in the secret, under the radar world of punk rock-whateverthefuck, was through a music and graphics fanzine called *Blatch*.

I made the first issue of *Blatch* in 1982, age 17, using my mom's typewriter, assorted photos, graphics, and text clipped from newspapers and magazines, as well as a few of my own drawings and collages. The crazy and shocking content of *Blatch* raised a few eyebrows of copy shop workers in uptight Bartlesville. One printer remarked, after seeing the layouts I presented him, "Are you on *drugs*, son?" I learned a lot about layout and basic graphic design during the creating and publishing of those early issues of *Blatch*. It was learning by *doing*—D.I.Y. in the strictest sense. At times, it was embarrassing to read and see some of the stuff I had published. I realized early on there was no better way to reveal what worked best, than by

making ugly mistakes in a public, for all to see way.

By the 6th and 7th issues of *Blatch*, I had honed my rudimentary layout skills, and was able to produce nice, straight columns of typewriter text and halfway decent headlines using my hoard of stolen "rub-down" Letraset type. My cartoon drawings and collages had always been a part of *Blatch*, but with each new issue, the art became increasingly weird and unrelated to the rest of the magazine—for the most part devoted to punk band interviews, live show reviews, and record reviews. In 1984, independent music distributors Dutch East India and Systematic contacted me when they saw the 10th issue of *Blatch*, the first one to be offset printed, rather than xeroxed. After signing on with a few other indy music distributors, the magazine was getting around to a wider audience. With the increased circulation, I was able to sell advertising to small record labels like SST, Homestead, Touch & Go, Mordam, and C/Z to help pay for the mag.

In addition to creating and publishing *Blatch*, for a few months in 1986 I played the role of frontman/"singer" for an unusual, post-hardcore band called Gift (German for "poison"). The music we made was an odd mix of punk rock, psychedelia, and noise. The other three members of the band were accomplished musicians, but I had no clue what I was doing, and I'm afraid I loused the whole thing up. Gift played eight or nine shows, including two shows with Scratch Acid, and our final show in Kansas City with Sonic Youth. I was under the impression that no photographs of Gift existed—imagine that, nowadays! Some shots of our last show in Kansas City surfaced in 2014. I'm glad that I had the experience of being in a rock band, but it obviously wasn't my calling, and when it fell apart, it further confirmed that I should focus on the *visual* art realm, and get the hell off the stage!

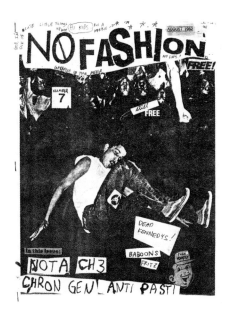
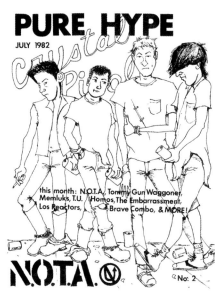
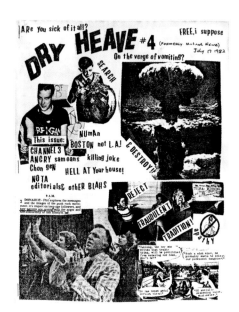

NO FASHION #7, PURE HYPE NO. 2, DRY HEAVE #4- Tulsa, Oklahoma xeroxed punk fanzines, 1982.

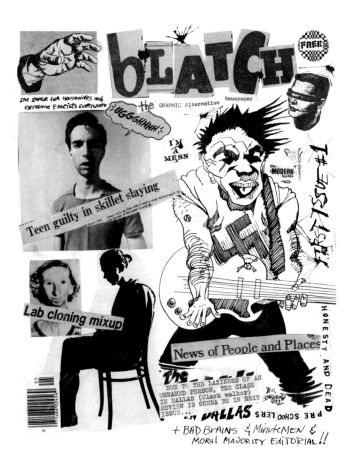

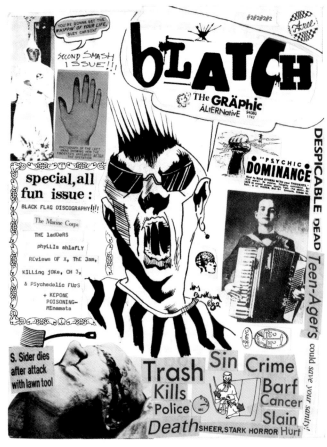

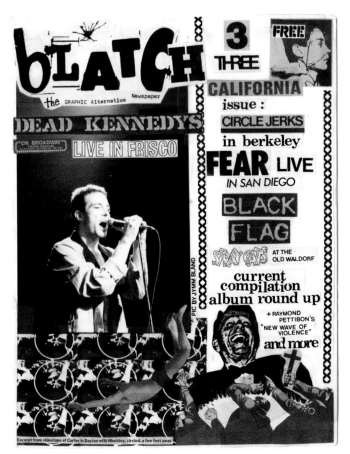

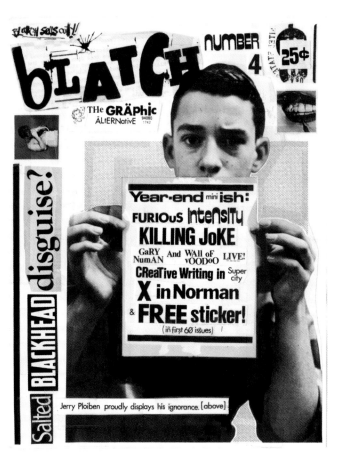

BLATCH 1-4- cover art paste ups, 1982-1983.

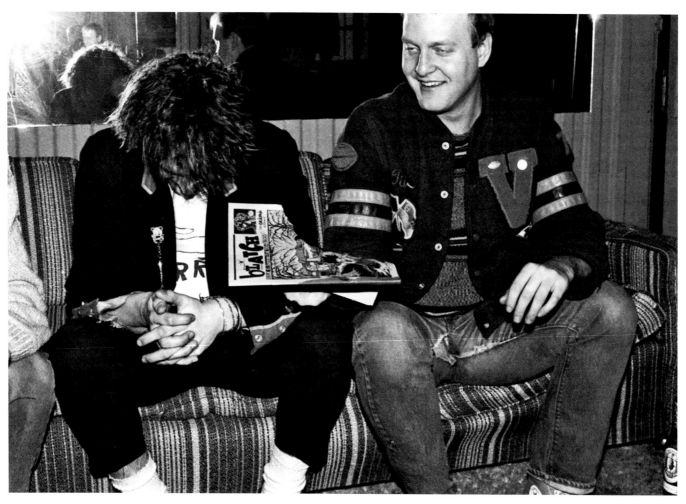

THE REPLACEMENTS Tommy and Bob Stinson with ripped *Blatch* #10 backstage at The Bowery in Oklahoma City, OK, 1985. Photograph by Mike Mitchell.

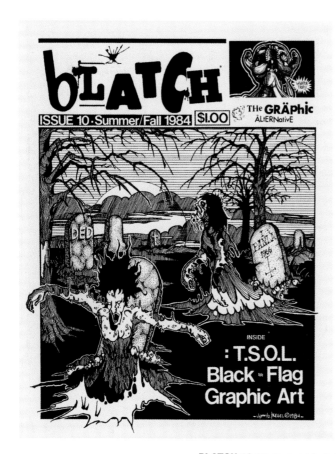 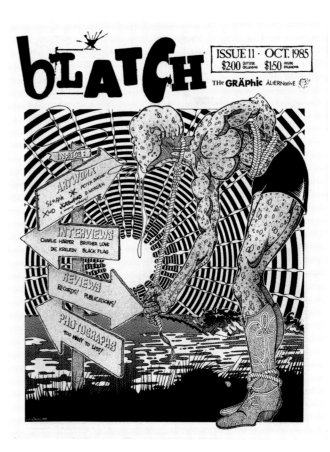

BLATCH 10-11- cover art (collaborations with Chris Kegel), 1984-1985.

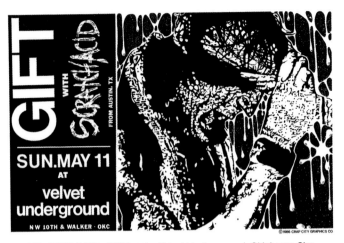

SCRATCH ACID, GIFT at the Velvet Underground, Oklahoma City, Oklahoma, May 11, 1986- xeroxed flyer.

A few months after I moved from Oklahoma to Seattle in 1987, I published the final 68-page issue of *Blatch*, number 14. By that time, the Great Hardcore Punk Revolution was long-since dead, and my interest in writing about music was dead, too. Seattle was already crawling with music know-it-alls, and there were a slew of publications covering the burgeoning national and local alternative music scenes. Five years of publishing *Blatch* had proved a great means to launch my career and force me to *do stuff* to fill its pages, but I felt a real need to jettison the rock reportage and move into Pure Art Mode.

There was gobs of rock-related art to do in Seattle in the late '80s through the '90s. I got started a

few days after I arrived from Oklahoma, designing the Linda Blair Redd Kross/Soundgarden poster on the kitchen table of Tony "Dismal" Godbehere, a local rock promoter. I cranked out flyers, logos, posters, record covers, and t-shirt art for local grunge and non-grunge bands, as well as other national bands I had met while doing my *Blatch* zine. One of my early jobs in Seattle was at "Rock 'n' Roll Kinko's" near the University of Washington, a copy shop where assorted Seattle rock luminaries like Tad Doyle from TAD, Mark Arm from Mudhoney, Matt Cameron from Soundgarden and Pearl Jam, and Tommy "Bonehead" Simpson from Alcohol Funnycar worked at one time or another.

Circa 1987-1989, the Northwest rock music scene was bubbling mightily and fixin' to blow up, but despite my proximity to it, I wasn't paying close attention. It wasn't "my generation" like the hardcore scene of the early '80s, and I was dismissive of many of the NW rock bands, some of whom were reverting to the lame hair-metal tendencies that HC punk set out to destroy. I was surprised when "grunge" turned into a huge mainstream trend. It was a beautiful thing to see local geeks Nirvana boot Michael Jackson and Gun N' Roses out of the top spot! Unfortunately, it was short-lived and the *last* time real rock 'n' roll acheived mainstream chart-topping pop success. Since then, popular music has been on a steady, rockless decline to the strange, wholly stale place we find it now (2016). Is it a conspiracy or what?

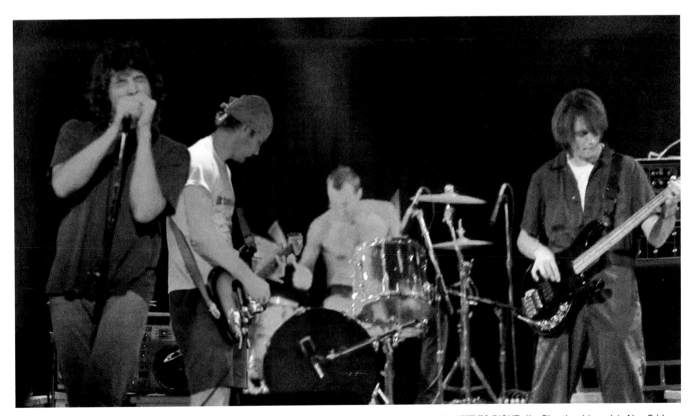

GIFT at Parody Hall in Kansas City, Missouri, July 14, 1986. Our final show, opening for Sonic Youth. LEFT TO RIGHT: Jim Blanchard (vocals), Alan Crider (guitar), Chris Ward (drums), and Dan Heidebrecht (bass). Photograph by David Goodrich.

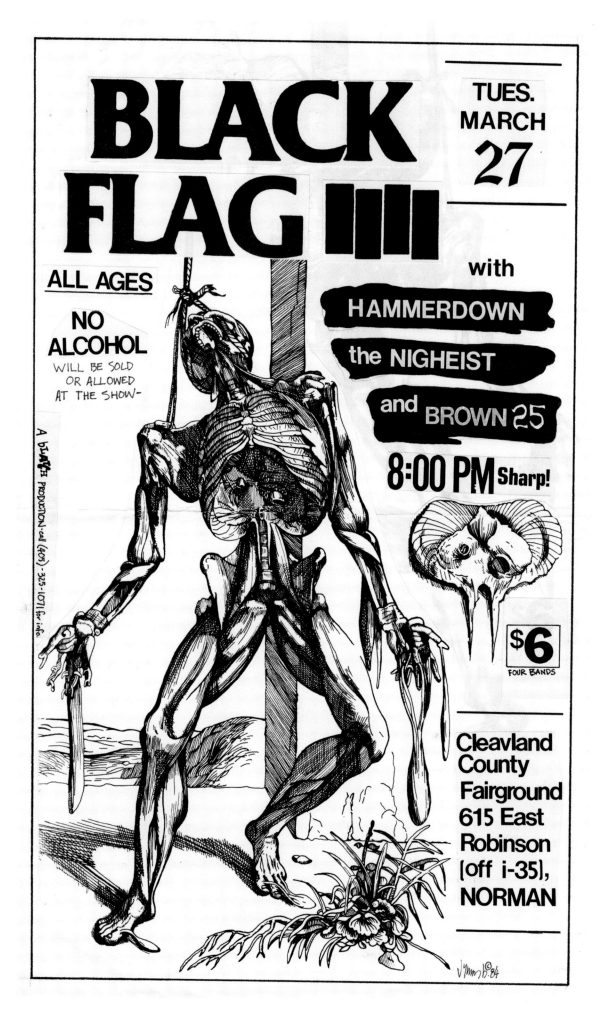

BLACK FLAG |||||

TUES. MARCH 27

ALL AGES

NO ALCOHOL WILL BE SOLD OR ALLOWED AT THE SHOW-

A bLaSH PRODUCTION · cal (405) · 325-1071 for info.

with

HAMMERDOWN

the NIGHEIST

and BROWN 25

8:00 PM Sharp!

$6 FOUR BANDS

Cleavland County Fairground 615 East Robinson (off i-35), NORMAN

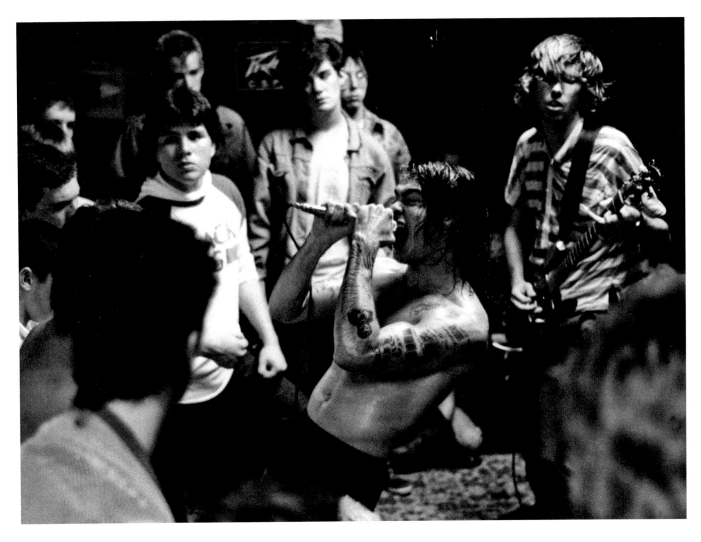

BLACK FLAG, BROWN 25, GOMERS (HAMMERDOWN & NIG HEIST did not play) at the Cleveland County Fairgrounds, Norman, Oklahoma, March 27, 1984. OPPOSITE PAGE: flyer paste up. THIS PAGE, ABOVE: Henry Rollins and Greg Ginn; RIGHT: exhausted Henry Rollins after the show (photographs by Mike Mitchell, March 27, 1984).

"We had to move to the Cleveland County Fairgrounds for shows because we lost the American Legion Hall after the campus newspaper did a story about how military vets were renting the hall to a bunch of radical punk rockers. The publicity put the folks that managed the Legion in a very awkward position. The Fairgrounds was the next best thing we could find for the money, though it was a shitty, horrible sounding venue." —David Fallis (No Direction)

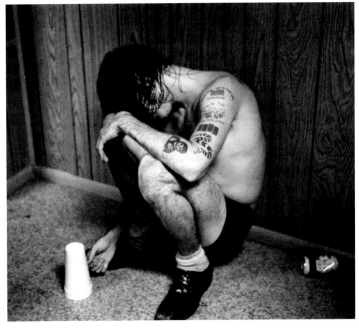

"A snow storm in the Texas Panhandle had delayed Black Flag's arrival until 2AM. When their Spider-Man van finally pulled up, it was like a military exercise, we all helped the band unload and within a very short amount of time they were performing. I will always remember the smell that hit me when that van door opened! I'd never seen a band pour everything into a performance like that. When they were finished, Henry was soaked in sweat, totally spent and curled up against a wall. Kira was collapsed in a corner in serious pain, nursing her swollen hands." —Mike Mitchell

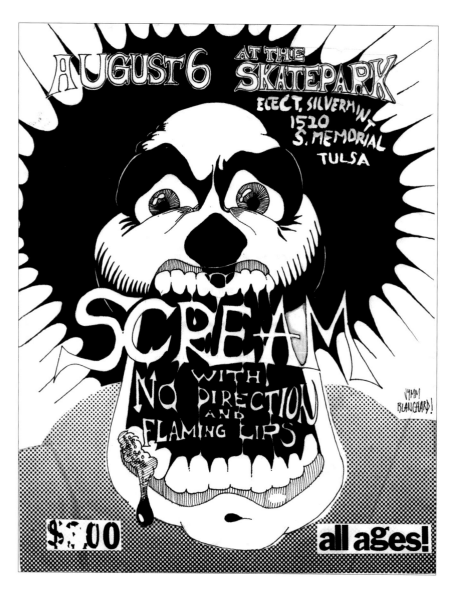

UPPER LEFT: **SCREAM, NO DIRECTION, FLAMING LIPS** at the Skatepark, Tulsa, Oklahoma, August 6, 1983- flyer paste up/ink original; UPPER RIGHT: **SCREAM SETLIST** from Tulsa Skatepark show; LOWER LEFT: **CRUCIFIX, N.O.T.A., NO DIRECTION, HOSTAGES** at American Legion Hall, Norman, Oklahoma, November 18, 1983- xeroxed flyer; LOWER RIGHT: **HÜSKER DÜ, N.O.T.A., NO DIRECTION, EXHAUST** at North Base National Guard Armory, Norman, Oklahoma, January 22, 1983- xeroxed flyer.

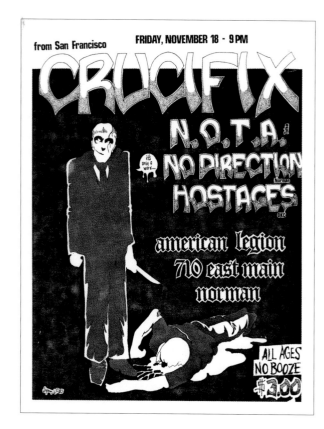

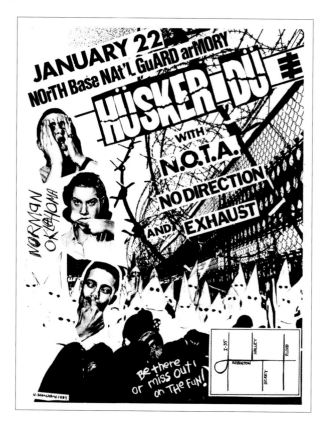

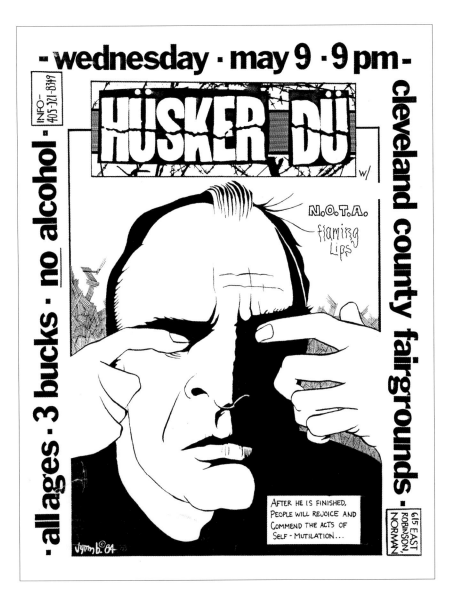

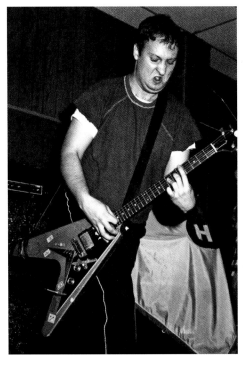

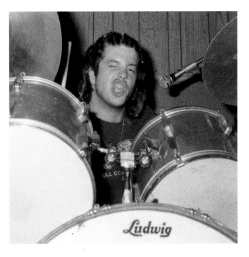

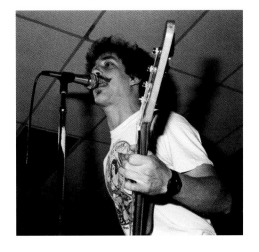

HÜSKER DÜ, N.O.T.A, FLAMING LIPS at the Cleveland County Fairgrounds, Norman, Oklahoma, May 9, 1984. ABOVE LEFT: xeroxed flyer; ABOVE RIGHT: Bob Mould; CENTER RIGHT: Grant Hart; LOWER RIGHT: Greg Norton (photographs by Mike Mitchell, May 9, 1984).

"It was a fairly small turnout, of probably 75 or so. I recall that the Huskers got a late start and by the time they got set up and began to play, quite a few kids had already been picked up by their parents given that it was a Wednesday night. Huskers played a blistering set and closed out the show with a long, drawn out version of 'Reoccurring Dreams.' Mould held a single, pulsating note forever on the Flying V, literally driving most everyone out of the building. It was one of those great, moment-in-time shows given that the band would release Zen Arcade *in the coming months."*—David Fallis (No Direction)

"In Norman, Oklahoma, just for the hell of it, we played a version of 'Reoccurring Dreams' that lasted almost an hour; the last forty-five minutes, I played one E chord on my guitar. It was funny, watching people go from smiling to 'OK we get it' to 'now we're pissed' to then just being plain stunned." —Bob Mould (Hüsker Dü)

"I remember that show being incredible and I'll never forget Grant Hart standing barefoot in a puddle of piss in the men's room taking a leak and wondering if I would EVER be that punk rock or if I even wanted to." —Jason Hadley (Diet of Worms)

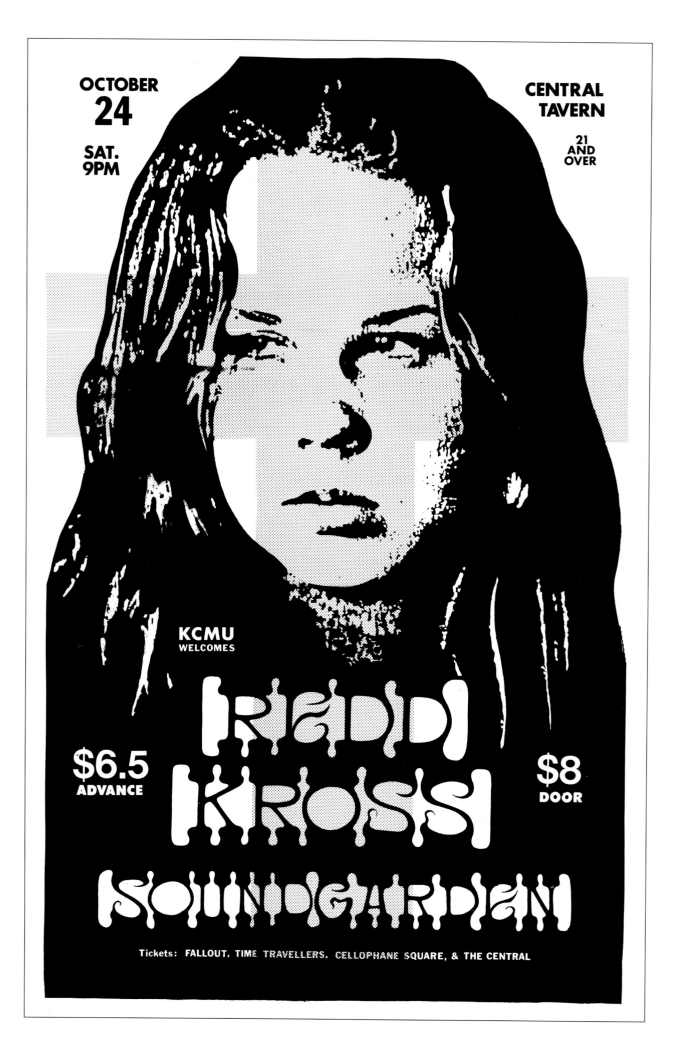

OCTOBER
24

SAT.
9PM

CENTRAL
TAVERN

21
AND
OVER

KCMU
WELCOMES

**REDD
KROSS**

$6.5
ADVANCE

$8
DOOR

SOUNDGARDEN

Tickets: FALLOUT, TIME TRAVELLERS, CELLOPHANE SQUARE, & THE CENTRAL

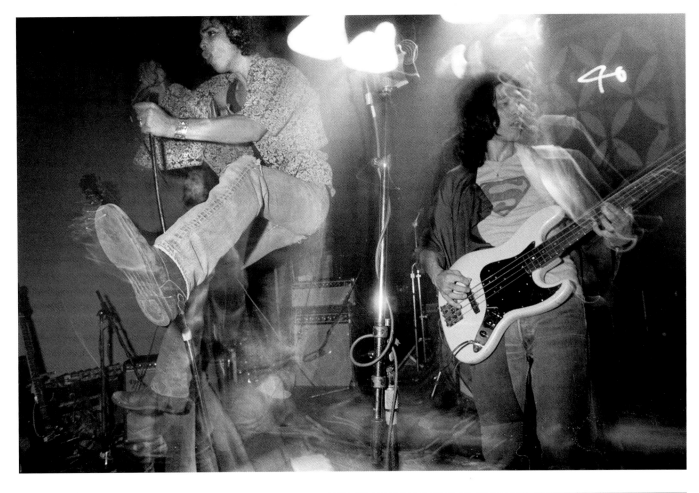

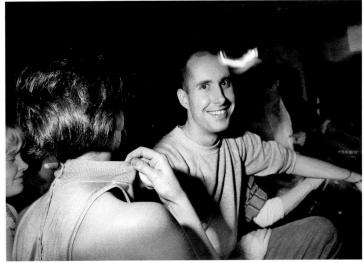

REDD KROSS, SOUNDGARDEN at the Central Tavern, Seattle, Washington, October 24, 1987. OPPOSITE PAGE: offset printed flyer. THIS PAGE, ABOVE: Chris Cornell and Hiro Yamamoto; RIGHT: Sub Pop founder Bruce Pavitt in audience (photographs by Charles Peterson, October 24, 1987).

"Historically significant show. Soundgarden's Screaming Life *EP was just hitting the stores, and the band crushed it live, mixing atonal guitar lines with too-commercial-for-punk vocals. Destined to be bigger than huge…. Headliners Redd Kross played tracks from the immediately popular* Neurotica *LP, with the McDonald brothers introducing synchronized hair twirling, officially signaling the death of hyper-masculine hardcore. Ecstatically fun."* —Bruce Pavitt

"I remember Seattle had very stiff policies about minors. There were underage kids hanging off of a fire escape ladder peering through a window watching the show."
—Steven McDonald (Redd Kross)

"This was my first taste of Grunge after moving to Seattle from Oklahoma. I was immediately impressed with Kim Thayil's superb and complicated guitar playing. Soundgarden at that time were a great heavy rock band without all the typical heavy metal trappings. Redd Kross had hair so long they sometimes got tangled up in it."
—Jim Blanchard

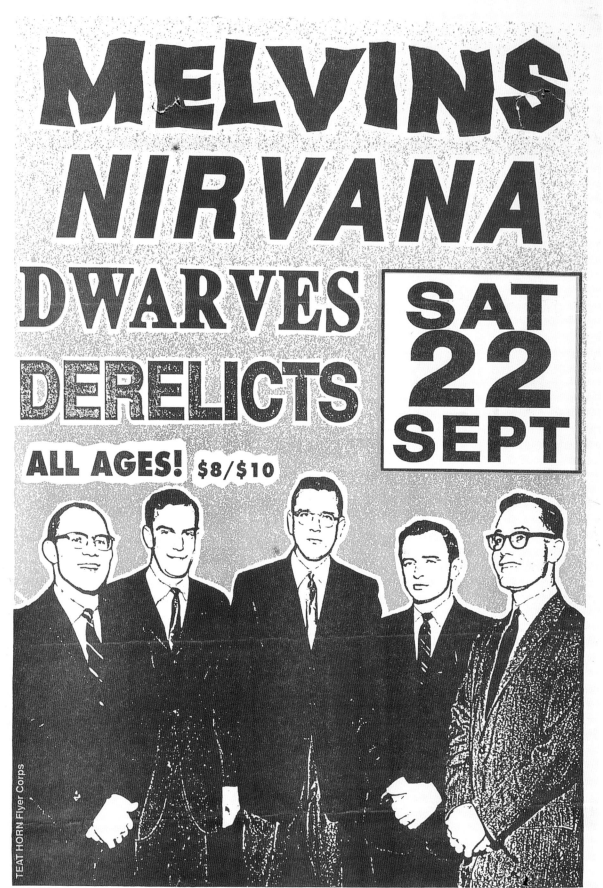

MELVINS
NIRVANA
DWARVES
DERELICTS

SAT 22 SEPT

ALL AGES! $8/$10

TEAT HORN Flyer Corps

Motor Sports Int'l Garage

AT STEWART & YALE (JUST OFF THE STEWART/DENNY EXIT)

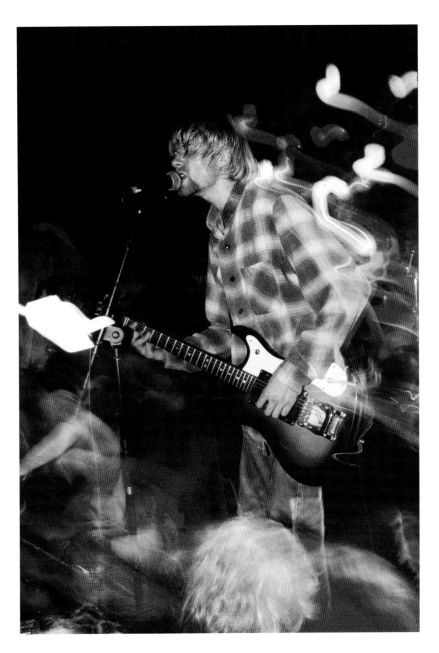

MELVINS, NIRVANA, DWARVES, DERELICTS at Motorsports International Garage, Seattle, WA, September 22, 1991 (Nirvana headlined despite billing). OPPOSITE PAGE: offet printed flyer (photograph courtesy EMP Museum). THIS PAGE, UPPER LEFT: Kurt Cobain (photograph by Charles Peterson, September 22, 1991); LOWER LEFT: flyer paste up (photograph courtesy EMP Museum).

"The Derelicts had finished playing and I was standing on the side of the stage watching the Dwarves set. As they started their third song I saw a perfectly thrown beer bottle flying end over end from deep in the crowd. The bottle hit the bassist Salt Peter directly on the forehead. He played two more notes and fell to the stage with blood pouring out all over his face. I've always believed this was payback for an incident from a previous Dwarves show, either The Vogue a few months earlier when their drummer threw a glass beer pitcher into the crowd, cutting a fan's face wide open, or their first Seattle appearance at COCA when Blag booted a guy in the front row in the head. The point being that the Dwarves came to Seattle and started assaulting the audiences, and then the audience got them back. Tit for tat. Dan Peters of Mudhoney played drums for Nirvana at this show. Dave Grohl from Scream (DC) was in town to audition for them, and joined the band the next day.
—Neil Rogers (The Derelicts)

"On August 25 and 26, 1989 I hosted a closing party for the Modern Primitives art show at Seattle's Center on Contemporary Art. I partnered with Sub Pop, featuring acts that included, among others, Gwar, TAD, Dickless, Supersuckers, Mudhoney, and Catbutt, with the Dwarves opening for headliners Nirvana on the final night. Right at the start of the Dwarves set, their frontman — without warning or provocation — kicked an audience member in the back of the head, who had the misfortune of leaning on the stage with his back to the band. Kicked him really hard with the heel of his boot. The guy recovered quickly, but was really unhappy about the incident, as was I. So about a year later I'm at the Dwarves/Melvins/Nirvana show at the Motorsports Garage and was surprised to see the victim of the earlier attack. I later learned why. During the Dwarves set a beer bottle comes flying out of the audience and smacks a band member square in the head. I remember lots of blood, but the show went on. I immediately knew the motive and was reminded of the classic Klingon proverb, 'Revenge is a dish best served cold.'" —Larry Reid

"A high-energy crowd with lots of stage diving and craziness. There must have been over a thousand people, which confirmed the fact that 'the scene' was getting very big. I was at the first Lollapalooza at King County Fairgrounds in Enumclaw less than a month before this show, and it blew my mind how many people were there for an 'alternative' festival with groups like Butthole Surfers and Rollins Band. They played Minor Threat and hardcore over the P.A. in between bands. 1991 was indeed 'The Year Punk Broke.'"
—Jim Blanchard

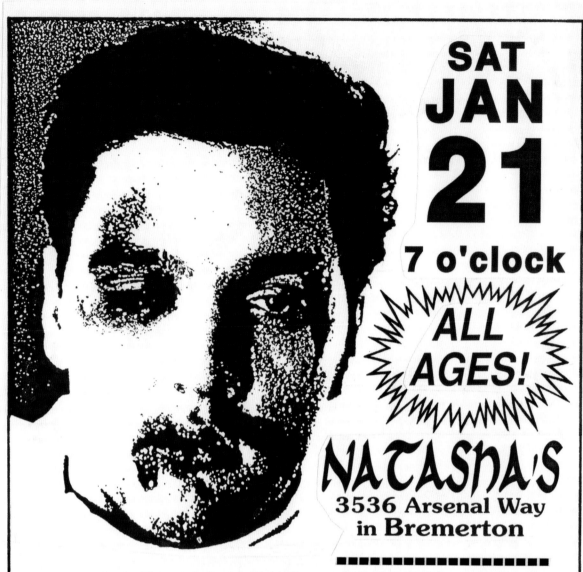

SAT
JAN
21

7 o'clock

ALL
AGES!

NATASHA'S
3536 Arsenal Way
in Bremerton

▪▪▪▪▪▪▪▪▪▪▪▪▪▪▪▪▪▪▪

*from
Redondo
Beach /
Eugene*

DETONATORS

COFFIN BREAK

SUBvERT TAD

JESTERS OF CHAOS $6

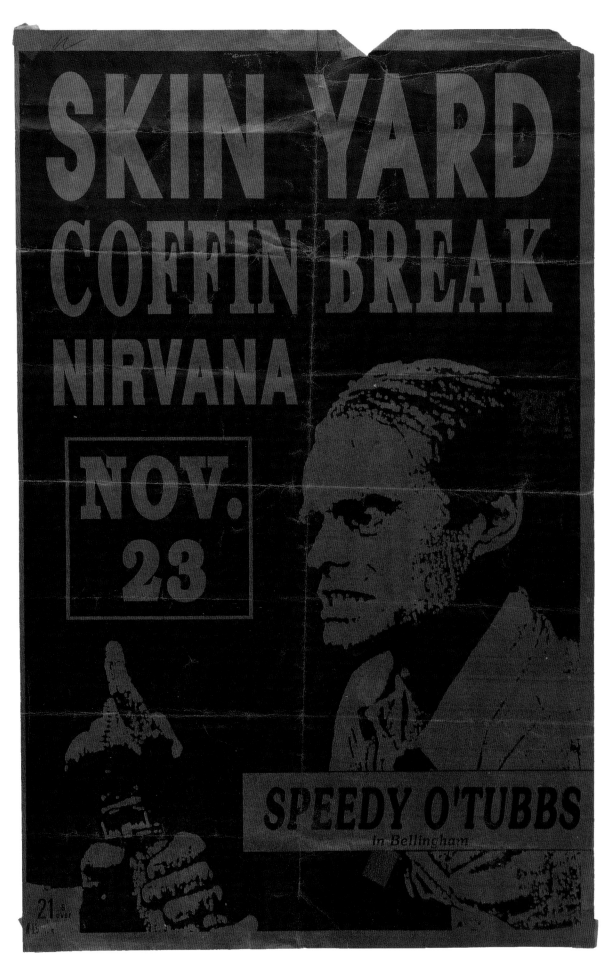

OPPOSITE PAGE: **DETONATORS, COFFIN BREAK, SUBVERT, TAD, JESTERS OF CHAOS** at Natasha's, Bremerton, WA, January 21, 1989- flyer paste up.
THIS PAGE: **SKIN YARD, COFFIN BREAK, NIRVANA** at Speedy O'Tubbs, Bellingham, Washington, November 23, 1988- xeroxed flyer which was folded and
pocketed by Nirvana bass player Krist Novoselic (photograph courtesy EMP Museum).

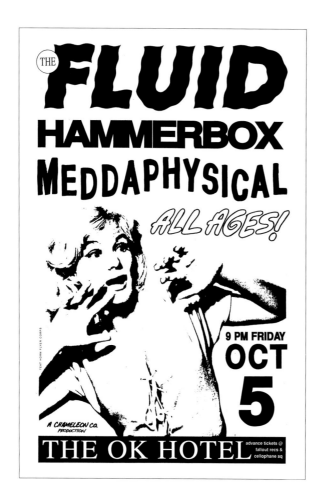

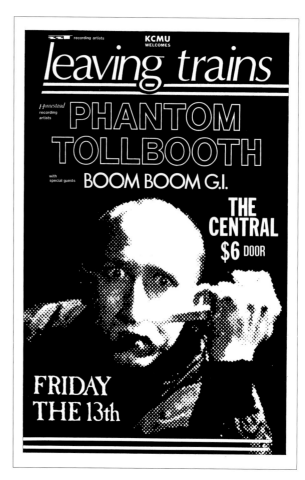

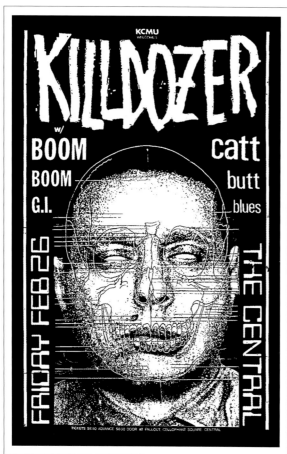

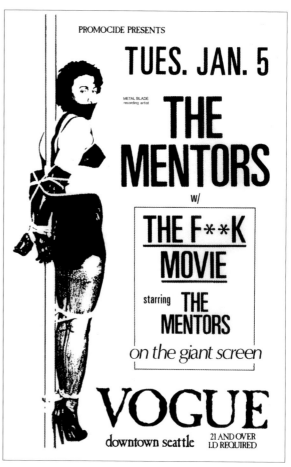

THE FLUID, HAMMERBOX, MEDDAPHYSICAL at The OK Hotel, Seattle, WA, October 5, 1988- offset printed flyer; **LEAVING TRAINS, PHANTOM TOLLBOOTH, BOOM BOOM G.I.** at The Central Tavern, Seattle, WA, May 13, 1988- xeroxed flyer; **KILLDOZER, BOOM BOOM G.I., CATT BUTT** at The Central Tavern, Seattle, WA, February 26, 1989- xeroxed flyer (restored); **THE MENTORS** at The Vogue, Seattle, WA, January 5, 1988- offset printed flyer.

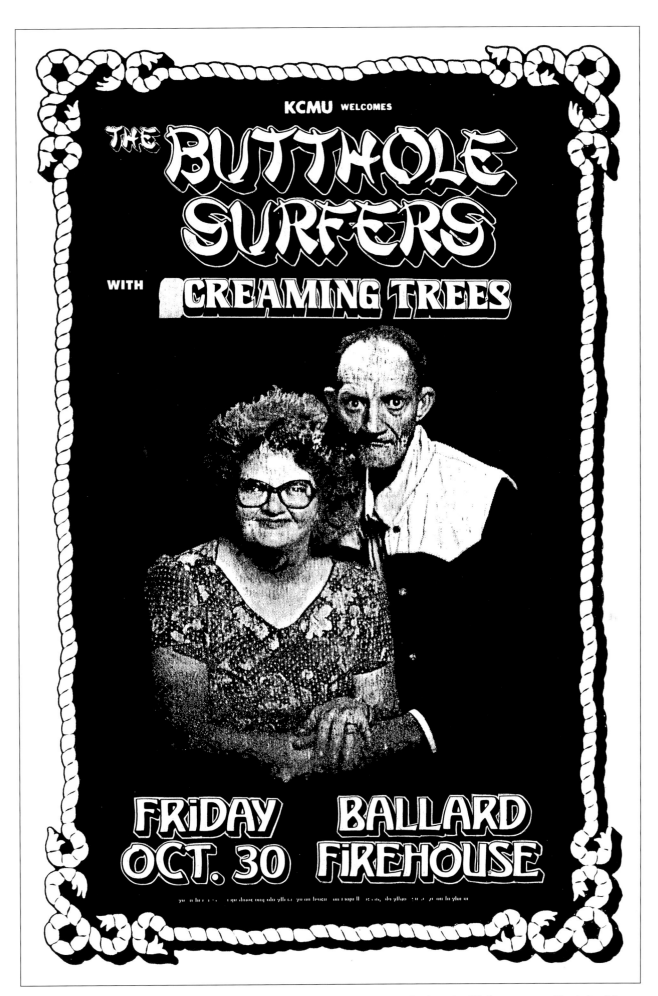

BUTTHOLE SURFERS, SCREAMING TREES at the Ballard Firehouse, Seattle, WA, October. 30, 1988- flyer paste up with missing "s".

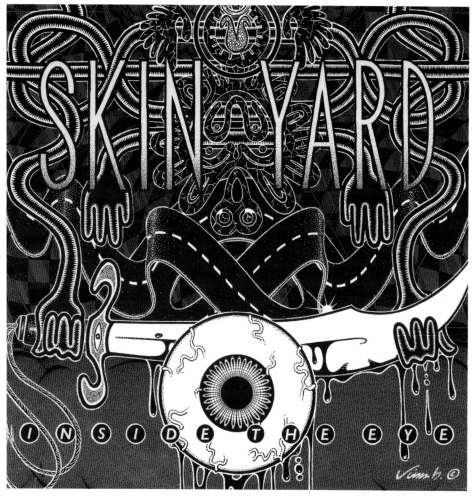

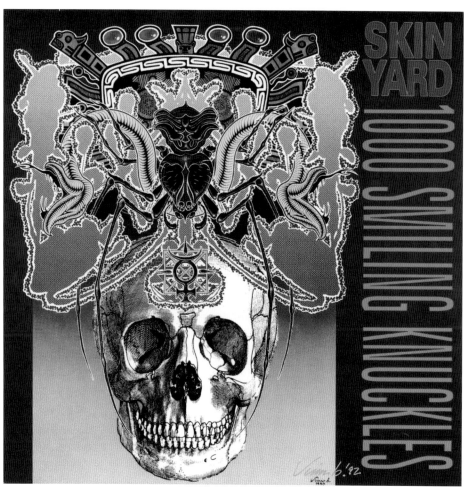

THIS PAGE, UPPER: **INSIDE THE EYE**- LP cover for Skin Yard, Cruz Records, 1993; LOWER: **1000 SMILING KNUCKLES**- LP cover for Skin Yard, Cruz Records, 1991. OPPOSITE PAGE, TOP: **HEY BULLDOG**- 10-inch EP cover for Skin Yard, Cruz Records, 1991; LOWER LEFT: **SKIN YARD, TAD, MY NAME** at The Vogue, Seattle, Washington, January 29, 1989- color xerox flyer; LOWER MIDDLE: **SKIN YARD**- Ben McMillan, Daniel House, Barrett Martin, and Jack Endino (photograph by Jane Duke, 1989); LOWER RIGHT: **SKIN YARD, WEDGE, D.N.C.** at V.F.W. Hall, Seattle, Washington, July 6, 1991- offset printed flyer.

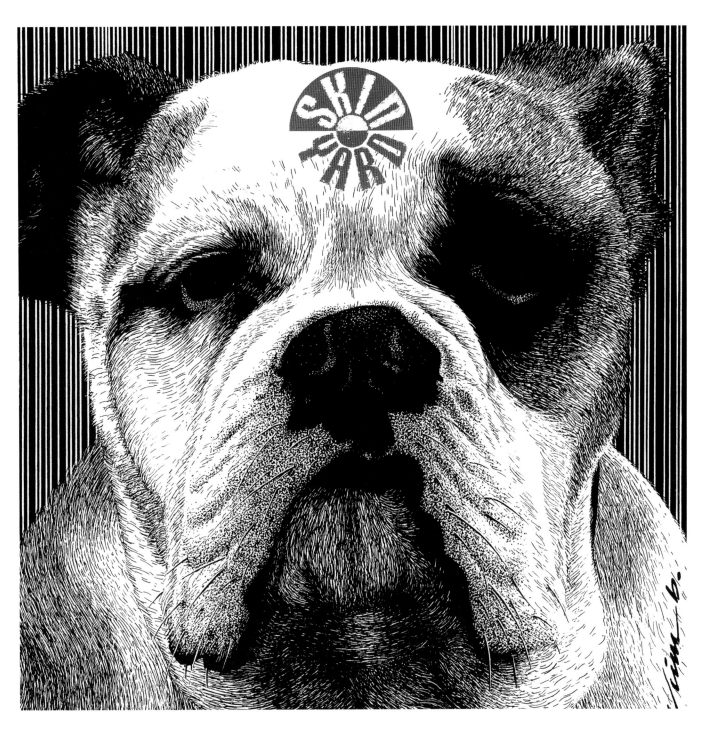

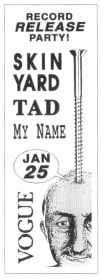

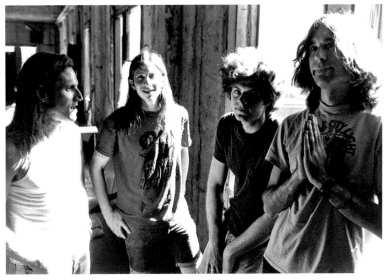

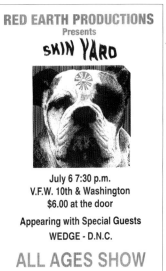

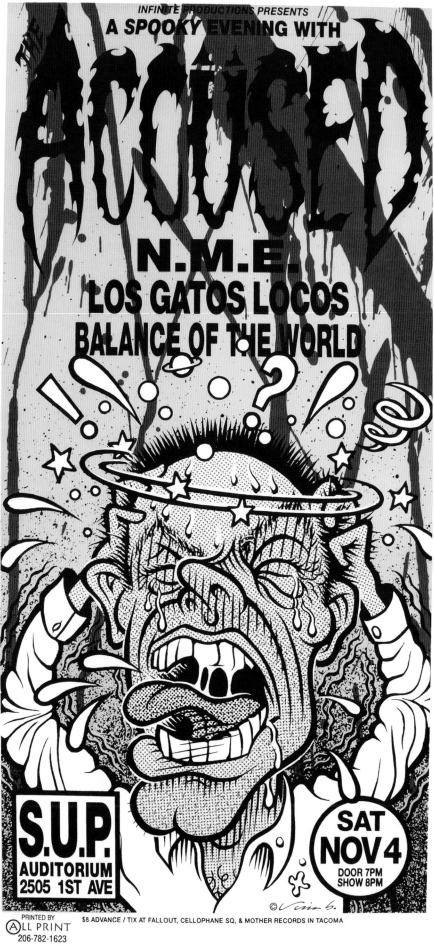

ABOVE LEFT: **EATING OUT WITH MARTHA SPLATTERHEAD**- promotional poster for The Accüsed (collaboration with Stevo Winters, originally a strip from *Martha Splatterhead's Maddest Stories Ever Told* comic), Nasty Mix Records, 1991; RIGHT: **THE ACCÜSED, N.M.E., LOS GATOS LOCOS, BALANCE OF THE WORLD** at S.U.P. Auditorium, Seattle, Washington, November 4, 1995- silk-screened poster.

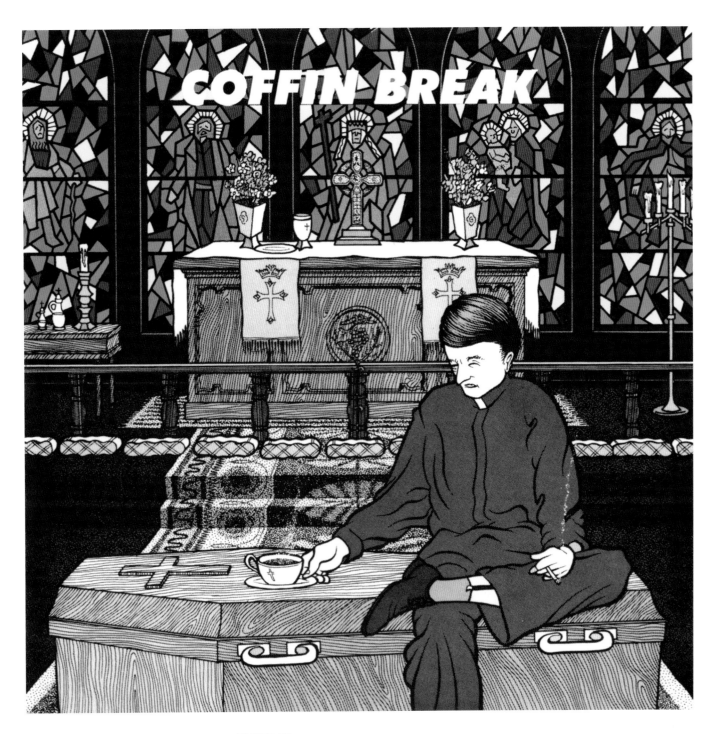

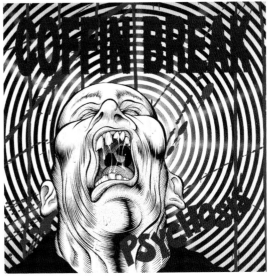

ABOVE: **LIES**- 45 cover for Coffin Break, Sub Pop Records, 1990; LOWER LEFT:
PSYCHOSIS- LP cover for Coffin Break, C/Z Records, 1988; LOWER RIGHT:
Coffin Break logo from *Noise Patch* 45 cover, 1988.

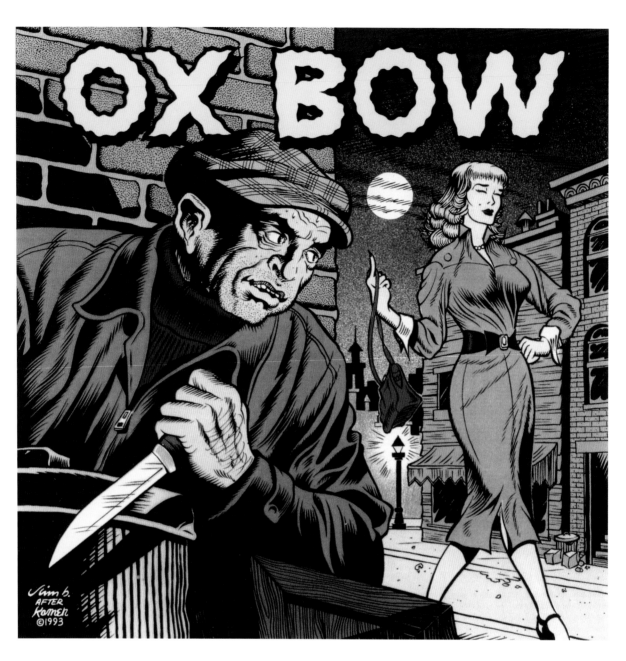

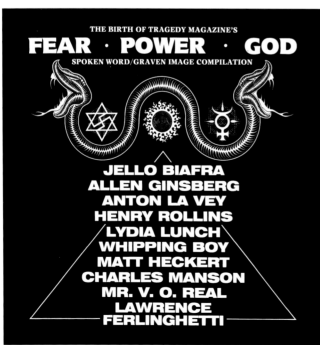

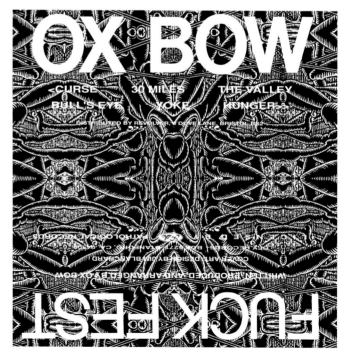

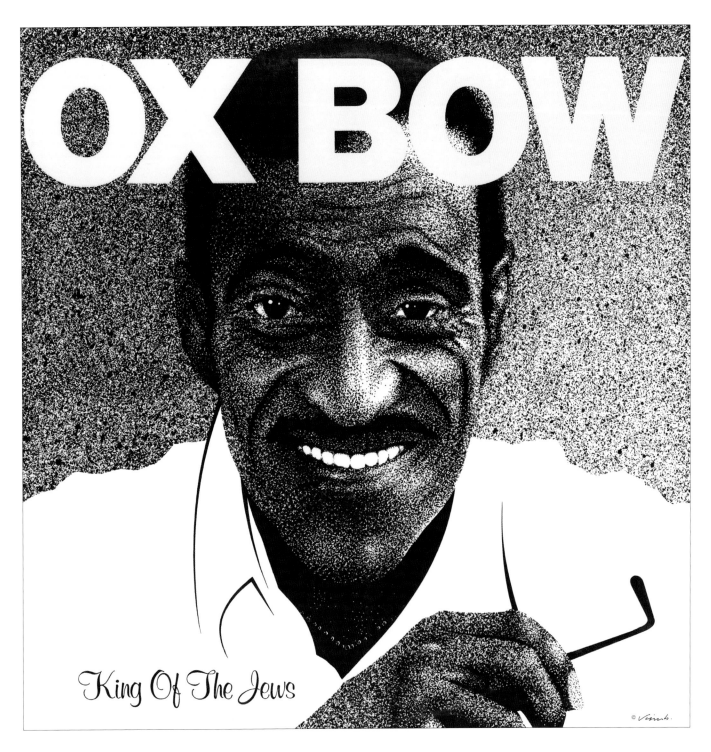

OX BOW

King Of The Jews

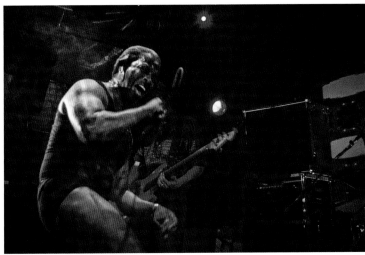

OPPOSITE PAGE, ABOVE: **LET ME BE A WOMAN**- CD cover for Ox Bow (unused version, based on EC Comics cover by Jack Kamen), Brinkman Records, 1993; LOWER LEFT: **FEAR • POWER • GOD**- LP cover for various artists compilation organized by Eugene Robinson of Ox Bow for his *Birth of Tragedy* magazine, CFY Records, 1987; LOWER RIGHT: **FUCK FEST**- LP back cover for Ox Bow, CFY Records, 1989. THIS PAGE, ABOVE: **KING OF THE JEWS**- LP cover for Ox Bow, CFY Records, 1992; LEFT: **OX BOW**- Eugene Robinson (vocals) and Dan Adams (bass) (photograph by Kasia Meow @Meow's Imaginarium).

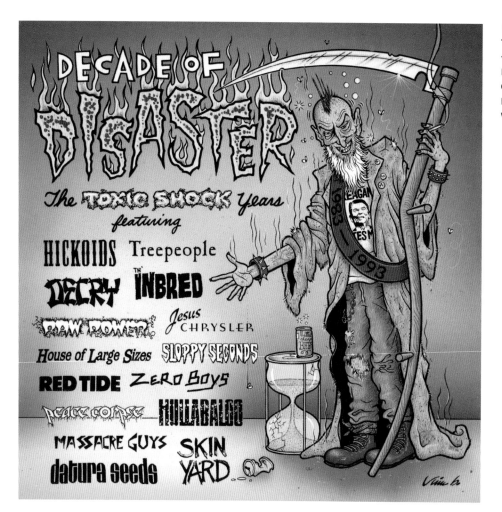

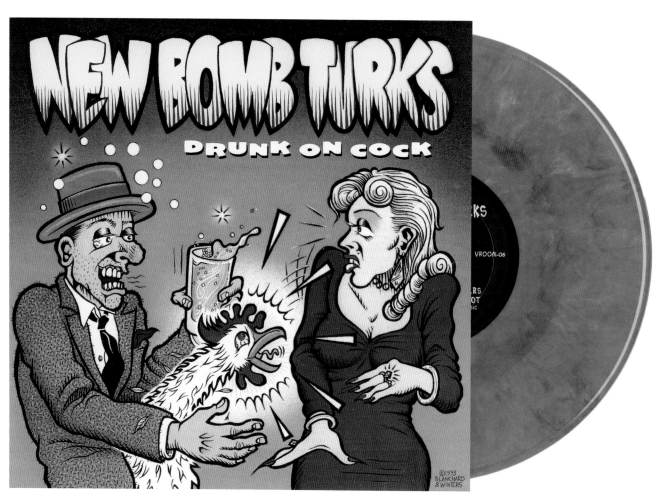

UPPER: **DECADE OF DISASTER, THE TOXIC SHOCK YEARS**- LP cover for various artists compilation, Westworld Records, 1994; LOWER: **DRUNK ON COCK**- 10-inch EP cover for The New Bomb Turks (collaboration with Stevo Winters), Engine Records, 1993.

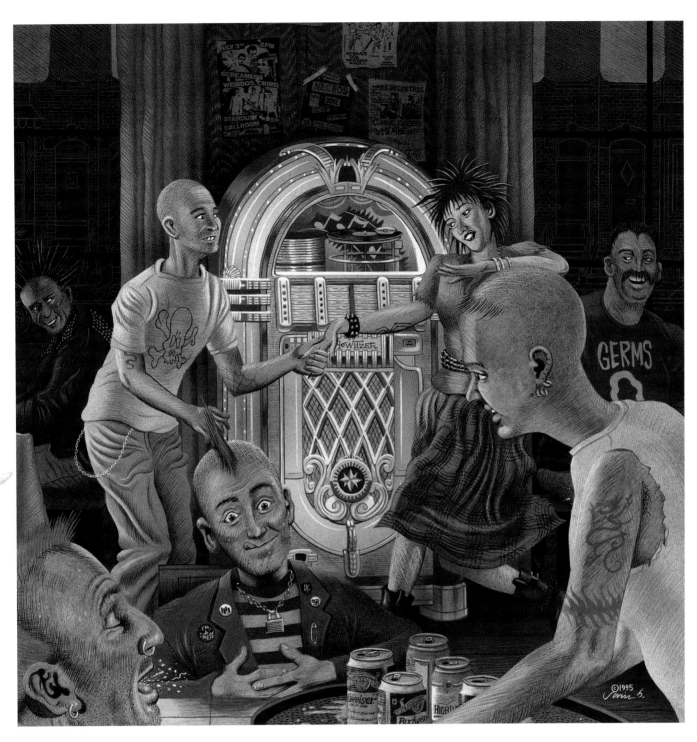

ABOVE: **PUNK ROCK JUKEBOX**- CD cover for various artists compilation (acrylic painting), Cherry Disc Records, 1995; RIGHT: **PUNK ROCK JUKEBOX**- preliminary ink drawing.

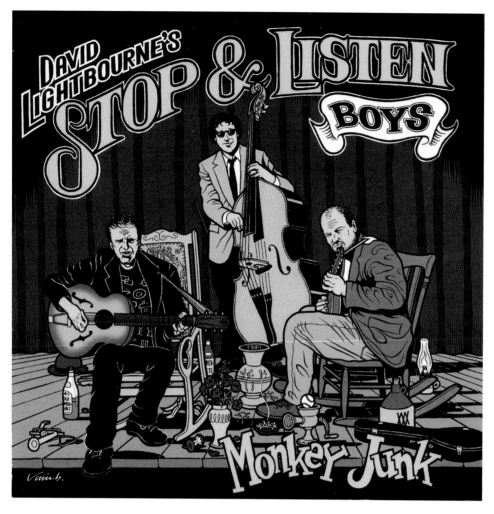

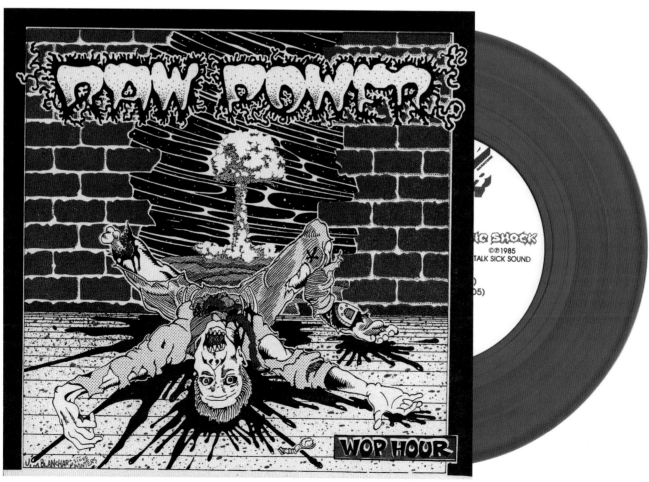

UPPER: **MONKEY JUNK**- CD cover for David Lightbourne's Stop & Listen Boys, Upland Records, 2000; LOWER: **WOP HOUR**- 45 cover for Raw Power (collaboration with Stevo Winters), Toxic Shock Records, 1985.

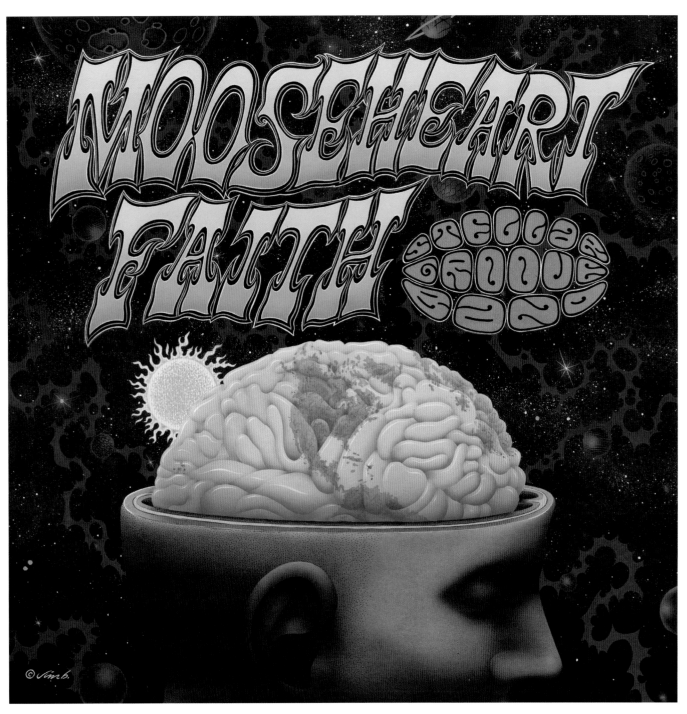

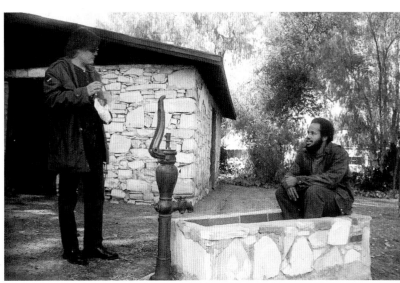

ABOVE: **GLOBAL BRAIN**- LP cover for Mooseheart
Faith Stellar Groove Band (acrylic painting), September
Gurls Records (Germany), 1995; RIGHT: **MOOSEHEART
FAITH**- Todd Homer (left) and Larri Robinson (right)
(photograph by Steve Lange, 1991).

ERINNERUNGEN AN DIE ZUKUNFT

1. THE FACE ON MARS
2. TRANSCEND THE MURMUR...
3. OF SYLLABLES...
4. AND SOUNDS
5. VIVA VON DÄNIKEN
6. AMPERSANDS OF TIME
7. SUBSPACE
8. PRAIRIE DOG
9. LOST PIRATES
10. INVISIBLE INVADERS
11. WE TOW THE LINE
12. RECYCLED SOUL
13. IN YOUR UNDERWEAR
14. I HAVE NO MEMORIES
15. JUST AROUND THE CORNER

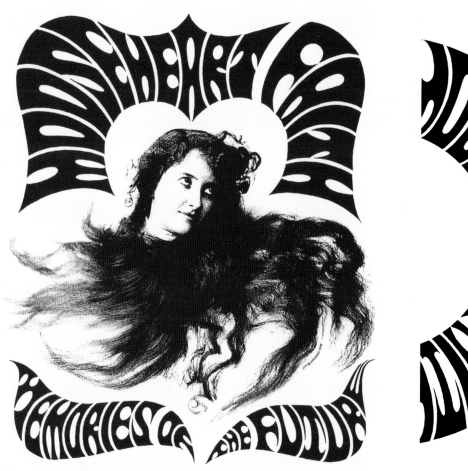

GODSHEART CLUB

MEMORIES OF THE FUTURE

GODSHEART CLUB

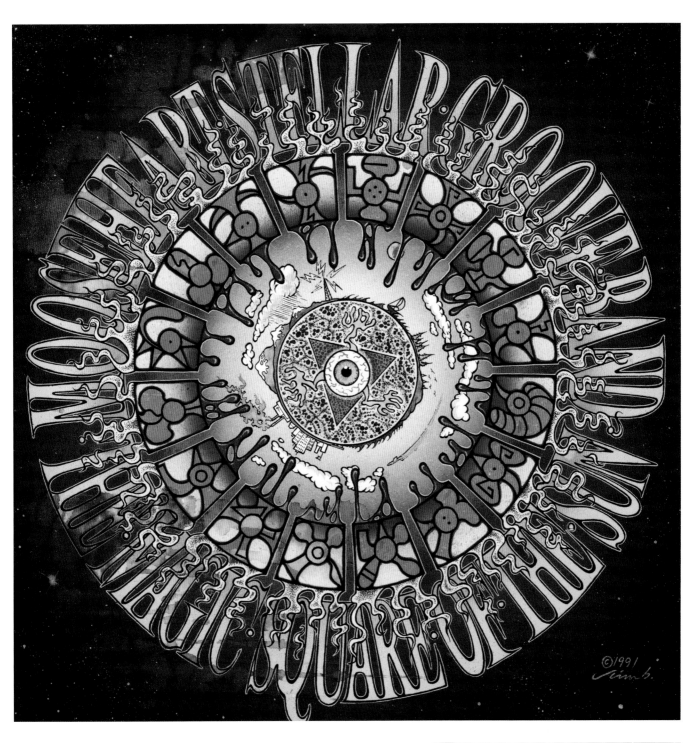

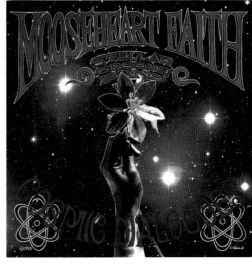

OPPOSITE PAGE: **MEMORIES OF THE FUTURE**- CD package art for Mooseheart Faith
Stellar Groove Band, Stellar Records, 2000 (unissued until 2010). THIS PAGE, ABOVE: **MAGIC
SQUARE OF THE SUN**- CD cover for Mooseheart Faith Stellar Groove Band (bong water
damaged), Stellar Records, 1991, and double-LP September Gurls Records, 1994; RIGHT:
COSMIC DIALOGUES- LP cover for Mooseheart Faith Stellar Groove Band, September Gurls
Records, 1993.

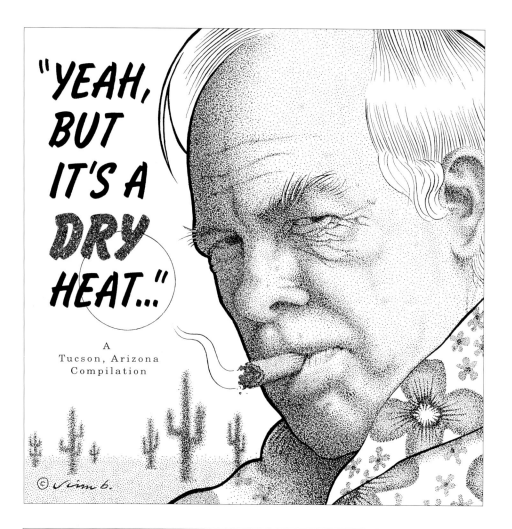

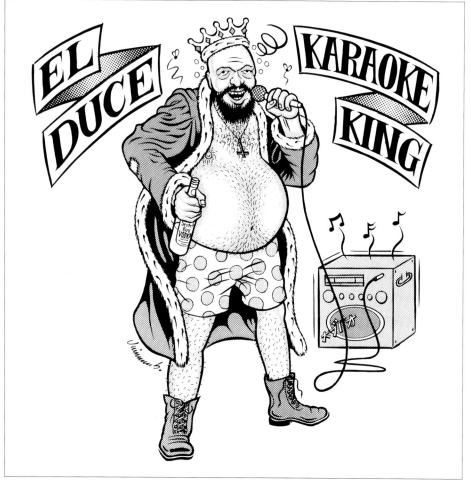

UPPER: "**YEAH, BUT IT'S A DRY HEAT...**" - CD/LP cover for a compilation of Tucson, Arizona rock bands, Westworld Records, 1993; LOWER: **KARAOKE KING PART 2** - CD cover for El Duce, bootleg, 2001. El Duce adds his crude lyrics and vocals to karaoke hits. The CD also contains Mentors demos and El Duce's high school band The Cornshuckers.

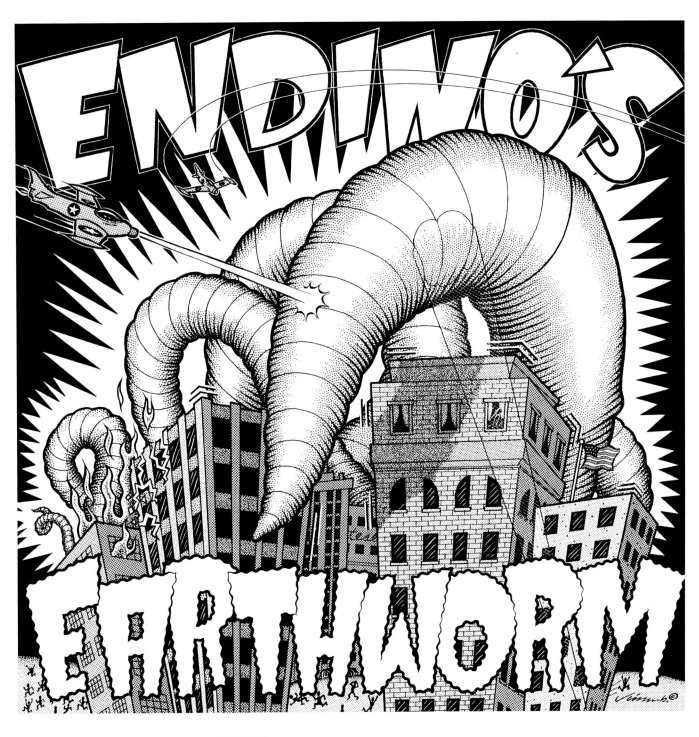

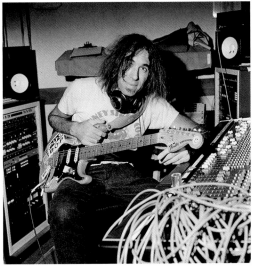

ABOVE: **ENDINO'S EARTHWORM**- CD/LP cover for Endino's Earthworm, Cruz Records, 1992;
LEFT: **JACK ENDINO AT RECIPROCAL RECORDING**- (photograph by Charles Peterson, 1989).

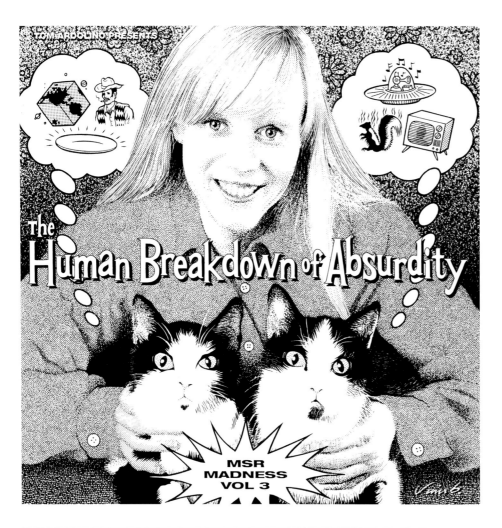

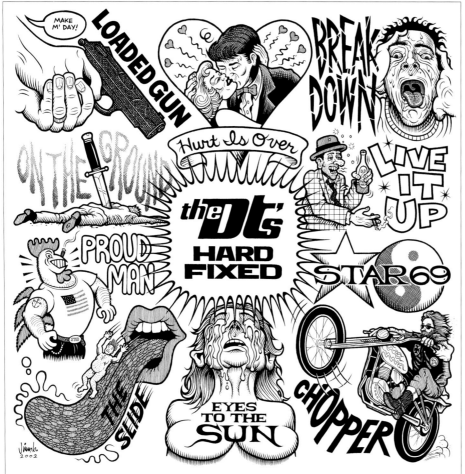

UPPER: **THE HUMAN BREAKDOWN OF ABSURDITY**- CD cover for a compilation of "song poem" music selected by N.R.B.Q. drummer Tom Ardolino, Carnage Press, 1996; LOWER: **HARD FIXED**- poster insert for The Dt's *Hard Fixed* CD/LP, Estrus Records (USA), 2002, and GP Records (Spain), 2002.

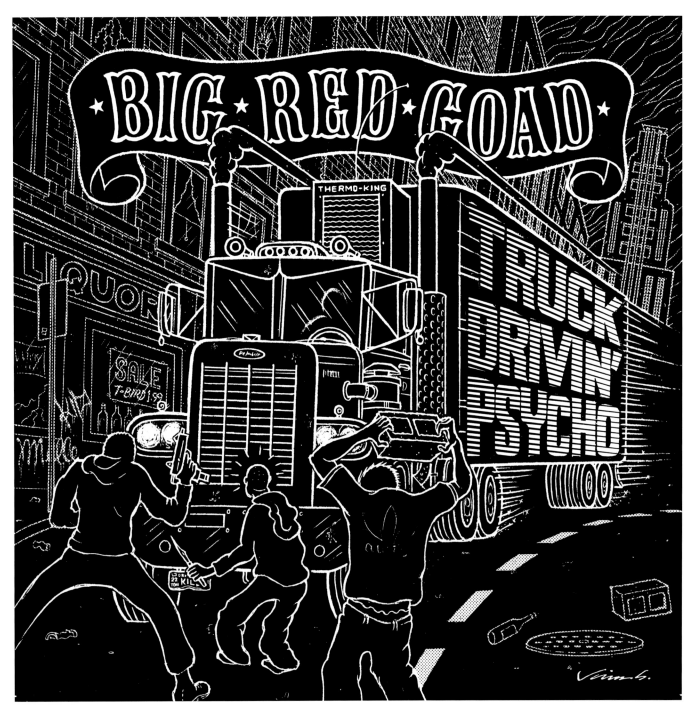

ABOVE: **TRUCK DRIVIN' PSYCHO**- CD cover for Big Red Goad aka *Answer Me!* magazine founder Jim Goad, World Serpent Records (U.K.), 1995; RIGHT: **JIM GOAD**- (photograph by "some Portland rockabilly girl named Kristen").

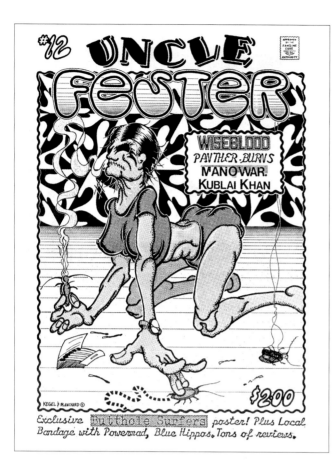

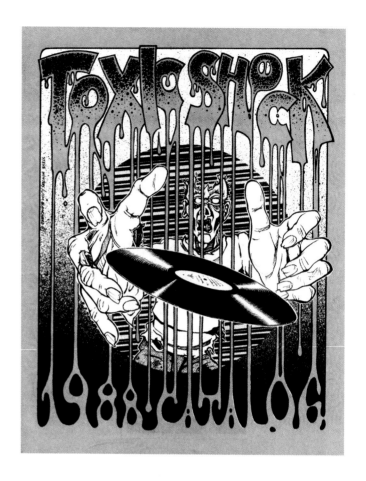

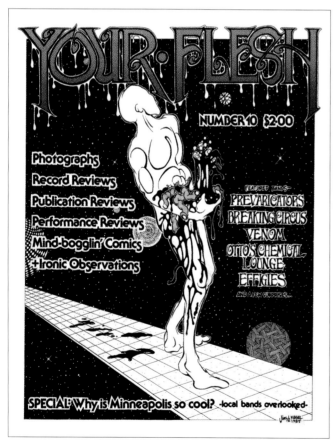

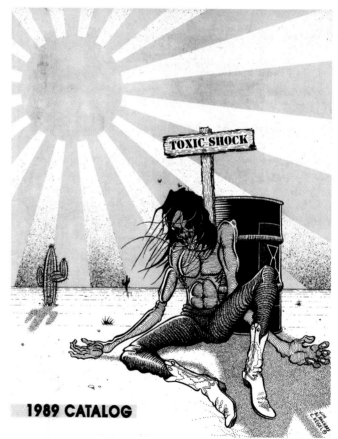

THIS PAGE, ABOVE LEFT: **UNCLE FESTER #12**- cover for punk fanzine (collaboration with Chris Kegel), 1986; ABOVE RIGHT: **TOXIC SHOCK 1988 CATALOG**- cover for mail-order catalog (collaboration with Stevo Winters), 1988; LOWER LEFT: **YOUR FLESH NUMBER 10**- cover for punk fanzine (collaboration with Chris Kegel), 1985; LOWER RIGHT: **TOXIC SHOCK 1989 CATALOG**- cover for mail-order catalog (collaboration with Chris Kegel), 1989. OPPOSITE PAGE: **WESTWORLD 1994-95 CATALOG**- cover for mail-order catalog, 1994 (unused).

WEST WORLD

1994-95 CATALOG

*Formerly TOXIC SHOCK

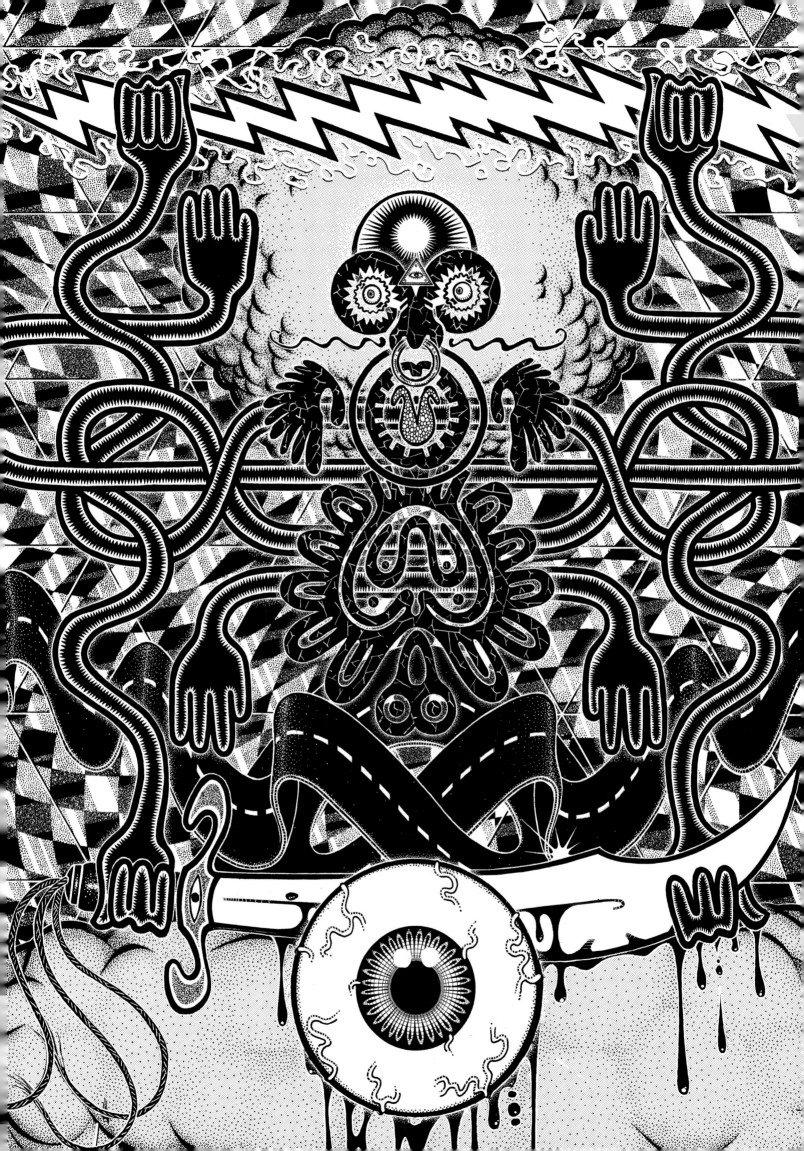

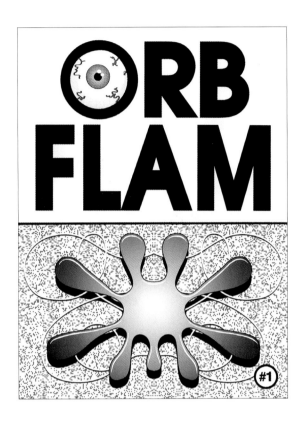

RETINA DAMAGE

Bulging, dilated pupils stare back at me from the bathroom mirror of the Red Apple Bowling Center in Bartlesville, Oklahoma. I'm sixteen years old and an hour into my first trip on lysergic acid diethylamide. It's much different than I thought it would be. No hallucinating, everything just seems *clearer*: seeing and hearing sharpened significantly, perceiving an energy field that I've never perceived before, but that must have been there all the time. The ability to effortlessly "read" people and environments—see *through* them. At one point I'm convinced I can see the rumbling molecules that make up matter. Everything is alive and pulsing, even inanimate objects. It's very strange and enjoyable. Above all else, it's *funny*. I can't stop laughing at myself, and every single thing around me. I'm laughing so hard it *hurts*. Now I understand why LSD was such a big deal in the 1960s.

I took acid a couple dozen times in my teens and twenties, and rarely had a bad trip. The only bad trips I had were caused by bad acid (probably not real LSD to begin with), or taking it in the wrong place with the wrong people. Timothy Leary preached the importance of "(mind)set and setting" during the use of psychedelics, and he was right.

In some ways, acid and pot merely confirmed what I already knew. I felt the psychedelic inclination very early on. When I was six years old in Stavanger, Norway, one of my first and strongest inspirations to make art happened when I saw felt marker hippy art made by Mark Ingram, the teenage son of a guy my father worked with. (I hung out with Lori, Mark's little sister who was my age.) The walls of Mark's basement bedroom were covered with his trippy, brightly colored poster board creations, obviously influenced by Peter Max and the tacky psychedelic art that was en vogue in 1971. Mark's magic marker posters, with their symmetry, checkered patterns and swirling, radiating lines had me captivated, and I quickly set out to make my own versions of them.

In second or third grade, I developed the predilection for rendering fields of texture in microscopic detail. I would fill sections of typewriter paper with row upon row of tightly stacked little circles and

ovals. Or rows and rows of outlines. Or cross hatched lines. Or simply dots. For some reason I found it comforting to wile away hours of time filling a blank piece of paper with a repeating graphic pattern, my face just six inches from the surface. It was like creating my own little graphic realm to wallow around and disappear in. These dense areas of texture and the exactness of the detail would later become my artistic signature. When most people see my crowded, overtly psychedelic artwork, I think there's a presumption that it's influenced by pot, speed, or acid. But the instinct to make that kind of art was with me way before I ever did drugs.

There were many *psych* signposts along the way. Like scores of kids, seeing extravagantly detailed record cover art left its mark on my prepubescent aesthetic sensibilities: *Sgt. Pepper's Lonely Hearts Club Band* and *Magical Mystery Tour* by The Beatles, *Monster* by Steppenwolf, the Hindu-inspired *Axis: Bold As Love* by Jimi Hendrix, and even *Captain Fantastic* by Elton John come to mind. I was intrigued by comic book advertisements for psychedelic posters, patches and t-shirts, with their meticulous layouts of postage stamp sized reproductions. Marvel/DC comics artists like Jack Kirby, Jim Starlin and Berni Wrightson, surrealist Salvador Dalí, and the Renaissance era's Hieronymus Bosch could all be considered psychedelic catalysts.

Two books that had a profound effect on my impressionable young art brain were *Mouse & Kelly* and *Rick Griffin*, both budget-priced titles from the Pedigree/Paper Tiger imprint. I bought them at a shopping mall book store when I was fourteen or fifteen years old, and studied them cover-to-cover, especially the Rick Griffin one. The primary color schemes, uncanny precision and centered, emblematic nature of the art really grabbed me. It seems very apparent from looking at my art in this chapter how indelibly Rick Griffin informed my "psychedelic" art style.

Another important book I chanced upon in my early teenhood was *Optical and Geometrical Allover Patterns* by Jean Larcher. Produced by the excellent visual reference and public domain publisher Dover Books, *Optical and Geometrical* contains full page after full page of Larcher's eyeball-tweeking "op art," and would be a source and inspiration for my psychedelic backgrounds for years to come. I still have the copy I bought in 1980, and it's battered and chopped to pieces.

By the time I started college at Oklahoma University in 1983, I had a pretty good command of my graphic art skills, and began creating dense, single-page illustrations that were, more or less, an evolved version of the full pages of texture that I had done

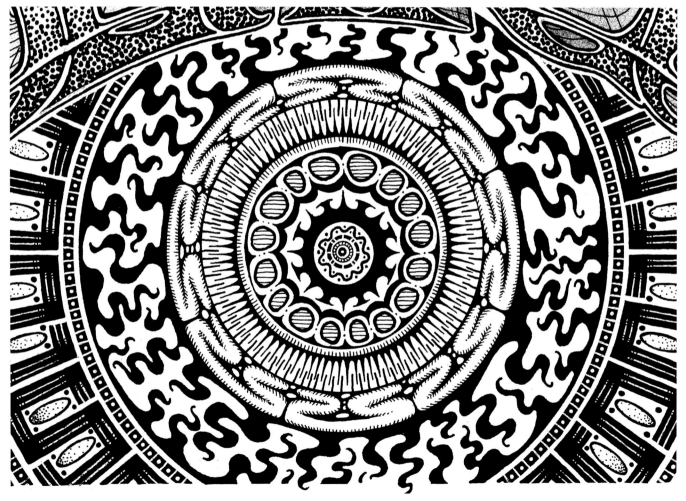

PSYCHEDELIC LOGO FOR BLATCH MAGAZINE- detail, 1985

as a pre-teen. Every square inch was crammed with as many precise black or white dots and lines that I could fit into them. The subject matter was less important than the technique. These one-page psychedelic illustrations existed for no purpose other than to *get me off*, and they became an addiction and personal challenge. I worked on them feverishly.

1983 was also the year that I met Chris Kegel, a friend of my college roommate Ben Blankenship. Chris had an uncanny knack for drawing outrageous, exaggerated human figures, and shared my sick and provocative sense of humor. The first time I inked some of Chris' tossed off pencil sketches, I knew immediately that we were on to something cool. Chris had a natural ability to draw that I would never have, and over time he would become a cheif collaborator and we would produce hundreds of pages of hallucinatory, weirded-out comics and art.

In 1988, I was contacted by Jacaeber Kastor, who ran a small but crucial art gallery in New York City called The Psychedelic Solution. Jacaeber asked me to contribute art to a big group show he was currating called *Summer Solution 1988*, which included many of my art heroes like Rick Griffin, Stanley Mouse, Alton Kelley, Alex Grey, and Robert Williams. I was stoked to be part of the show. The piece I submitted was a collage composed of a human skull and assorted emanations cut from xeroxes of my '80s psych art. Jacaeber loved it, bought the original, and used the image for the gallery's business card. In 1990 the Psychedelic Solution produced a full color version of the skull art, both as a poster and large postcard. *Psych Skull* proved to be one of my most popular images, and appears on the cover of this book.

In 1991 I took the plunge and self-published a collection of my full-page psychedelic works in a large-format art book called *Retina Damage*. Despite its unwieldy 13 x 11 inch format, the book sold relatively well through comic book and indy music distributors.

The last section of this chapter is a *Rogues gallery* of what I call "eyeball-poppin' tongue-waggers." These grotesque faces and characters are the byproduct of a steady diet of assorted pop culture ingredients, among them: Warner Brothers *Looney Tunes* cartoons, Big Daddy Roth/Stanley Mouse hot rod monsters, plastic *Nutty Mads* figurines, Topps *Ugly Stickers* by Norman Saunders, and the art of Basil Wolverton, who I probably first encountered on the covers of DC's *Plop!* comics of the '70s. I see these types of creatures as personifying a certain wacky, cathartic mind state that is an appropriate response to a world gone insane. In fact, I can't think of a more definitive visual distillation of the American *id* than Big Daddy Roth's hot rod monsters: thrusting recklessly forward, full throttle, spit and sweat flying, crushing anything that gets in its way, in a machine that's way too powerful. These goofy, grimacing faces also function as an extension of my own proclivity for making funny faces, so in a sense, they are self-portraits!

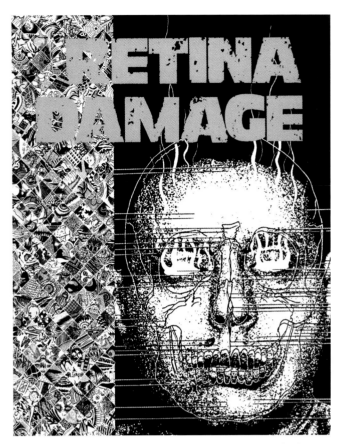

RETINA DAMAGE- cover for large-format, self-published art book, 1991.

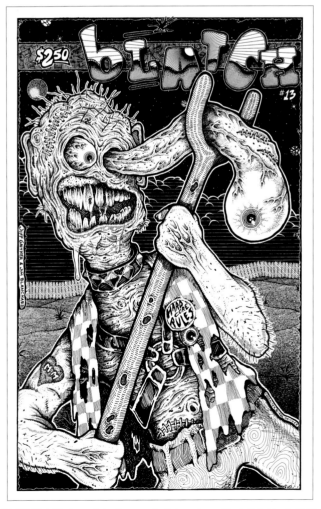

BLATCH #13- front & back cover (collaboration with Jeff Gaither), 1986.

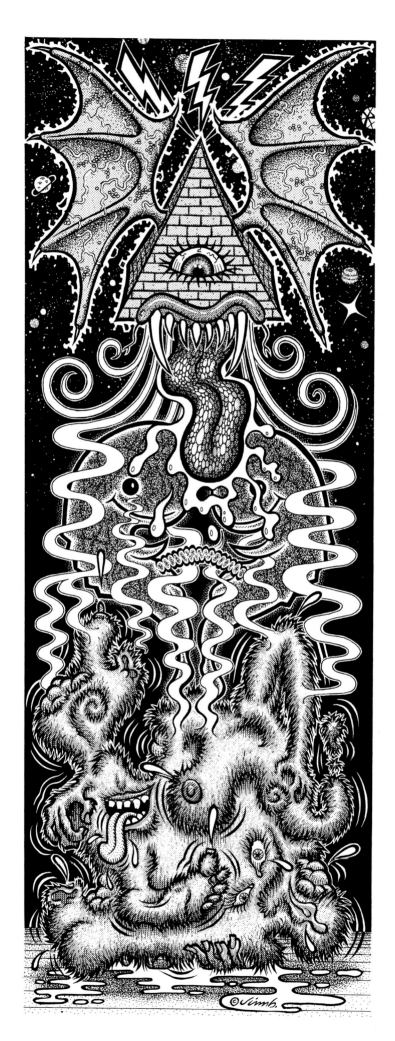

THIS PAGE: Appeared as **SEX WITH THE ELDER GODS** in the Church of the Subgenius book *Revelation X*, 1994, and as **THE 100TH BONOBO** in the comic *Bad Meat* No. 3, 1997 (both with text pieces by Rev. Ivan Stang). OPPOSITE PAGE: **AZTEC GOD**- from *Blatch* #12, 1986.

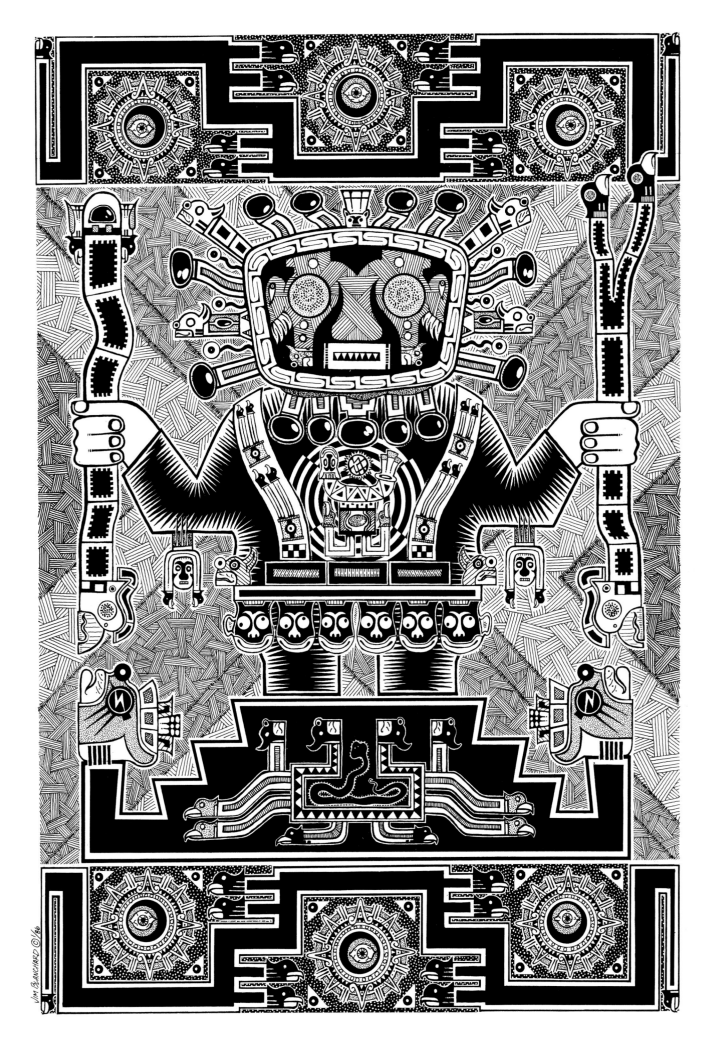

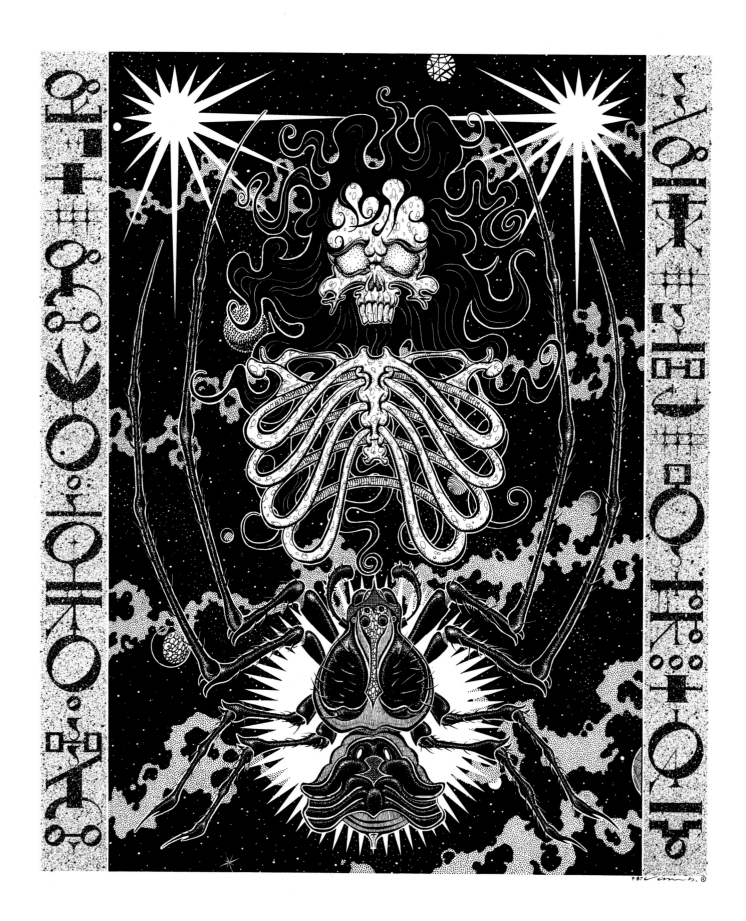

PSYCHEDELIC SKELETON AND SPIDER- from *Blatch* #14, 1988.

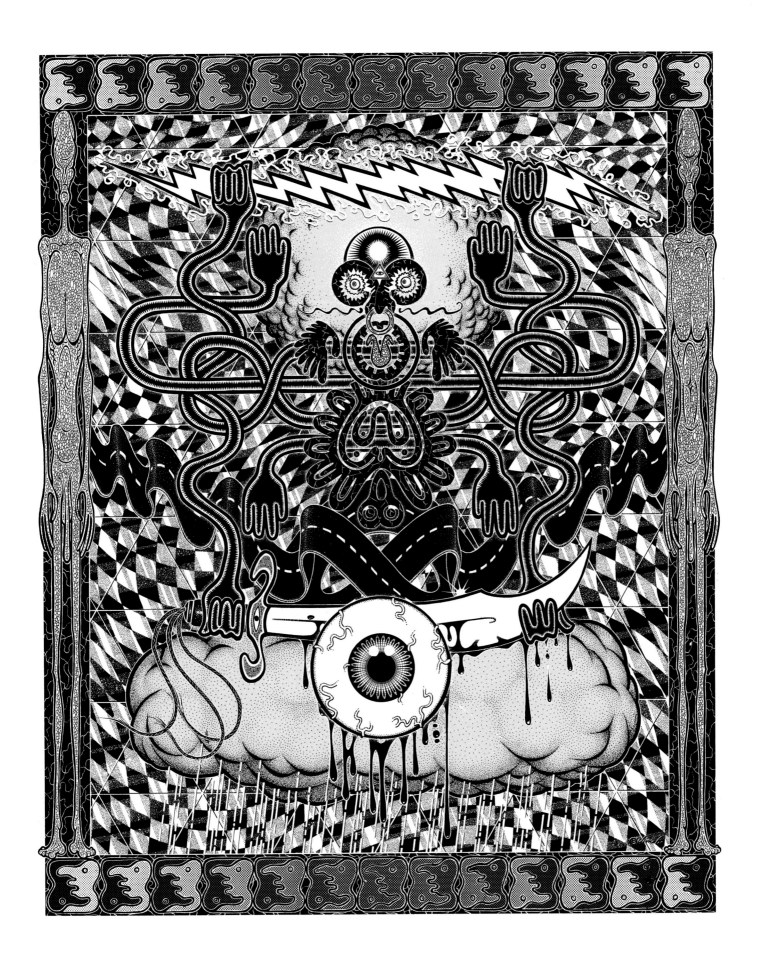

EYE/I KILL I/EYE (ROAD-WEARINESS IS NEXT TO GODLINESS)- from *Orb Flam* #1, 1989, and *Retina Damage*, 1991. Printed as a large poster in 1994.

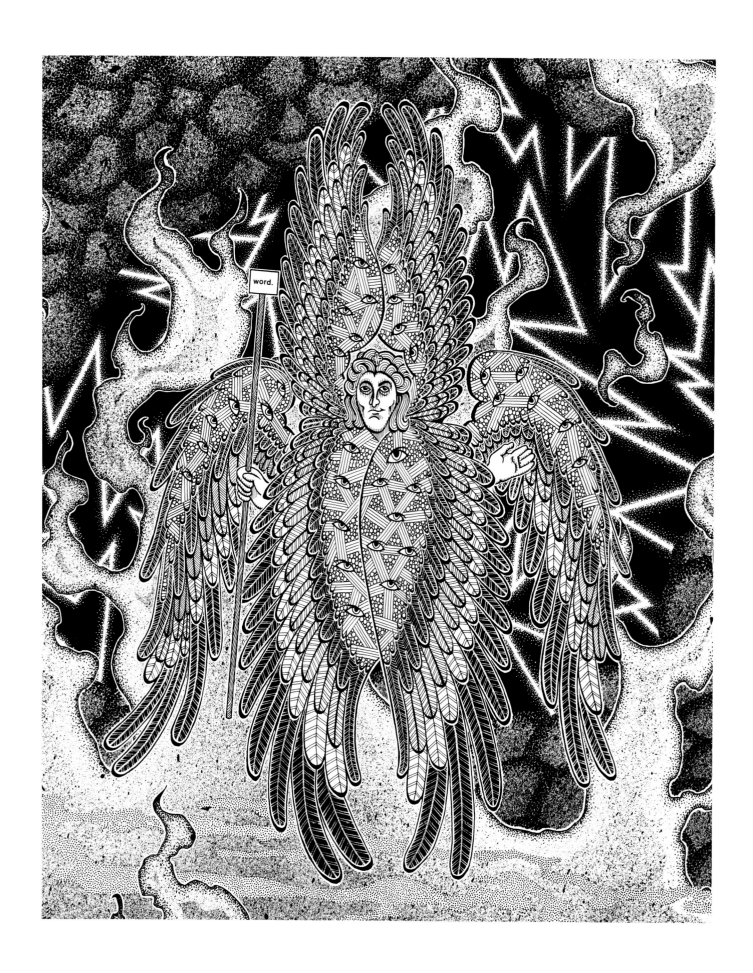

SMIRKING ANGEL IN HELL- from back cover of *Fear • Power • God* LP, 1987, and *Blatch* #14, 1988.

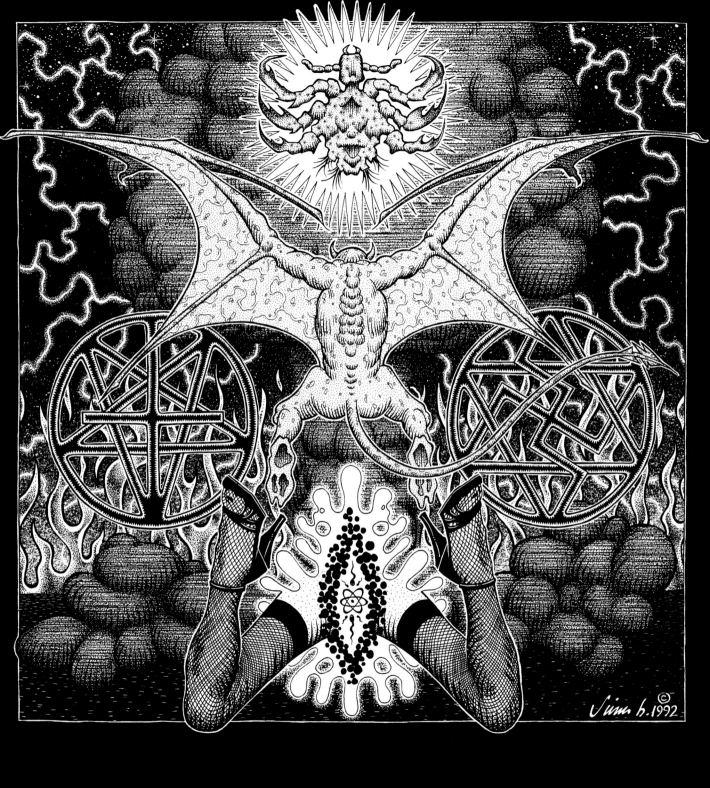

CRAB LOUSE APOCALYPSE- from *Cruel World* No.1, 1993, and *Irreparable Ignorance* 45 picture sleeve for metal band Subsanity, 1993.

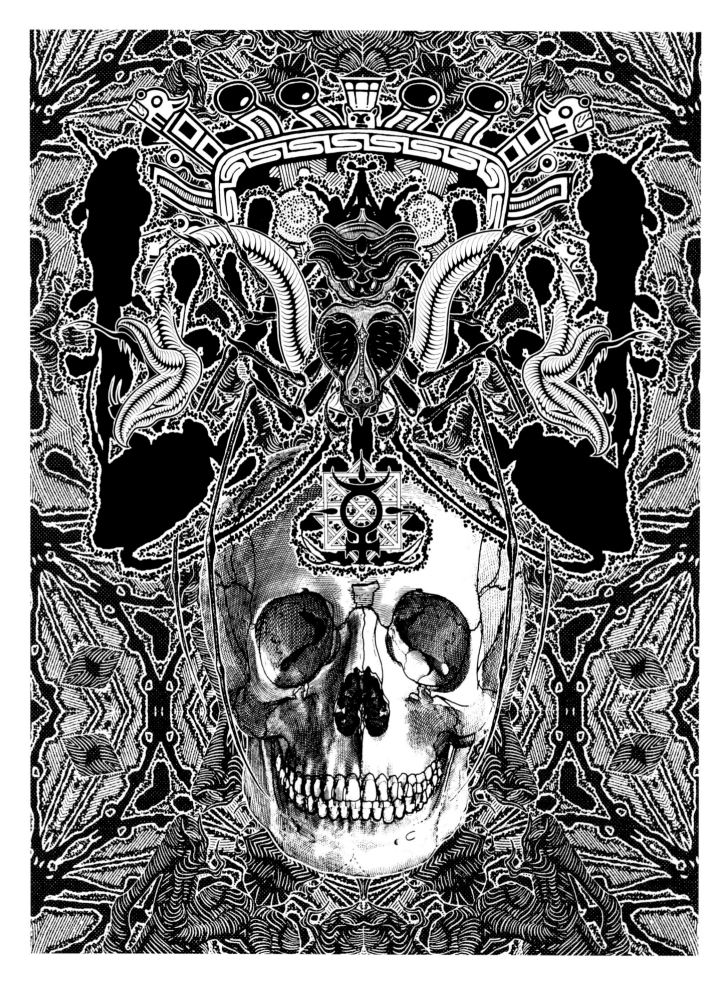

PSYCHEDELIC SKULL (VARIANT)- from *Retina Damage*, 1991.

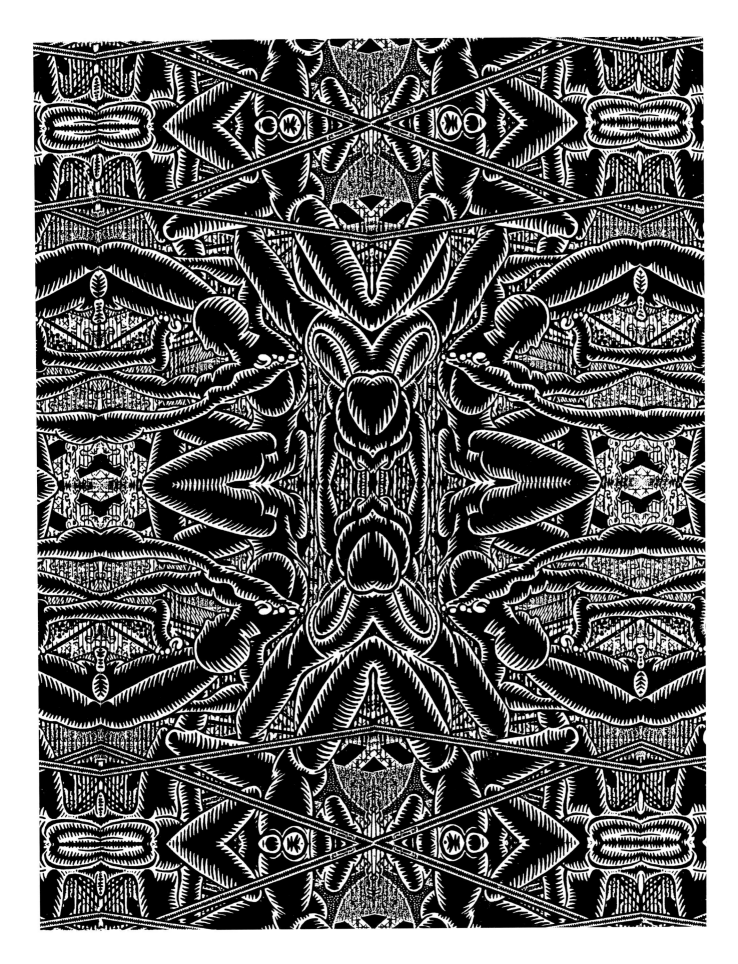

PSYCHEDELIC XEROX COLLAGE- from *Retina Damage*, 1991.

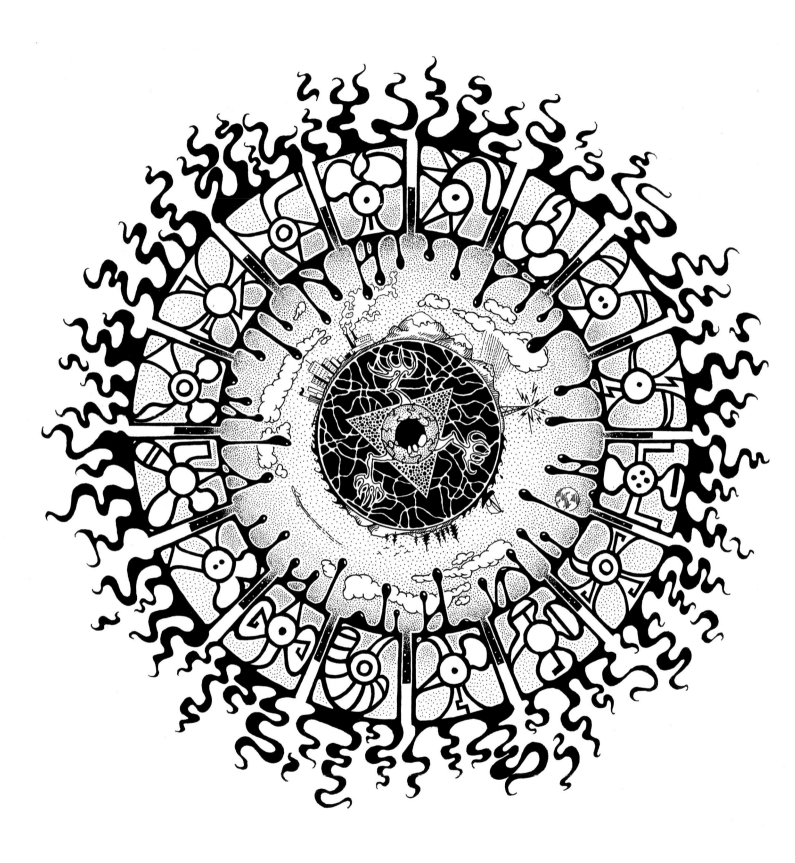

THIS PAGE: **COSMIC MANDALA**- from *Blatch* #12, and cover of *Wildmill* literary anthology (University of Oklahoma Press), 1986.
OPPOSITE PAGE: **UNTITLED**- from *Blatch* #12, 1986 (collaboration with Chris Kegel).

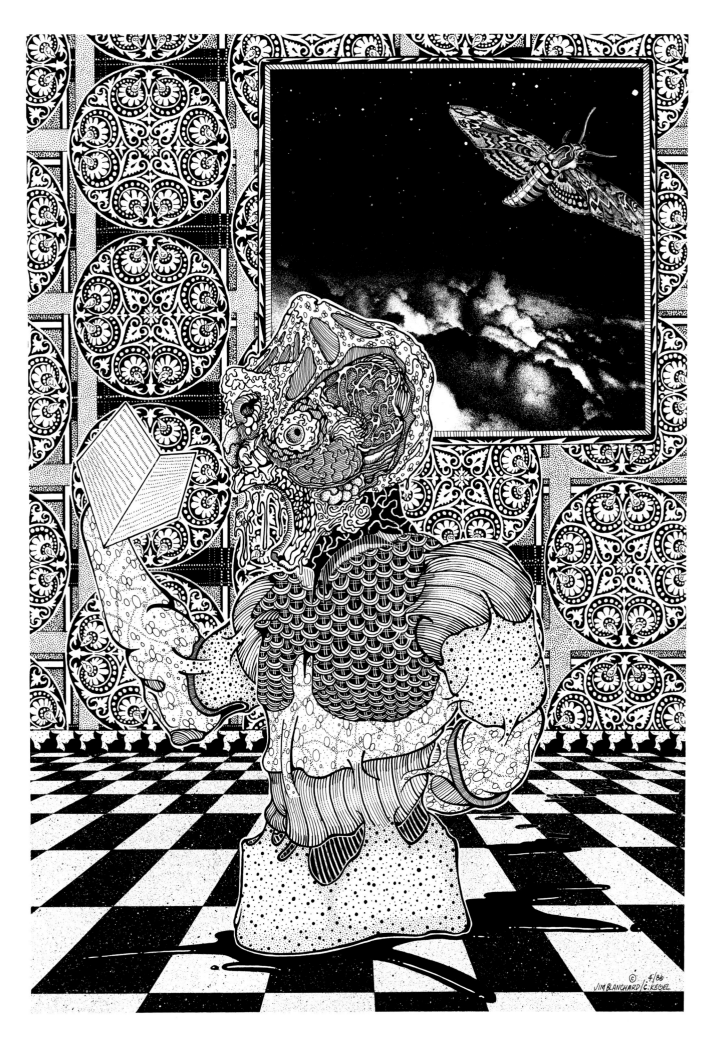

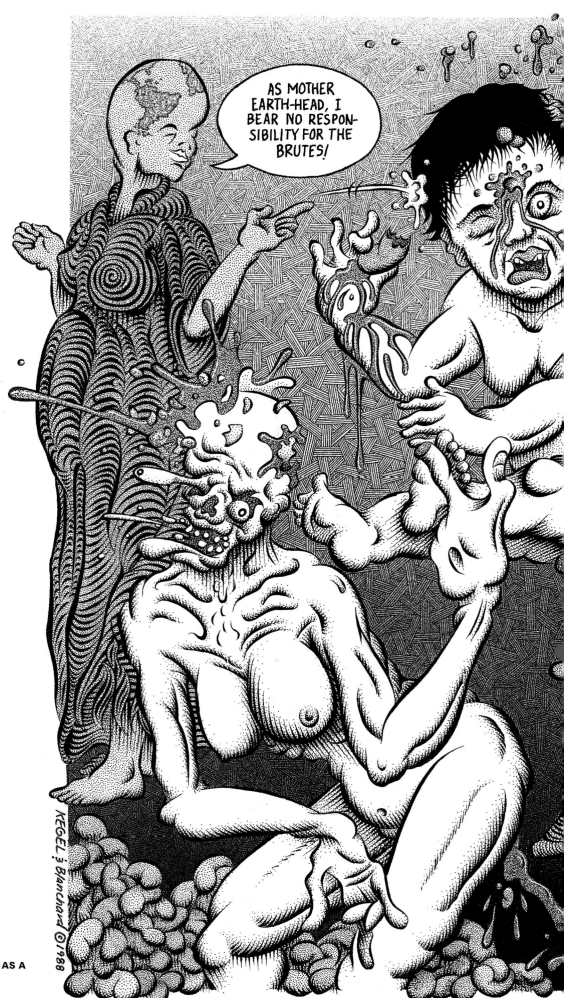

REVELATIONS 1: ARTIST CHILD AS A MAN- from *Blatch* #14, 1988 (collaboration with Chris Kegel).

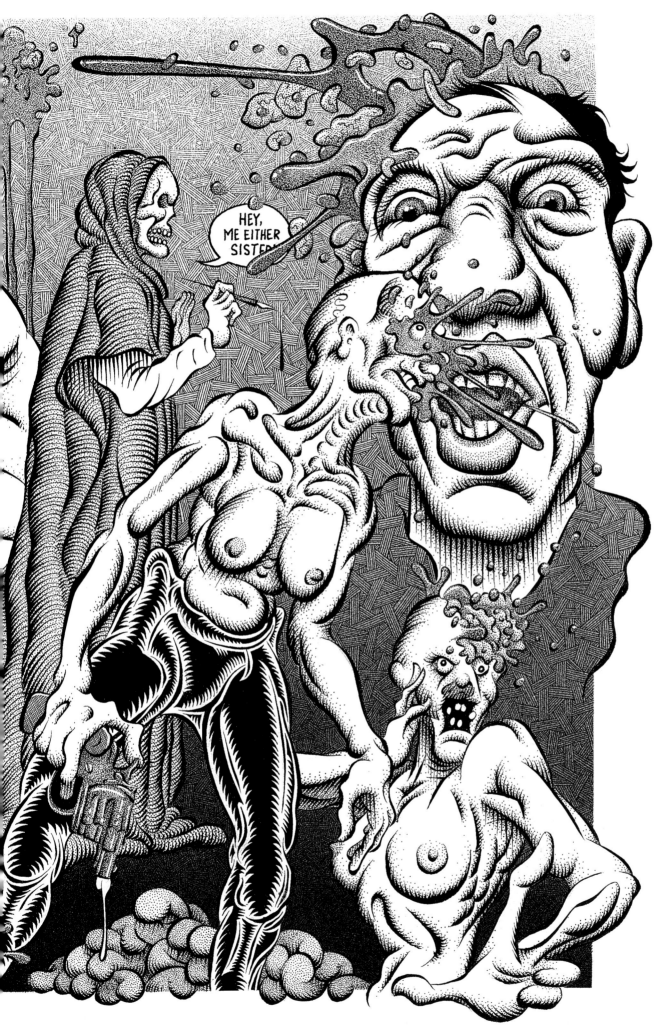

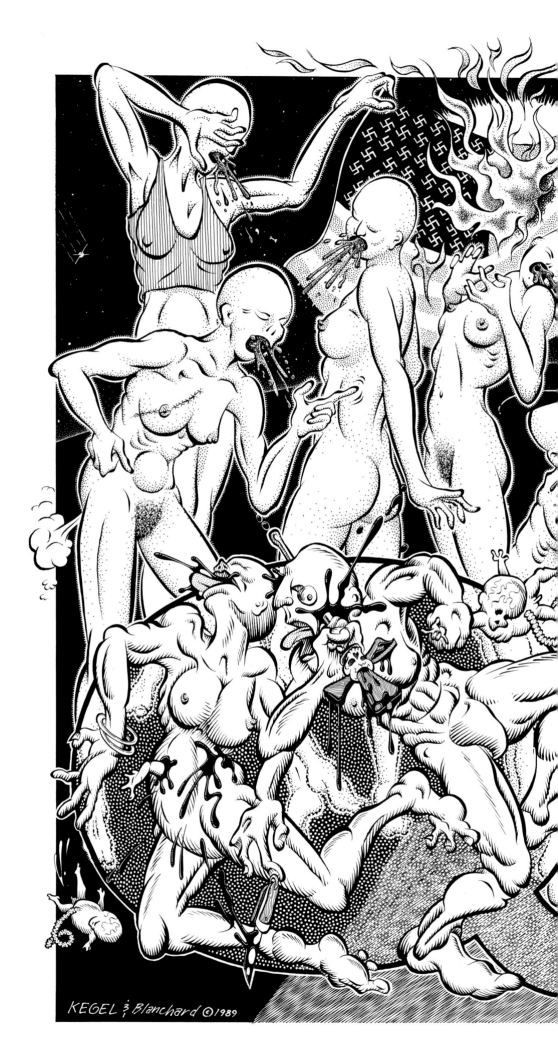

REVELATIONS 2: WHEN BUSHES COLLIDE- from *Bad Meat* #1, 1991 (collaboration with Chris Kegel).

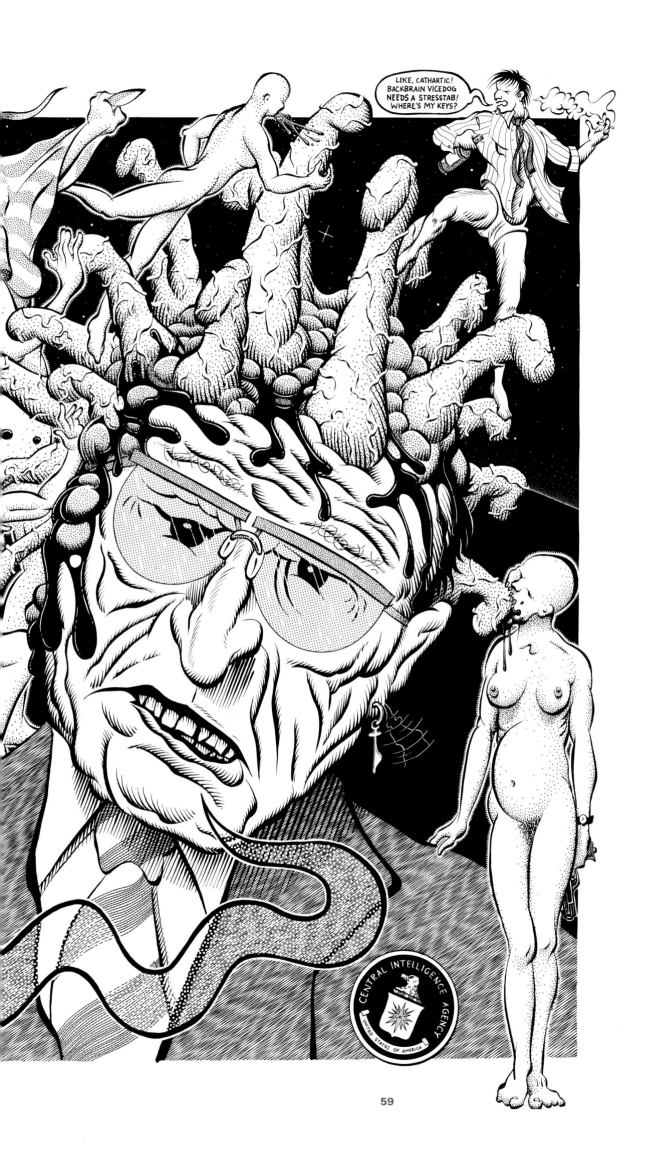

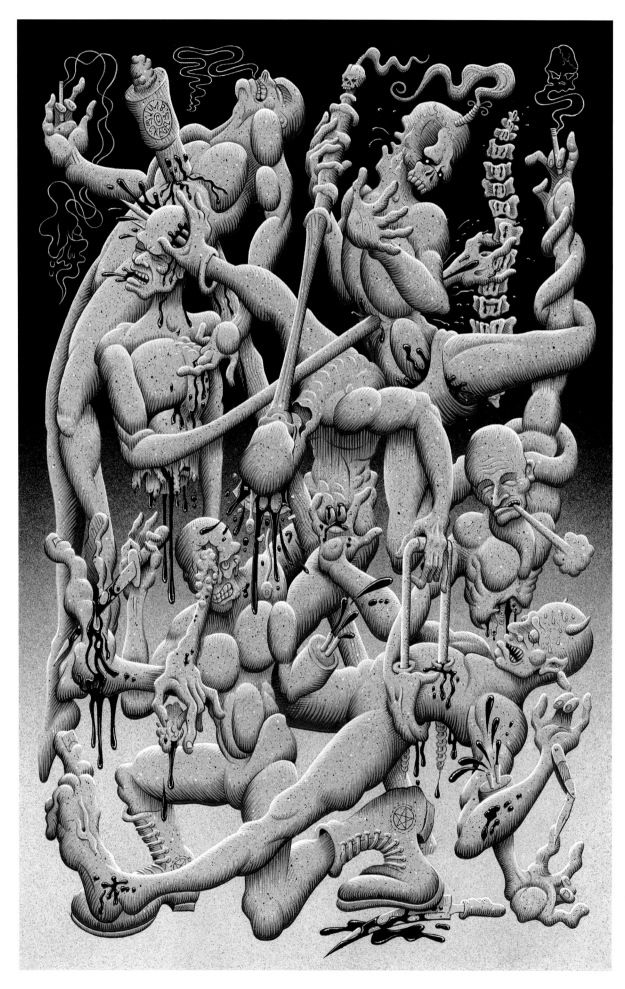

THE GLORY OF MAN- acrylic painting from *Bad Meat* No. 3, 1997 (collaboration with Chris Kegel).

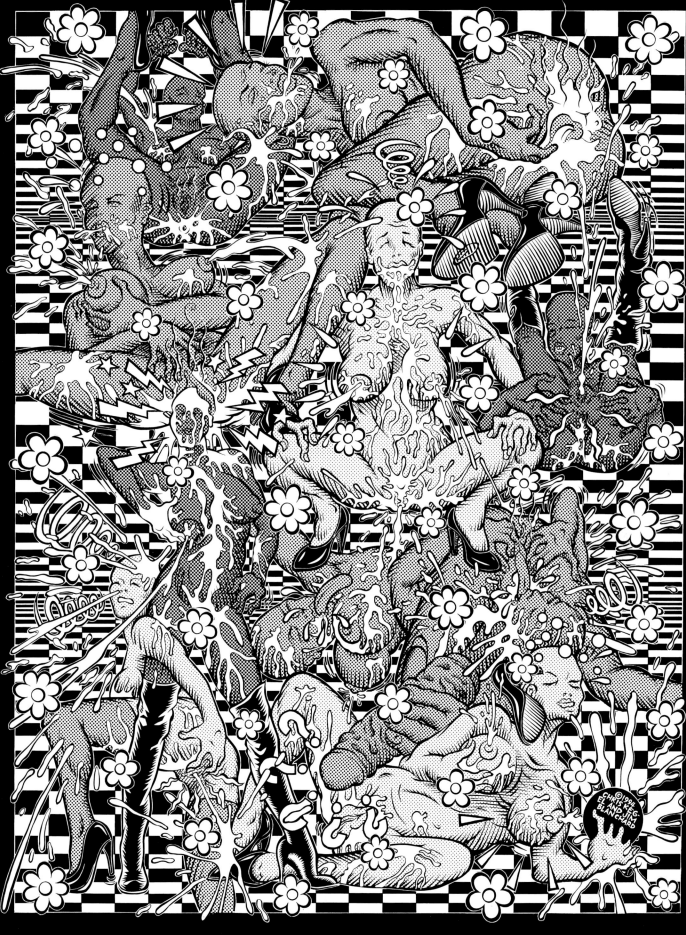

THE GLORY OF WOMAN- from *Bad Meat* No. 3, 1997 (collaboration with Chris Kegel).

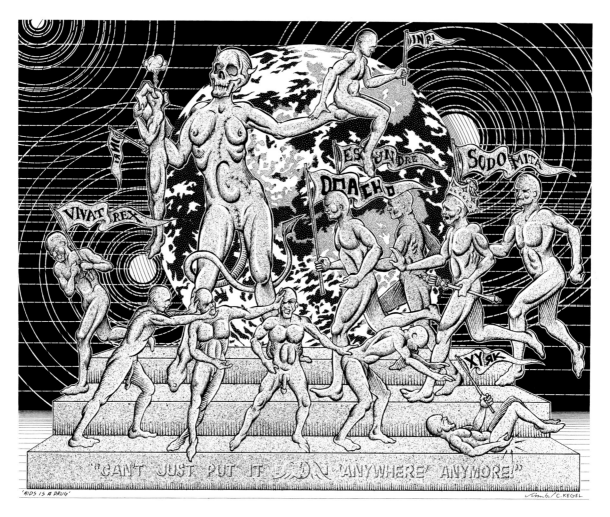

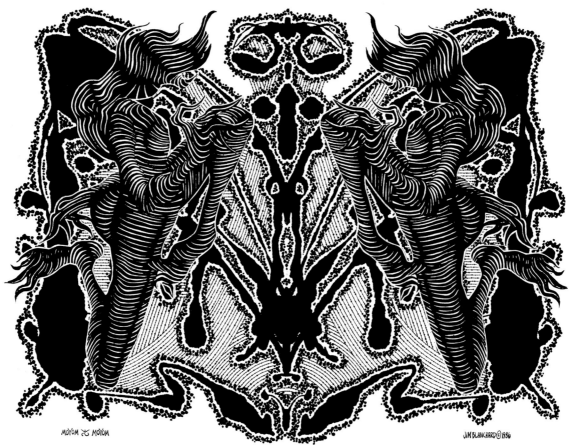

ABOVE: **AIDS IS A DRUG**- from *Blatch* #14, 1988 (collaboration with Chris Kegel); BELOW: **MOYOM VS. MOYOM**- from *Blatch* #13, 1986.

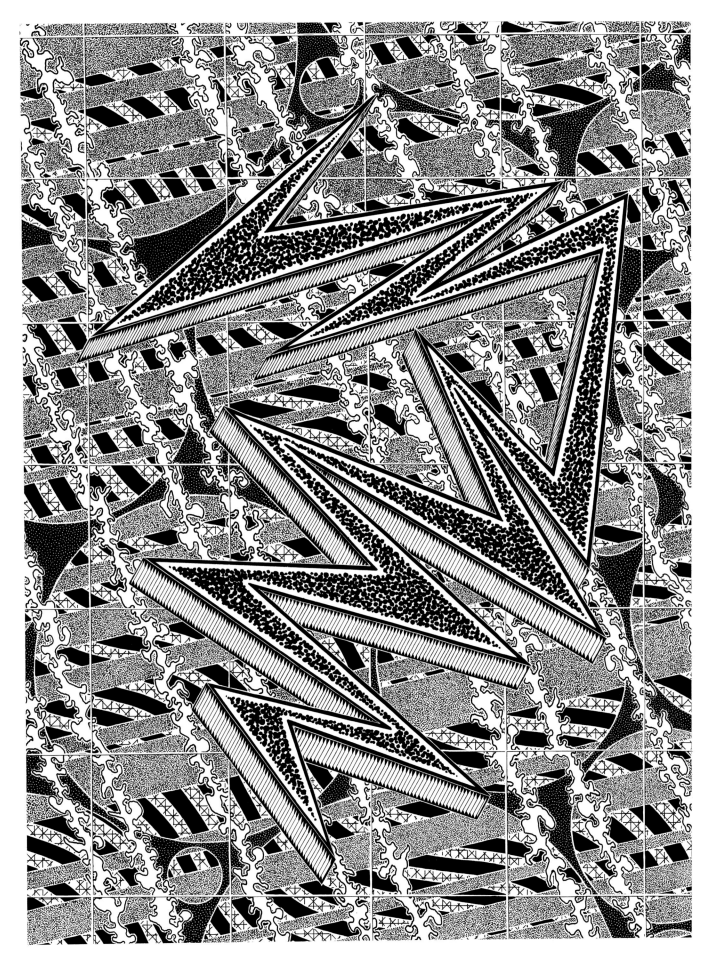

UNTITLED- from *Blatch* #13, 1986.

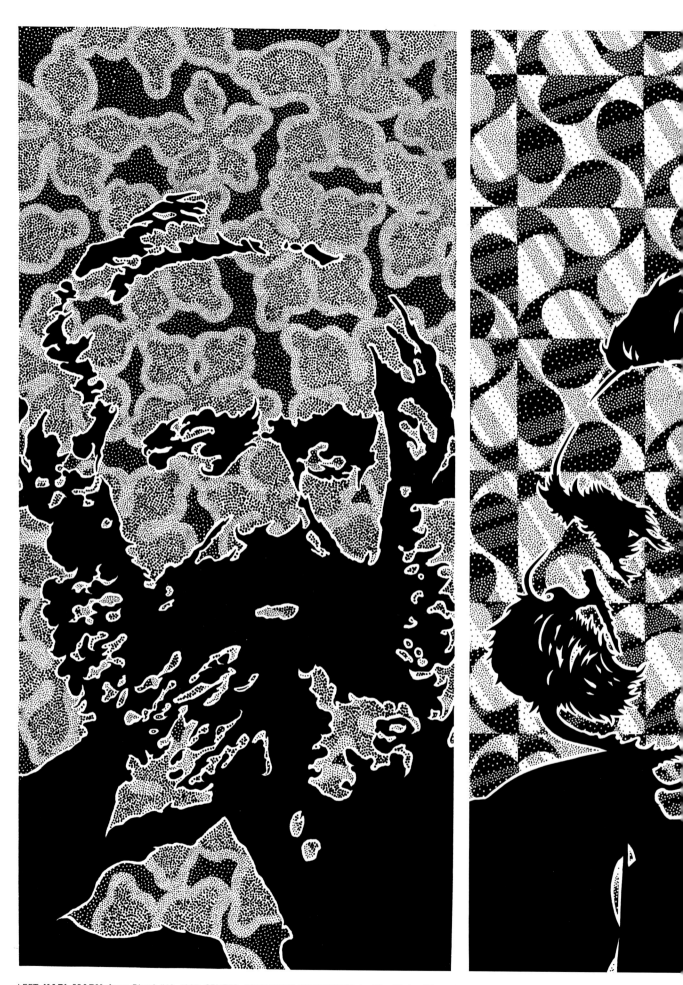

LEFT: **KARL MARX**- from *Blatch* #12, 1985; CENTER: **FRIEDRICH NIETZSCHE**- for *The Birth of Tragedy* magazine, 1985;
RIGHT: **WILLIAM S. BURROUGHS**- for *Forced Exposure* magazine, 1986.

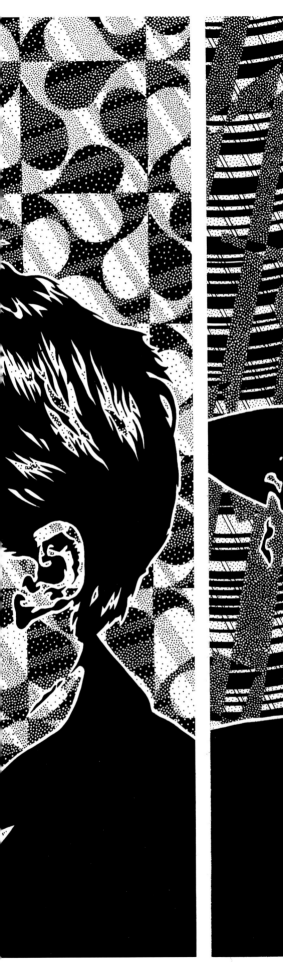
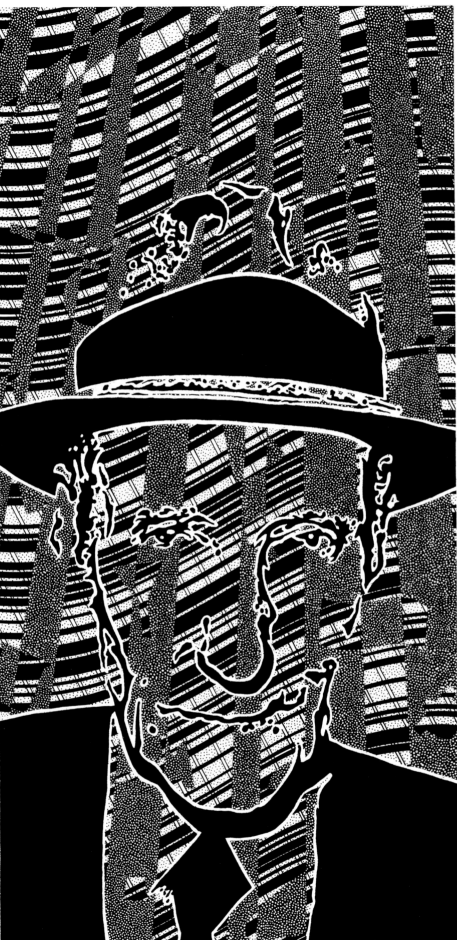

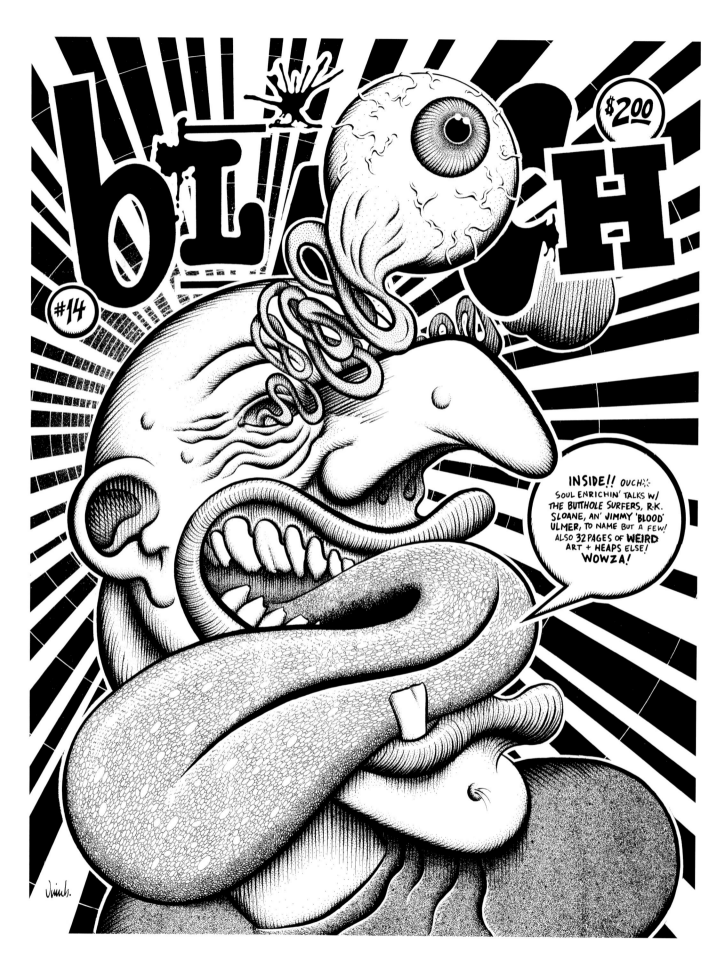

BLATCH 14- cover art, 1988.

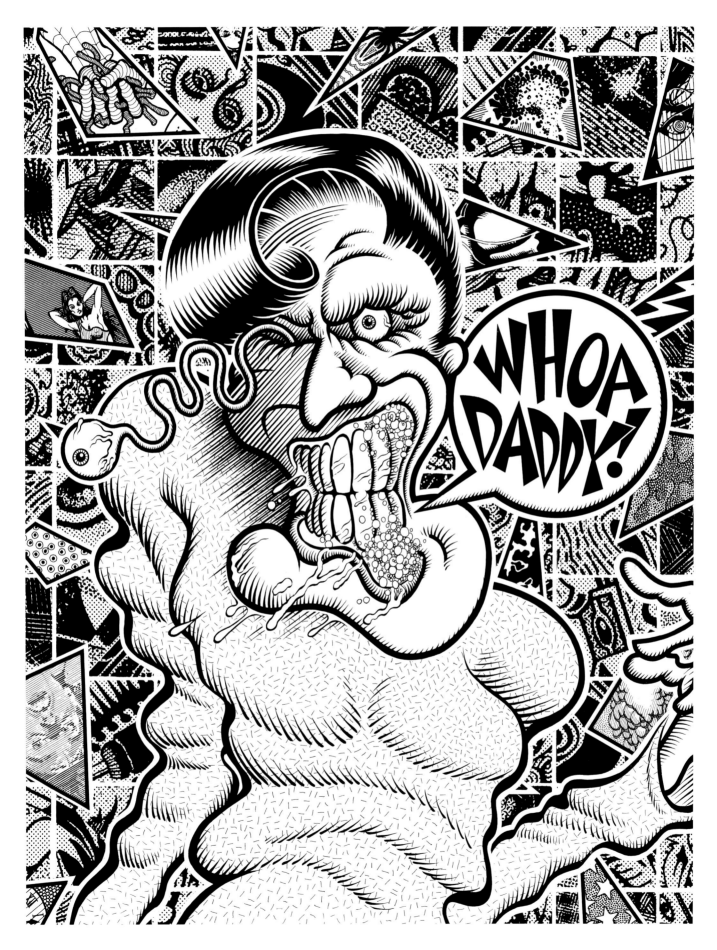

WHOA DADDY!- from *Cruel World* No. 1, 1993. Also appeared as cover art for *The Seattle Star* comics tabloid, and *Art Alternatives* magazine.

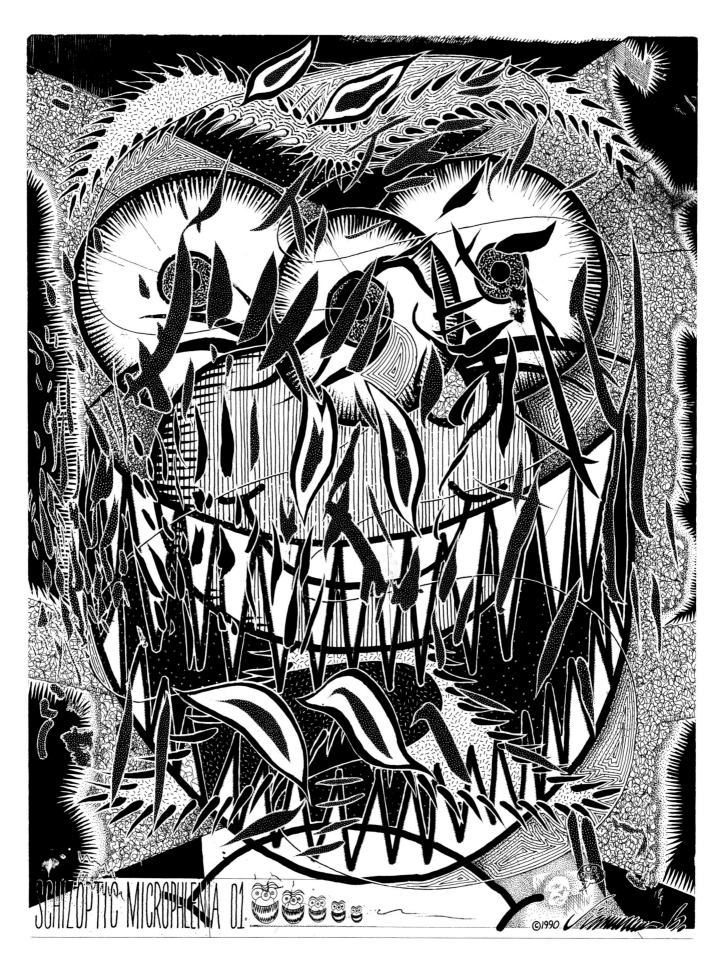

SCHITZOPTIC MICROPHLENIA 01- from *Retina Damage*, 1991.

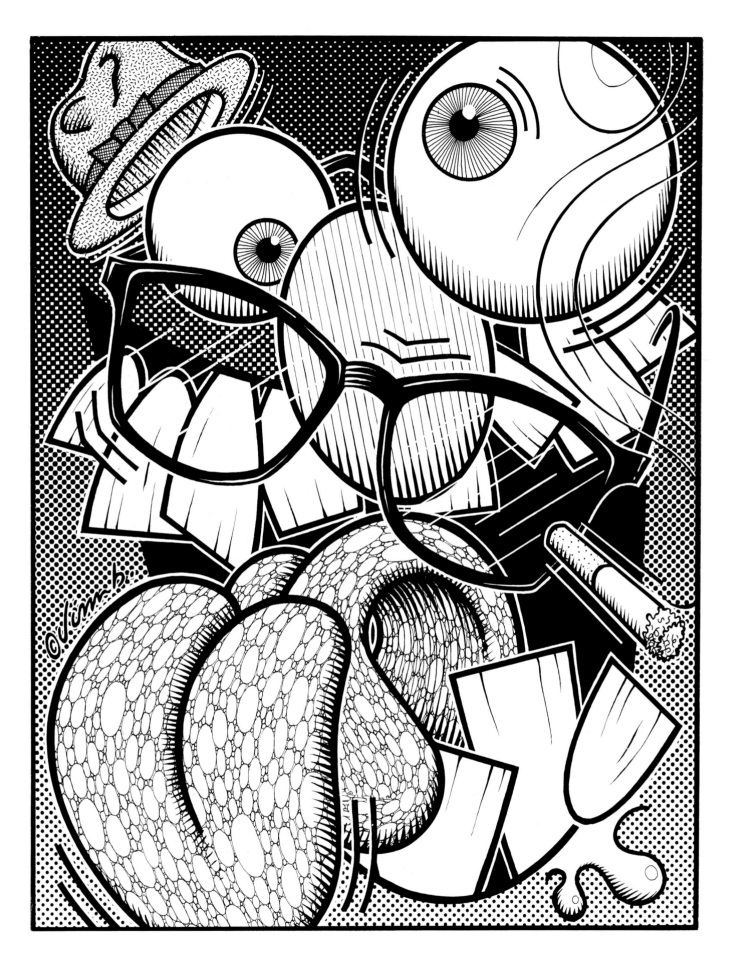

WACKY FACE WITH GLASSES, HAT, AND CIGARETTE- from *Retina Damage*, 1991.

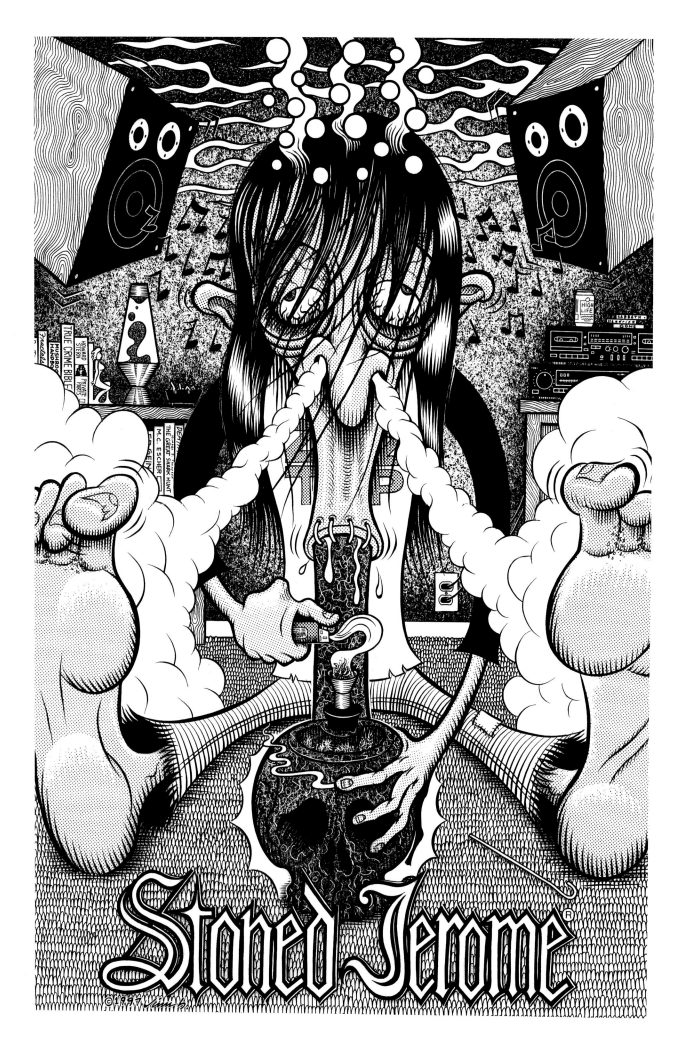

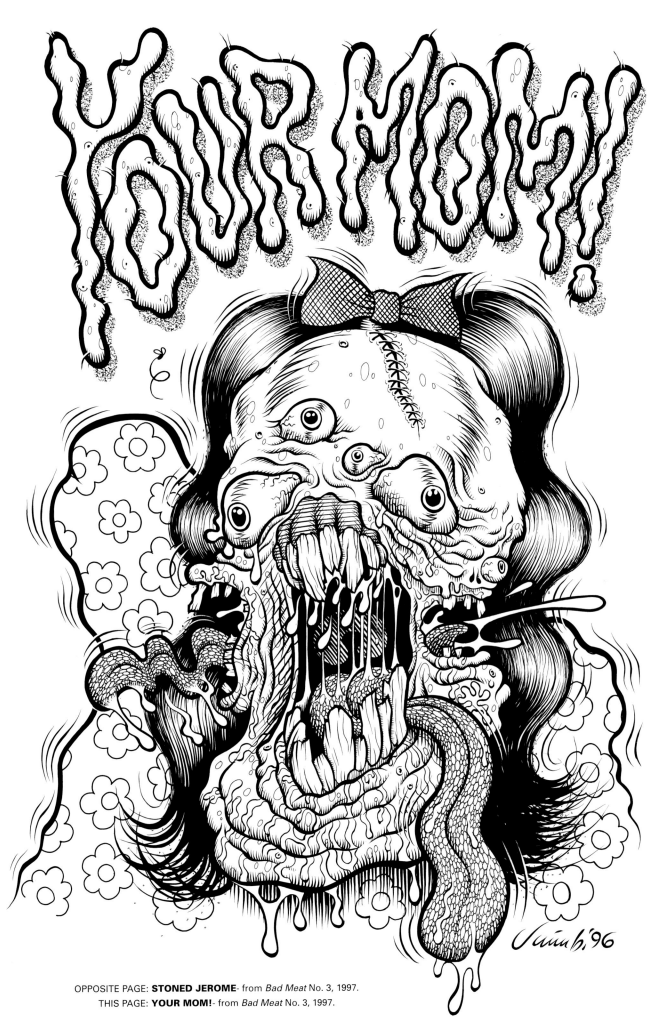

OPPOSITE PAGE: **STONED JEROME**- from *Bad Meat* No. 3, 1997.
THIS PAGE: **YOUR MOM!**- from *Bad Meat* No. 3, 1997.

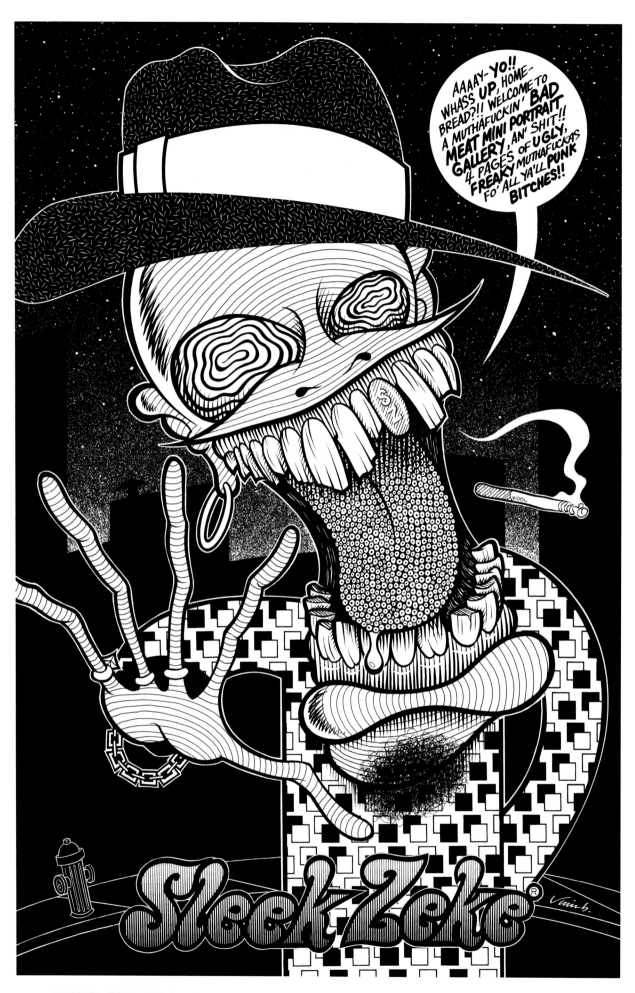

THIS PAGE: **SLEEK ZEKE**- from *Bad Meat* No. 3, 1997. OPPOSITE PAGE: **SLEEK ZEKE (STUDY)**- from school notebook, 1986.

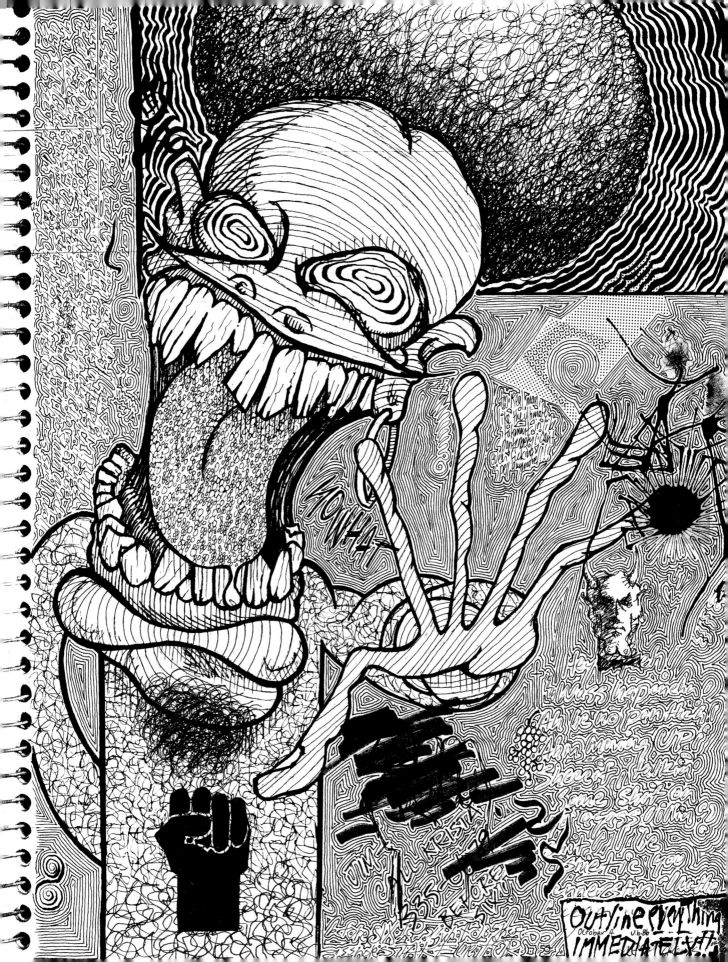

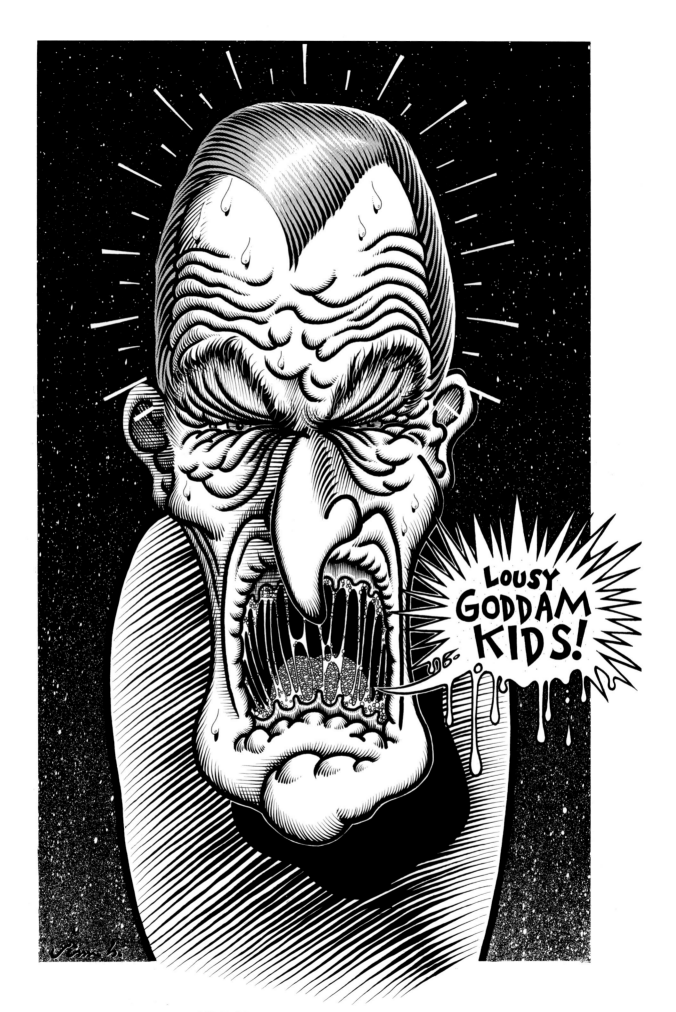

LOUSY GODDAM KIDS!- from *Retina Damage*, 1991.

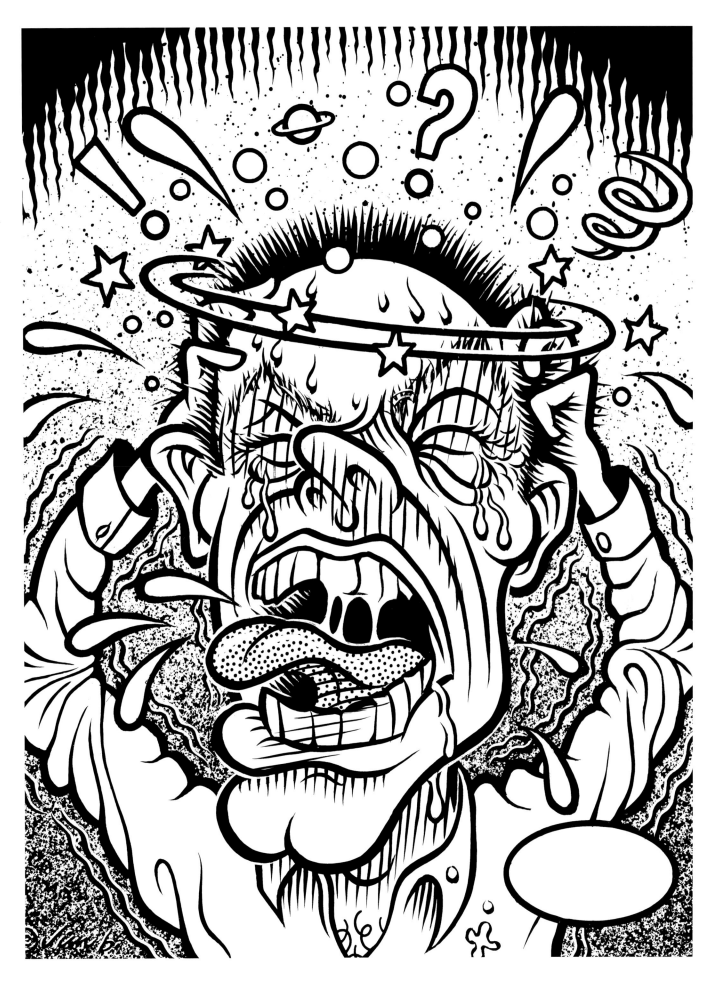

GASLIGHTING GUY- cover art for *Gaslighting* (Loompanics Books), 1994, also used for silkscreen rock poster, 1995.

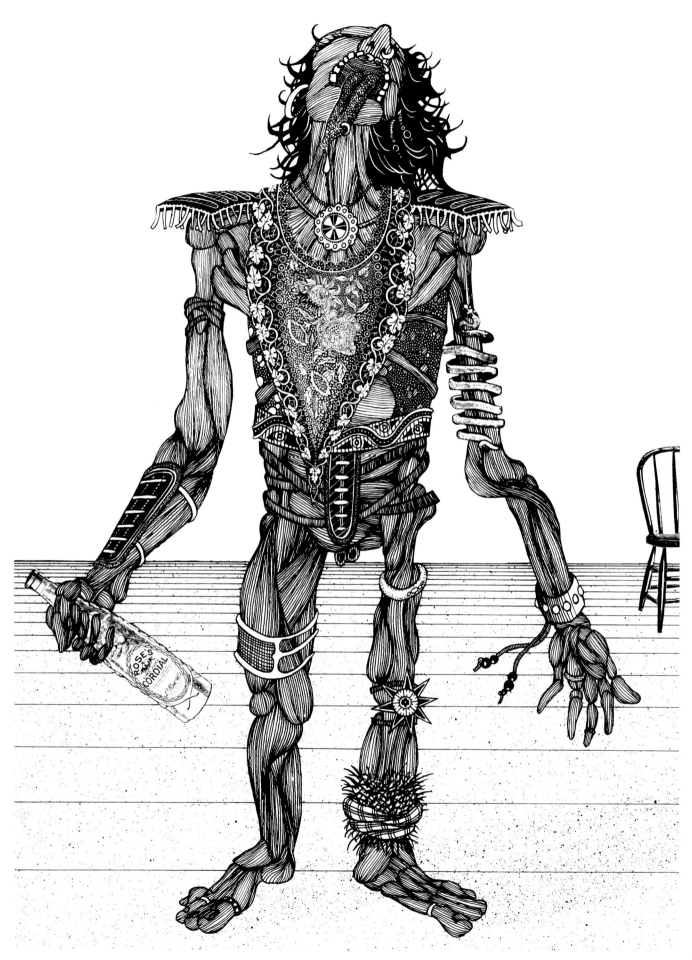

UNTITLED- unpublished, 1985.

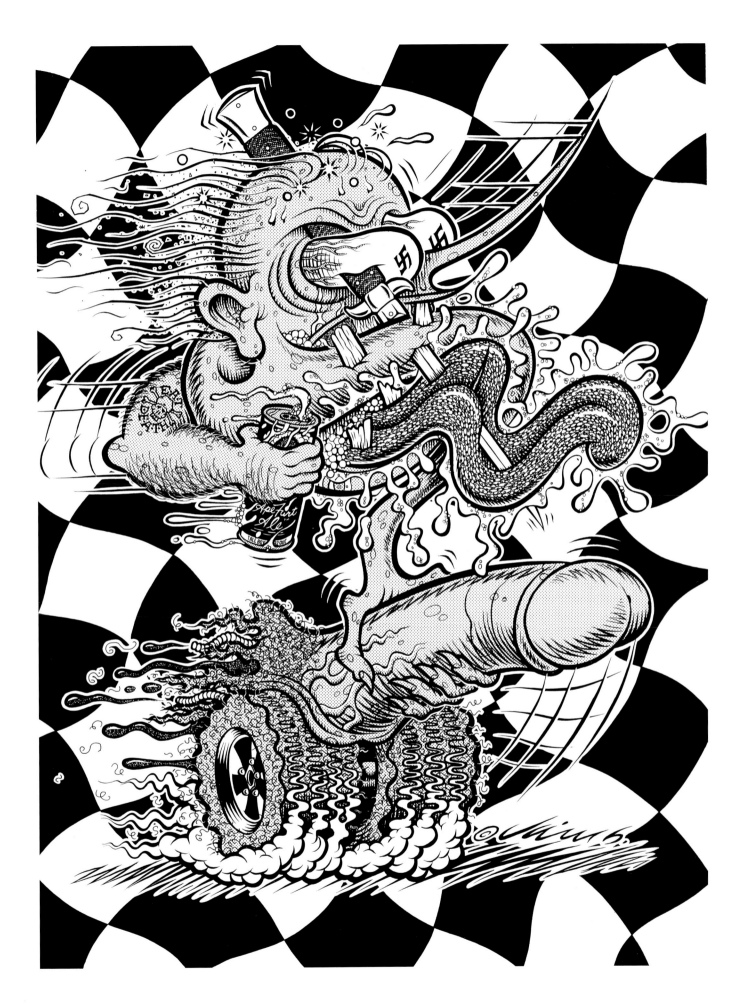

COCK FINK- from *Dirty Stories* #1 (Fantagraphics Books), 1997.

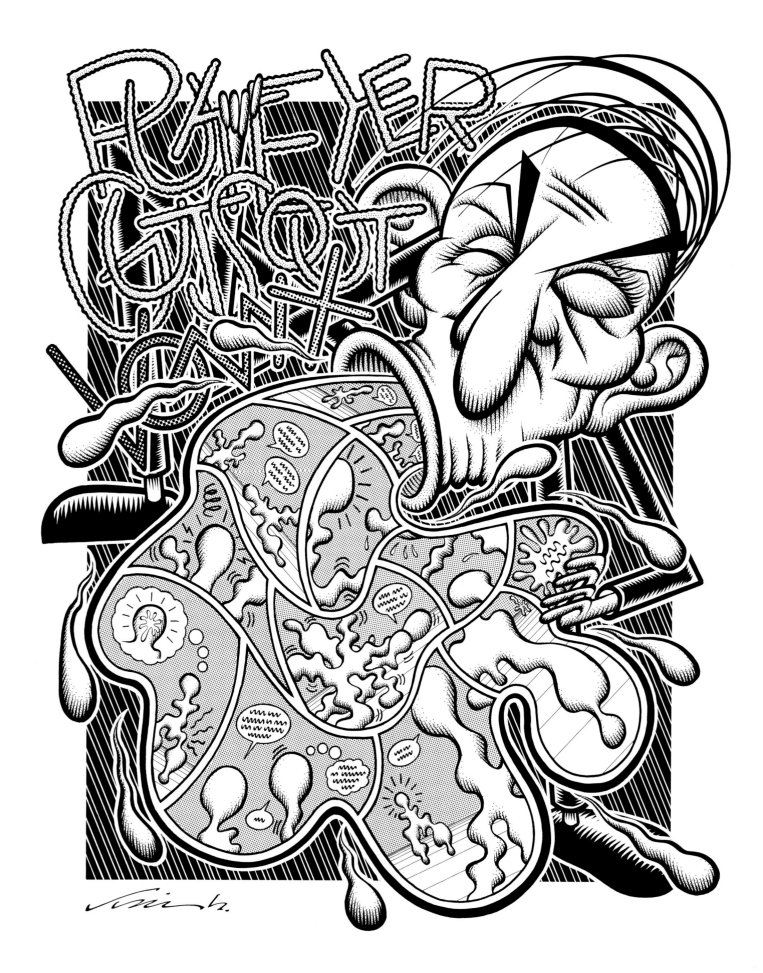

PUKE YER GUTS OUT VOMIX- from *Retina Damage*, 1991.

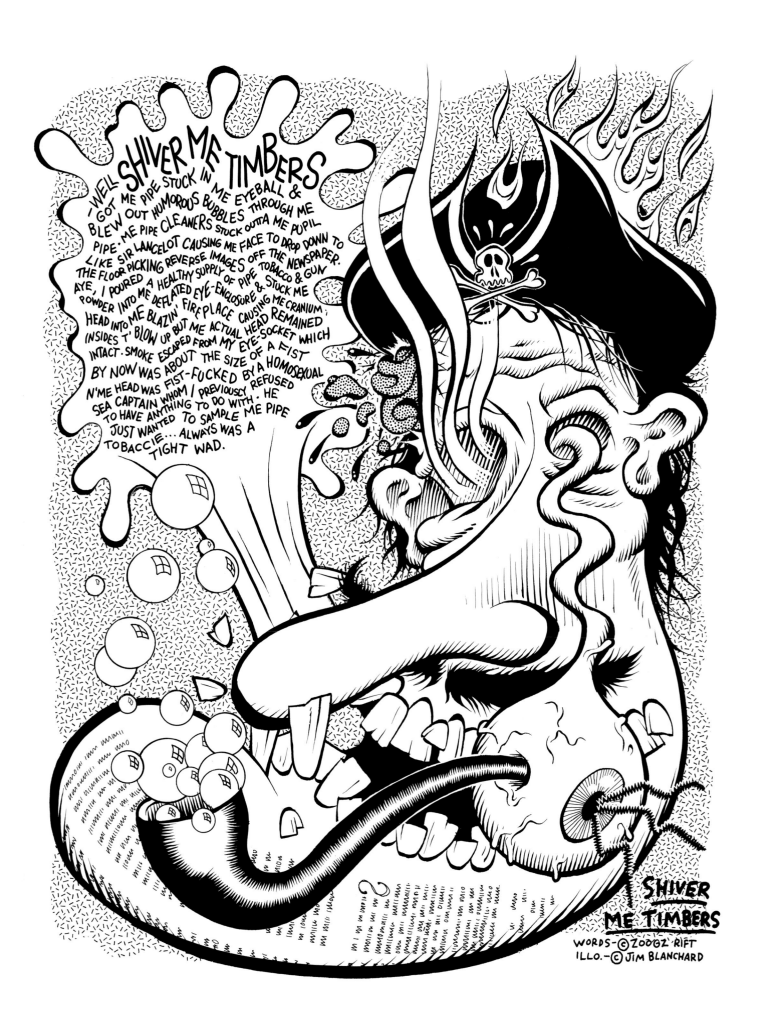

SHIVER ME TIMBERS- written by musician and wrestler Zoogz Rift. From *Cruel World* No. 1, 1993.

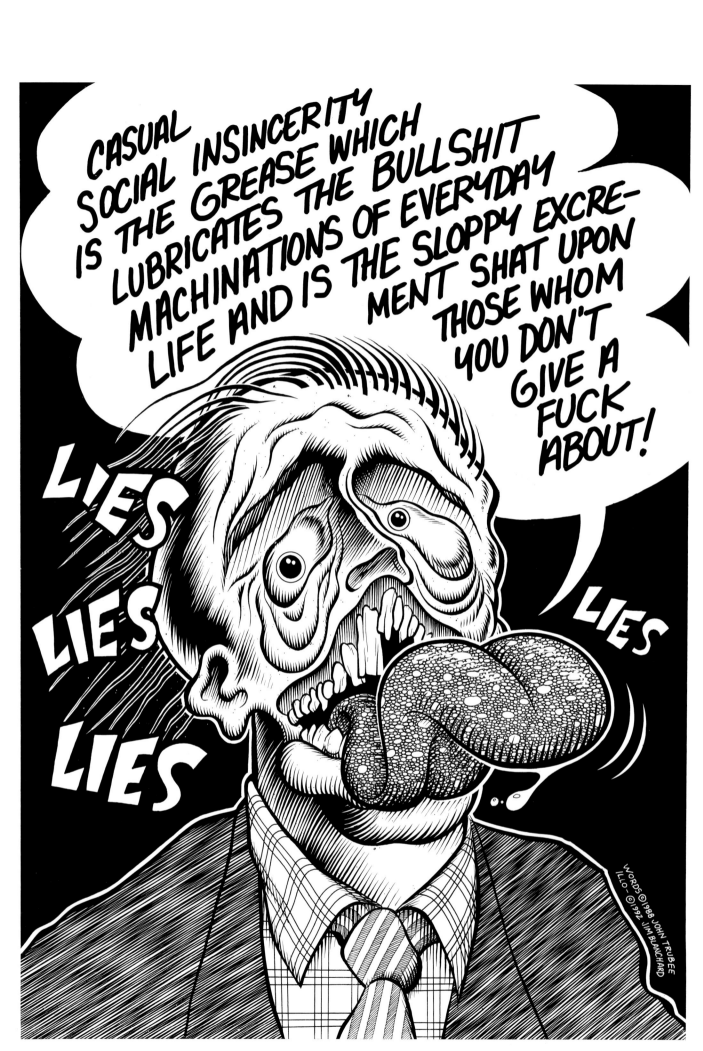

CASUAL SOCIAL INSINCERITY... - words by musician and prankster John Trubee. From *Cruel World* No. 1, 1993.

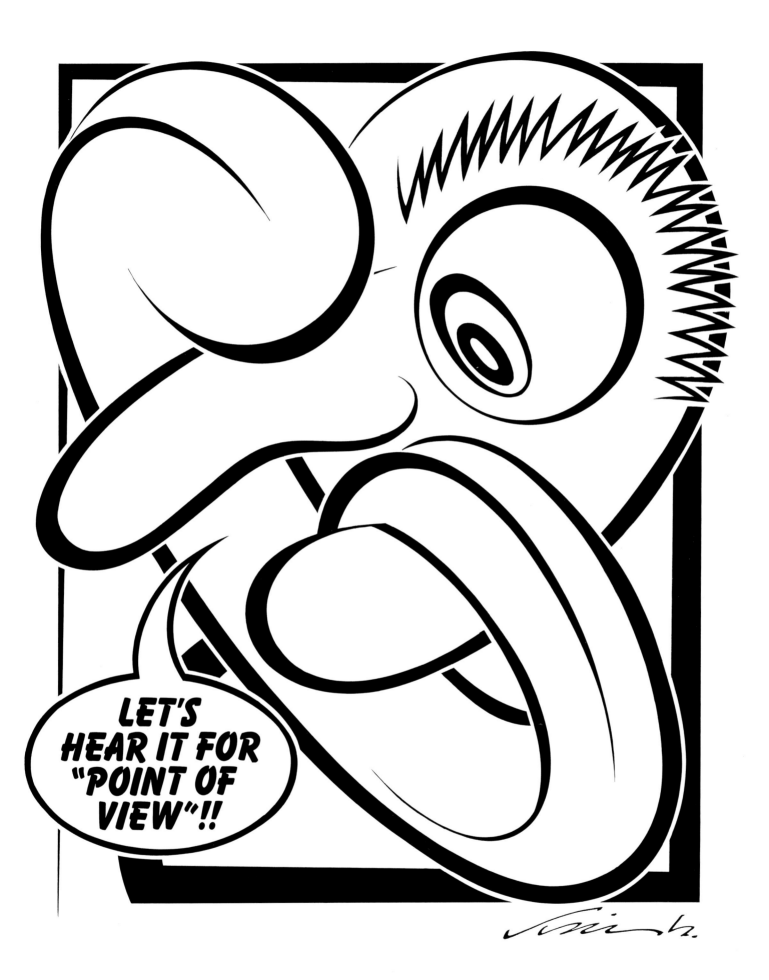

LET'S HEAR IT FOR "POINT OF VIEW"!!- from *Cruel World* No. 1, 1993.

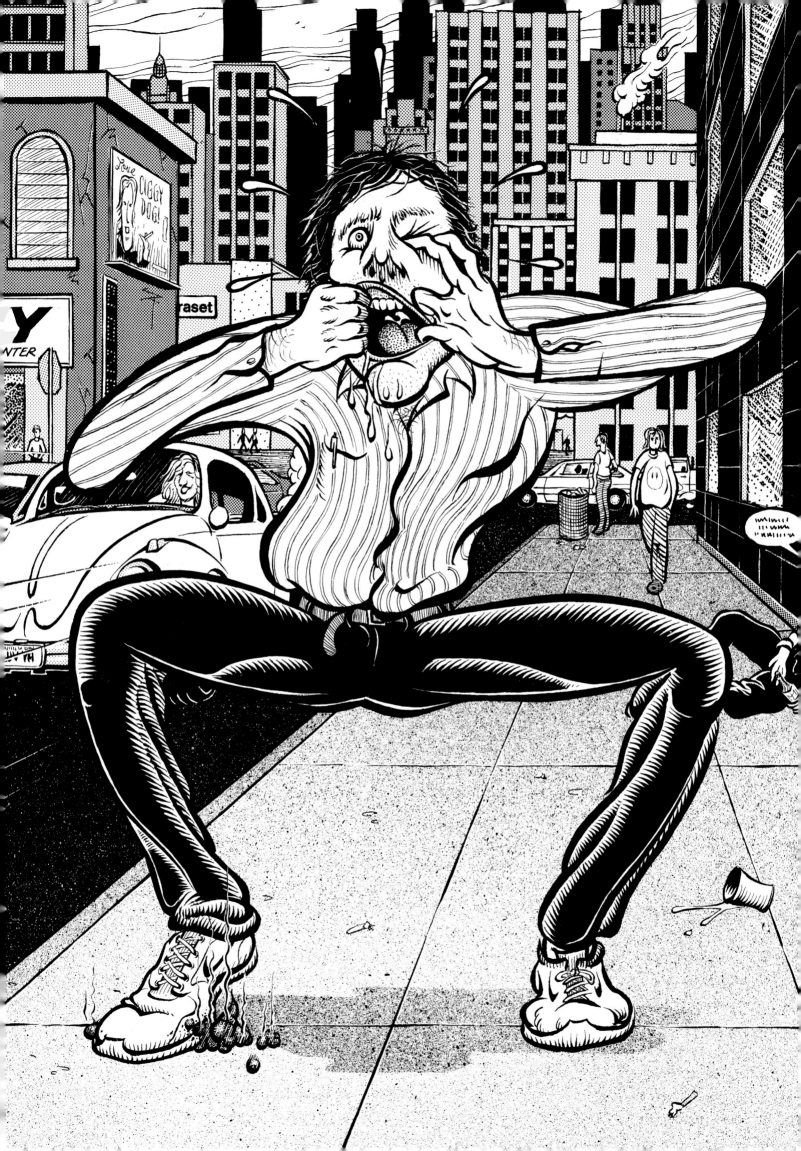

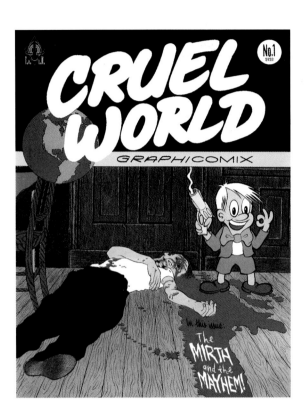

COMIX

Comics, be they from *Mad* magazine, Marvel & DC, or the Underground/Alternative sphere, shaped the look and attitude of my art in the '80s and '90s more than anything else, but I never felt entirely comfortable creating my own comics, or "sequential art". Making comics is tough work, and requires accurately drawing characters, backgrounds, word balloons, etc. over and over again. It favors artists with disciplined drawing skills, an economical technique and a gift for story-telling — all traits that I do not possess. There aren't many stories I feel compelled to tell, let alone spend the hours necessary to translate them to the comic format. In my view, most of the solo comics I did were experiments to test the graphic waters, rather than fully realized works.

I spent the later part of the 1970s obsessively collecting Marvel comics, and a smattering from DC. When I lived in Norway from 1970–1975, I didn't have access to new comics, other than a stray British comic like *Beano* or *Topper*. My Grandma Grace in Kansas would occasionally send a small batch via Air Mail, rolled up in brown kraft paper. When we returned to the States in 1975, I quickly bought as many comics as my allowance would permit, which was quite a few at 25¢ a pop. Fave Marvel titles included *Warlock, Captain Marvel, Captain America, Master of Kung Fu, The Incredible Hulk, Luke Cage: Hero for Hire, The Defenders, The Avengers, The X-Men, Tomb of Dracula, Conan, Marvel Team-Up*, and *The Amazing Spider-Man*. From DC, other than *Swamp Thing* and *Kamandi*, I favored their "horror" titles like *Tales of the Unexpected, House of Mystery, House of Secrets, Ghosts*, and *Weird War*. DC superheroes such as Superman, Batman, and Aquaman never appealed to me. Even as a kid, they seemed to be relics from a past era and lacked the modern *zing* that Marvel characters had.

I spent the early part of the 1980s obsessively collecting vintage "underground" comix from the late '60s and early '70s. I first encountered undergrounds like Gilbert Shelton's *Freak Brothers* and *Fat Freddy's Cat* in the late '70s. Soon, I developed a taste for them, and made it a mission to seek them out.

OPPOSITE PAGE: **FLAM NO. 1**- detail from cover art, 1989. THIS PAGE, ABOVE: **CRUEL WORLD NO. 1**- cover for self-published comics anthology, 1993.

Undergrounds could be difficult to find in the '80s. My main source was Starship head shop next door to Starship Records in Tulsa, Oklahoma, which had a great selection on two rotating racks. Other good sources were mail order catalogs from Krupp's, Last Gasp, and Don Donahue. Soon I had a sizable collection with titles like *Dope Comix*, *Insect Fear*, *Skull*, *Slow Death*, *Deviant Slice*, *Bizarre Sex*, and the ultimate underground comic, *Zap*.

Once *Zap Comix* artists Robert Crumb, S. Clay Wilson, Robert Williams, Rick Griffin, Spain Rodriguez, and Victor Moscoso got their hooks in me, there was no turning back. I was corrupted for life! The *Zap* artists, both collectively in *Zap Comix* and individually in their solo books, all had amazing, unique artistic chops, and established such a high threshold for no-holds-barred content that everything else paled in comparison. *Zap* blew my teenage mind the same way punk rock graphics did, eradicating limitations of what one could *get away with*.

When I arrived in Seattle from Oklahoma in the late '80s, I sent out change of address postcards, and the first person to contact me was cartoonist Peter Bagge, who visited my dirt cheap craphole Capital Hill apartment. My guess is that Peter wanted to put a face to the guy who published the oddball Okie punk/art zine *Blatch*, the final three issues of which he contributed artwork to. Pete invited me to watch a

Seattle Seahawks game at his house, and there I met his wife Joanne, cartoonists Mark Zingarelli and Michael Dougan, and writer Dennis Eichhorn.

Fantagraphics Books, who published Peter's *Neat Stuff* comic, moved their base of operations from Southern California to Seattle in 1989, and Pete introduced me to Gary Groth and Kim Thompson, the two co-owners. I was there when they first saw the house on Lake City Way NE where they have now been headquartered for almost thirty years. I got a job at the Fantagraphics warehouse, and worked with Michael Dowers, prolific small press publisher of Starhead Comix. At the "warehouse"—actually an old pet store and nothing like a real warehouse—there was enough down time to get acquainted with the impressive array of stuff Fantagraphics published: vintage comics by Windsor McCay, Hal Foster, and EC Segar, international titles by Jordi Bernet, F. Solano Lopez, and Muñoz & Sampayo, and their incredible roster of contemporary comics by Dan Clowes, Peter Bagge, Los Bros Hernandez, R. Crumb, Jim Woodring, Josh and Drew Friedman, Kaz, Joe Sacco, Bill Griffith, and Kim Deitch, among many others.

After a couple of years working in their mail order/shipping department, I was hired to work in the Fantagraphics production department, when art director Dale Yarger saw my design work on *Mondo Suburbia Trading Cards*, a satirical self-published

JIM BLANCHARD AT FANTAGRAPHICS PRODUCTION DEPARTMENT, SEATTLE, WA, 1995- photograph by Dale Yarger.

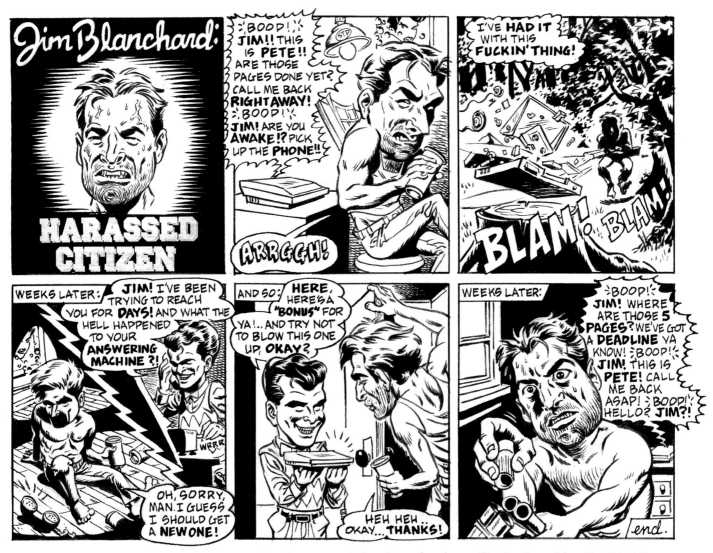

JIM BLANCHARD: HARASSED CITIZEN- art by Rick Altergott, story by Peter Bagge. One of several Blanchard "roasts" from *Hate* #30, 1998.

trading card set I did with Michael Dowers. Fantagraphics was having cash flow problems, and elected to start two new imprints: Monster Comics and Eros Comics. I handled much of the art direction and design work for the Monster and Eros lines. I cranked out logos and schlepped out type for Monster and Eros titles by the fistful. In total, there must have been thirty or more comics published a month. For a time, everything from Eros Comix sold well, so Groth and Thompson glutted the market, cashing in on the porno comix trend before it died off. I never worked more than thirty hours a week for Fantagraphics, so I was able to keep solo projects rolling at home. I continued to do freelance illustration work and produce my own comix.

I found a role in comics that fit me when I started inking other artist's pencilled art. I wasn't very good at drawing or writing comics, but I could sure as hell ink them. Some cartoonists excel at the plotting and pencilling part, but don't like the inking and "embellishing" part. One of my coworkers at the Fantagraphics production department was Pat Moriarity, who moved to Seattle a couple years after I did. Pat was a skilled layout artist who had a formal background in type design, unlike myself. Pat was

also a gifted and ambitious cartoonist. I started inking Pat's work in his *Big Mouth* comic in 1992. I knew what he was after and my inking complimented Pat's goofy, unhinged cartoons. Pat was a competent inker in his own right, but my inking gave his cartoons an added slickness.

Peter Bagge took notice of the stuff I was doing with Pat, and asked me to ink a crazy story he had drawn for the final issue of Denny Eichhorn's *Real Stuff* comic. The story was called "Fecal Feast" and

JIM AS ONE OF THE "FANTAGRAPHICS KIDZ"- art by Peter Bagge from *Hate* #29, 1997.

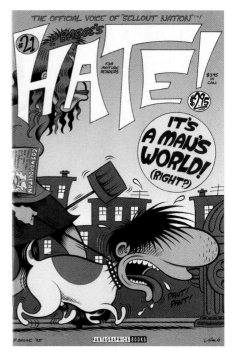
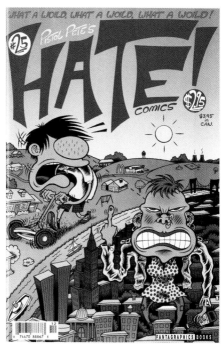
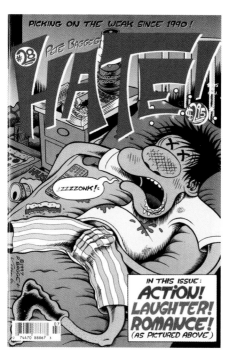

HATE #21, #25, #28- cover art by Peter Bagge, inked by Jim Blanchard, 1995-1997.

involved Denny accidentally showing his blind date a video tape that contained an disgusting act of *coprophagia*. It's a very funny story and there was good chemistry between myself and Peter.

In 1994, Bagge wanted to increase the frequency that his hit alternative comic *Hate* came out, as well as add color to the art and print it on nice white paper, rather than newsprint. He asked me to take over the task of inking *Hate*, a duty he had never enjoyed. Jim Woodring's wife Mary would handle the color. It took two or three issues to get used to Bagge's peculiar rubbery cartooning style, but eventually I got a handle on the best way to ink it, and everything gelled. Inking *Hate* was a very demanding job. I was used to working on shorter comic stories, usually no longer than six pages. *Hate* stories sometimes reached twenty-five pages. In 1996, the steady income I was making from inking *Hate* and doing freelance work allowed me to quit my part time job at the Fantgraphics production department, and I haven't had a "day job" since. For several years, *Hate* was one of the most popular alternative comics in the world, and I would end up inking three hundred and forty three pages over fifteen issues between 1994 and 1998. Peter decided to discontinue *Hate* after issue 30, because he didn't want to be forever tied to only one character, in this case *Hate* protag Buddy Bradley. It was a good run, but I was ready to move on, too.

I learned a tremendous amount about what it took to create high quality "sequential art" from my years working on *Hate*. In 2001 writer Jim Goad asked me if I was up for illustrating a comic story he had been envisioning about two obese, closeted gay truck drivers. I said yes, and *Trucker Fags In Denial* was born. Over the next two and a half years, Jim and

I would produce a page of *Trucker Fags* every month for *Exotic* magazine, a Portland, Oregon strip club ad rag. Fantagraphics published the twenty-eight page collected *Trucker Fags In Denial* comic in 2004, and it would be the last time I ever worked in the comic medium. I was extremely happy with how *Trucker Fags* came out, and thought it would make for my perfect comic book *swan song*.

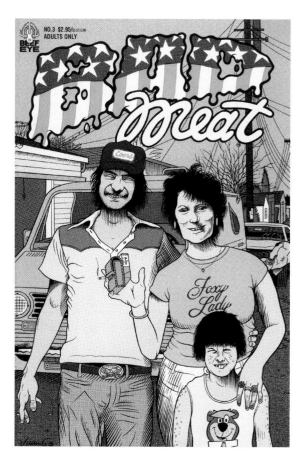

BAD MEAT NO. 3- cover art for self-published comics anthology, 1997.

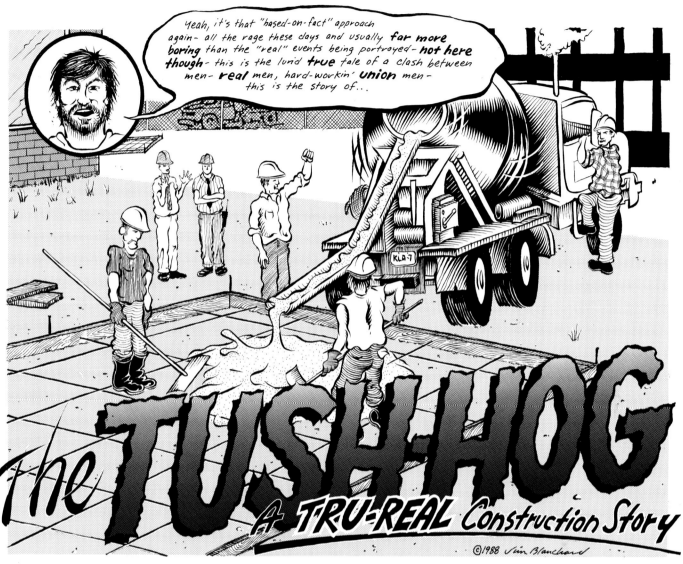

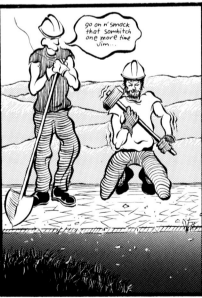

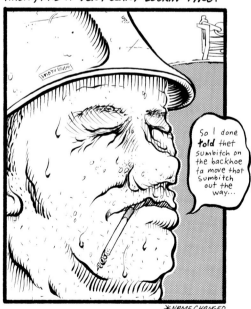

THE TUSH-HOG- first appeared in *Flam* #1, in 1989, later re-lettered for *Cruel World* No. 1 in 1993.

UNDERNEATH ALL THE UGLINESS WAS A TRULY KIND SPIRIT, THOUGH. LLOYD WAS A LEVEL-HEADED DUDE WHO HELD HIS TEMPER WELL.

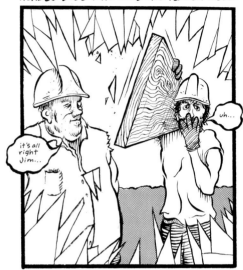

it's all right Jim...

uh...

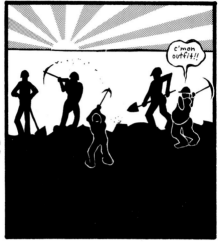

c'mon outfit!!

AND HE WAS ALWAYS WILLING TO GRAB A SHOVEL, JACKHAMMER, OR CUTTING TORCH AND JOIN IN WITH HIS BOYS RATHER THAN STAND AROUND AND "SUPERVISE" LIKE THE REST OF THE FOREMAN.

ONCE HE BROUGHT IN 2 BAGS OF **OKRA** HE'D HARVESTED, TO DISTRIBUTE AMONG FRIENDS AROUND THE JOB SITE.

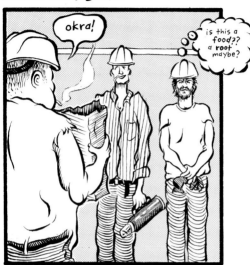

okra!

is this a food?? a root maybe?

BUT **HOLD IT!** THIS IS WHERE THE STORY TAKES A NASTY TURN. LABORERS ARE DEFINITELY THE **LOW MAN** ON THE CONSTRUCTION PYRAMID, AND INEVITABLY GET THE MOST **SHIT** FROM FELLOW WORKERS ON THE SITE. SINCE ONE OF OUR PURPOSES THERE WAS **DE**STRUCTION, NOT **CON**STRUCTION, WE **REALLY** ENDED UP ON THE RECEIVING END. WE WERE LOOKED UPON AS UNSKILLED SCUM, INCAPABLE OF PERFORMING ANY TASK OTHER THAN BRAINLESS "MUSCLEWORK" NOBODY ELSE WANTED TO DEAL WITH. (WHICH USUALLY LED TO ACUTE ARTHRITIS AND BACK PROBLEMS.)

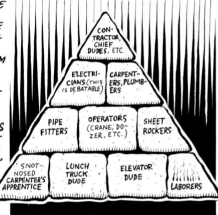

CONTRACTOR, CHIEF DUDES, ETC.

ELECTRICIANS (THIS IS DEBATABLE)

CARPENTERS, PLUMBERS

PIPE FITTERS

OPERATORS (CRANE, DOZER, ETC.)

SHEET ROCKERS

SNOT-NOSED CARPENTER'S APPRENTICE

LUNCH TRUCK DUDE

ELEVATOR DUDE

LABORERS

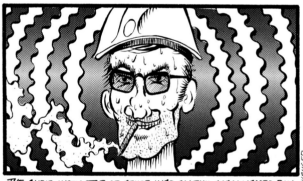

THE CHIEF INSTIGATOR OF ABUSE WAS AN EVIL MAN NAMED BILL COLE, * ONE OF THE CARPENTER'S FOREMAN. PEOPLE TEND TO KID AROUND ALOT IN CONSTRUCTION WORK — TEASING, RIBBING, DIRTY JOKES, ETC. — BILL WAS DOWNRIGHT **CRUEL**, THOUGH.

* NAME CHANGED

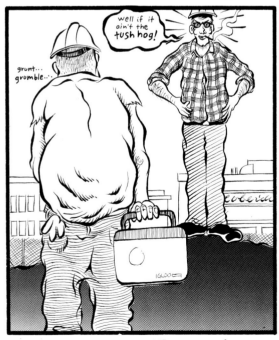

grunt... grumble...

well if it ain't the tush hog!

BILL HAD NICKNAMED LLOYD "**TUSH HOG**" (OR JUST "**TUSH**", AND SOMETIMES "**THE TUSH BOAR**") BECAUSE OF HIS PORCINE FEATURES AND THE WAY THE SEAT OF PANTS WAS ALWAYS DROOPING AND MISSHAPEN.

HE WOULD DRAW CARTOON FACES OF LLOYD WITH HIS MAGIC MARKER AND WRITE THE WORD "TUSH" PRACTICALLY EVERYWHERE HE STOPPED TO DO SOMETHING OR TALK WITH SOMEONE.

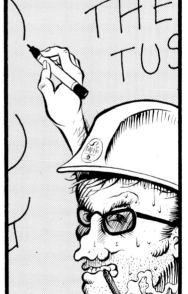

THE TUS

IN A FEW MONTHS THERE WASN'T ONE WHEELBARROW, TEMPORARY FENCE, DOOR, OR UNPAINTED WALL THAT DIDN'T BEAR THE EMBARASSING MONIKER. IT GOT REALLY BAD AND LLOYD COMPLAINED TO THE HIGHER-UPS, BUT I DON'T THINK IT DID HIM MUCH GOOD.

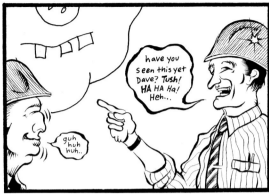

have you seen this yet Dave? Tush! HA HA Ha! Heh...

guh huh huh..

THE CARPENTER'S EVEN WENT AS FAR AS TO BUY A WHITE PORCELIN PIG'S HEAD AND MOUNT IT ON THEIR SHACK. SOON ALL OF LLOYD'S CREW, MYSELF INCLUDED, WERE REFERED TO AS "PIGLETS".

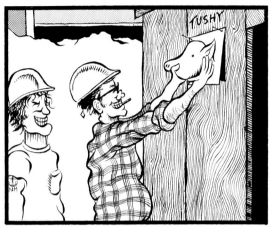

TUSHY

HAHAHA

THEIR LITTLE JOKE SEEMED TO GET *FUNNIER* TO THEM AS TIME PASSED RATHER THAN WEAR OFF.

I HAVE A FEELING ALL THE BOSSMEN THOUGHT "THE TUSH THING" WAS FUNNY TOO, GOOD FOR BUSINESS ANYWAY. LLOYD FUNCTIONED AS A PERFECT SCAPE-GOAT TO VENT HATRED AND HEAT PRESSURE ON, SO WHY NOT LEAVE WELL ENOUGH ALONE? THE SITUATION REMINDED ME OF THE FAT KID IN *FULL METAL JACKET* WHO WAS DERIDED TO MAINTAIN GROUP CAMARADERIE.

ONE DAY WE WERE JUST GETTING DONE LAYING DOWN SOME "RE-BAR" (REINFORCEMENT BAR) AND TIE-WIRE FOR A STRETCH OF SIDEWALK TO BE POURED AS SOON AS THE CONCRETE ARRIVED.

SOMEHOW LLOYD MANAGED TO RISE ABOVE ALL THE HARASSMENT AND KEEP HIS COOL. MAYBE HE REALLY NEEDED THE MONEY. I KNOW *I* WOULDN'T LAST LONG AT A JOB WHERE SO MUCH RIDICULE WAS HEAPED ON *ME*.

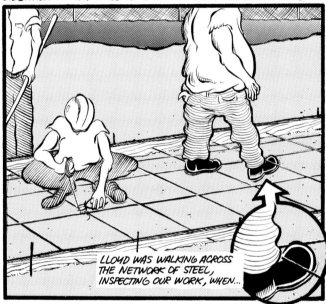

LLOYD WAS WALKING ACROSS THE NETWORK OF STEEL, INSPECTING OUR WORK, WHEN...

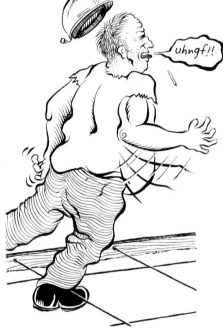

uhngf!!

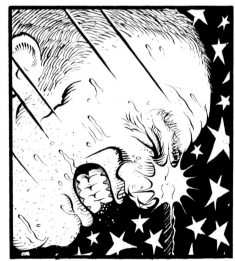

HE LANDED ON HIS HANDS, HARD, AND HIS HEAD SWUNG FORWARD ONTO A PIECE OF RE-BAR THAT JUTTED FROM ONE CORNER.

SO YARDS AWAY, THE CARPENTERS WERE PREPARING A WOODEN "FORM" FOR A GAZEBO THAT WAS TO BE POURED THE WEEK FOLLOWING. THEY IMMEDIATELY STOPPED WORKING TO TAKE NOTICE OF LLOYD'S FALL.

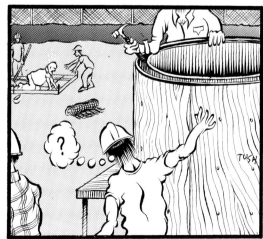

TUSH

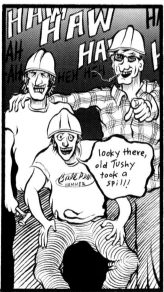

HA HAW HA HA HEH HEH

looky there, old Tushy took a spill!

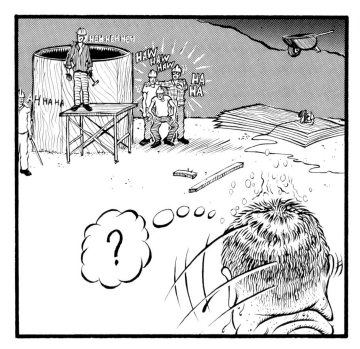

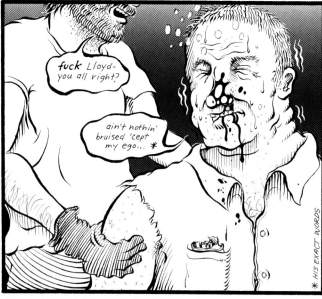

LLOYD WASN'T HURT BAD, BUT HE WAS OBVIOUSLY IN PAIN, AND BLOOD STREAMED DOWN HIS FACE FROM THE BRIDGE OF HIS NOSE.

SINCE THE MIXER WAS PULLING UP JUST AS ALL THIS WAS HAPPENING, LLOYD WIPED THE BLOOD FROM HIS FACE AND STUCK AROUND TO SUPERVISE THE POUR, RATHER THAN SEEKING IMMEDIATE MEDICAL ATTENTION LIKE HE PROBABLY SHOULD HAVE.

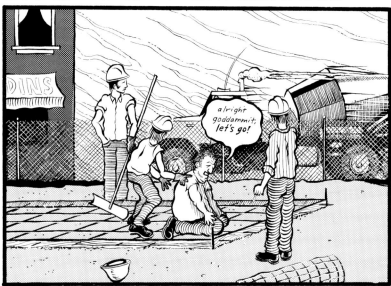

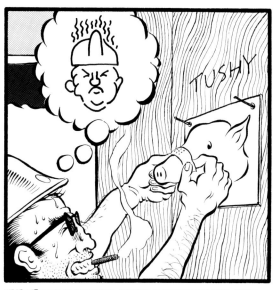

THE NEXT DAY THE EVIL CARPENTER'S FOREMAN, EVER THE OPPORTUNIST, PUT A BAND-AID ON THE SNOUT OF THE PIG, ADDING FURTHER INSULT TO LLOYD'S INJURY.

AFTER A FEW MONTHS OF THE EXTREME HEAT AND BACK-BREAKING WORK, I'D SAVED A GOOD THREE GRAND, WHICH I CONSIDERED SUFFICIENT TO GET STARTED ELSEWHERE.

I DON'T KNOW WHATEVER HAPPENED BETWEEN BILL AND LLOYD, BUT I'D GUESS THEY KEPT AT EACH OTHER UNTIL THE NEW BUILDING WAS FINISHED.

For over a year I've been meaning to get staples for my Swingline staple-gun. There's an edge of this oriental rug in my bedroom that curls upward hideously from where it gets kicked when walked across, and it bugs the hell out of me. I always trip on it when the lights are out. All it would take to smooth it out would be six well-placed heavy duty staples. So, while out running errands one day, I decided to make

a trip to the hardware store

after grocery shopping...

A TRIP TO THE HARDWARE STORE- from *Cruel World* No. 1, 1993.

SHOULD BE ON THIS ONE...

NUTS
BOLTS
WASHERS
FASTENERS

11

WIRE
PROD

NUTS
BOLTS
WASHERS
FASTENERS

11

WIRE
PRODUCTS

NUTS &
WASHERS

BOLTS

VSI
FASTENERS
INC.

? WIRE PRODUCTS

9627

MACHINE SCREWS

MACHINE SCREWS

MACHINE SCREWS

MACHINE SCREWS

MACHINE SCREWS

MACHINE SCREWS

MACHINE SCREWS

MACHINE SCRW

MACHINE SCREWS

1X10 METALIC 50PC.
SELF-DRILLING
SCREWS

CABINET
SCREWS

1½ X 5 50PC
WOOD TRIM
SCREWS

POWER DRIVE

ABINET
REWS

SELF-DRILLING
SCREWS

CABINET
SCREWS

ABINET
CREWS

POWER DRIVE

HMMMM. MAYBE AT THE OTHER
END, WITH NAILS...

1¼ X 1 1 X 2½ 10 X 1 1 X 1¼
VSI FASTENERS INC. VSI FASTENERS, INC.

HOUSE
WARES 4

3

2

HOODS
WATER
HEATERS
LAWN

3

GARDEN
AUTO

TAPE
LIGHTING
PAINT
CEMENT

2

NAILS

SHIT........

NUTS & WASHERS
NUTS BOLTS WASHERS FASTENERS
11
WIRE PRODUCTS
BOLTS

HOW ABOUT THIS ONE...

METAL DRAIN
CARDED PLUMBING
PVC DRAIN
SINK REPAIR
12
SHOWER HEADS
BATH F
TOILET
Oxford
Oxford
Oxford
Oxford

1¼ in
"9" TRAP
Drain Trap
1¼"
"9" Trap

BEHOLD! RIGHT NEXT TO SHOWER CURTAINS! OF COURSE!

Staples
3.39
5x1
Heavy-Duty Staples
○ BLACK & DECKER
Fits SEARS 9476872, 9476873, DUOFAST, COBRA 9717, 9718 Staplers
5/8

BLACK & DECKER? HMMMMMM. I NEED SWINGLINE. THE HELL WITH IT, THEY'RE THE SAME SIZE.

Heavy-Duty S
◆ BLACK
Fits SEARS

WRENCH COOKING
YOUTH OF TODA

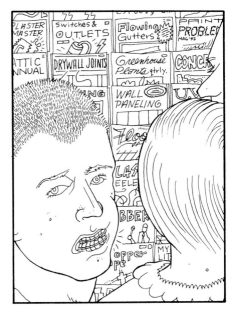

PLASTER MASTER
Switches & OUTLETS
Flowing Gutters
PAINT PROBLE
ATTIC NUAL
DRYWALL JOINTS
Greenhouse Plants qtrly.
CONC
UX
WALL PANELING

Switches & OUTLETS
Flowing Gutters
PAINT PROBLEMS MAG '92
DRYWALL JOINTS
Greenhouse Plants qtrly.
CONCRETE
CEILI Fan
OIL TANK
J.W.Y stems
LDING MAGIC
CERAMICS AMERICA
Amazing SHINGLES
FERNS

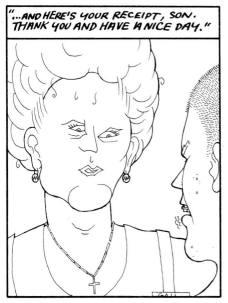

"...AND HERE'S YOUR RECEIPT, SON. THANK YOU AND HAVE A NICE DAY."

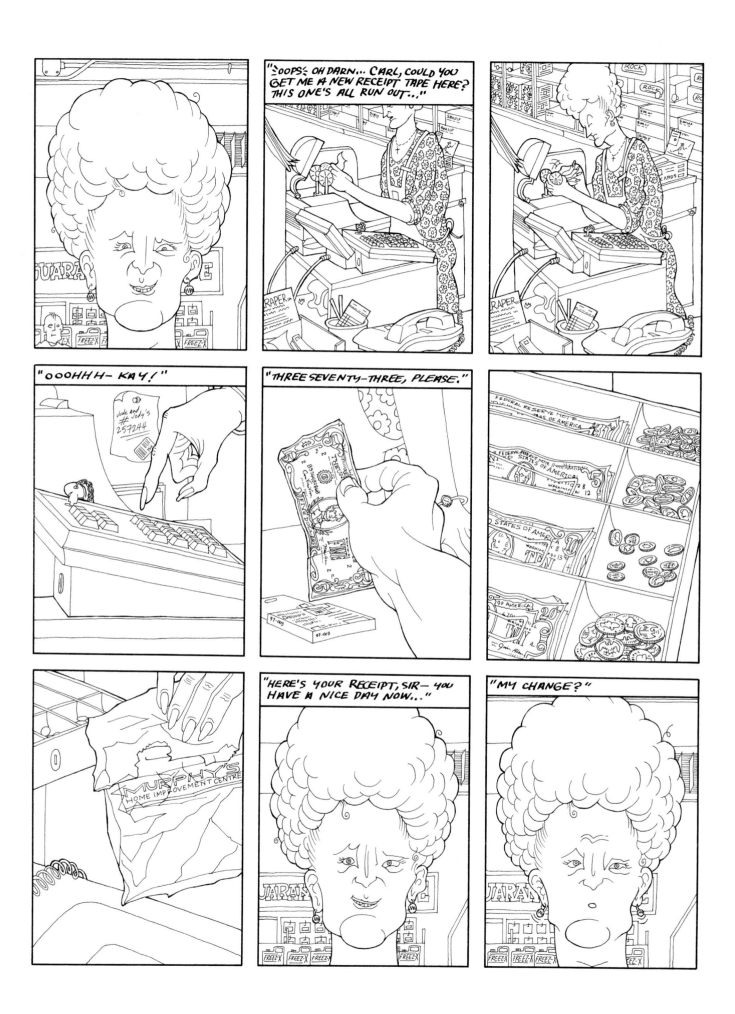

"OOPS! PFFFT! I'M SORRY!"

IN RUSSIA, I HEAR THE LINES ARE STILL ONLY 30 MINUTES LONG.

needless to say,

although the staples fit my staple gun, they wouldn't come out no matter what I tried, and all my hassles and horrors at The Hardware Store were for naught. I resolved never to set foot in the store again, even though I _could_ have returned the staples and got my money back.

©1992 Tim S.

Postscript: The next morning, a Monday, I overslept and didn't have time for My Morning Coffee. I left home five minutes after waking up, feeling like hell, and was halfway to work before I realized there was something wrong with my car. I pulled over and found a huge galvanized _nail_ in my left rear tire, obviously somehow picked up from The Hardware Store. I had to change the thing in traffic, in the hot sun, with a splitting headache and inferior equipment which I'd never used before. I arrived at work late, pissed, bleeding, greasy, and sweating.

Post-Postscript: Eventually I did find _Swingline_ brand staples at, of all places, an Art Supply Store. I should have known better. They worked perfectly and my carpet now lies flat like _Kansas_.

BATTLING PROTOPLASM- from *Cruel World* No. 1, 1993.

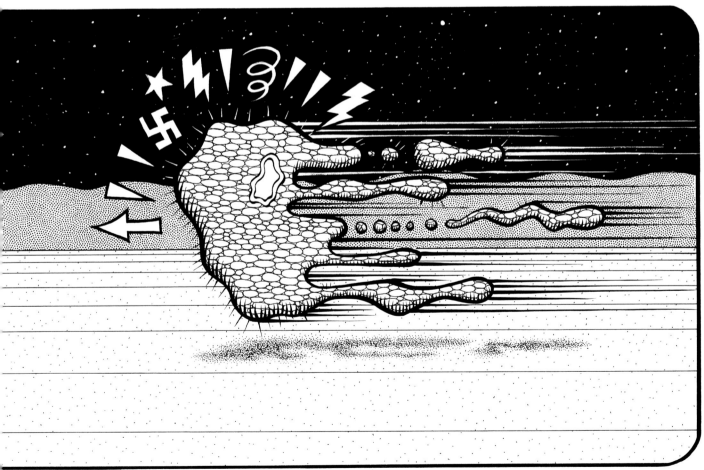

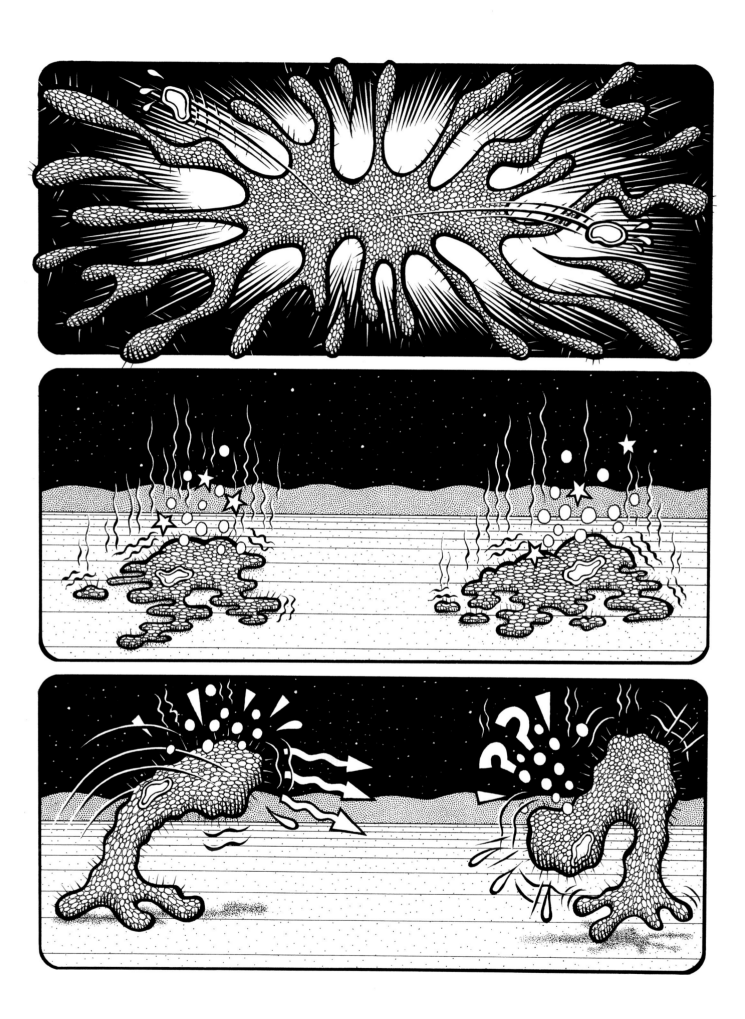

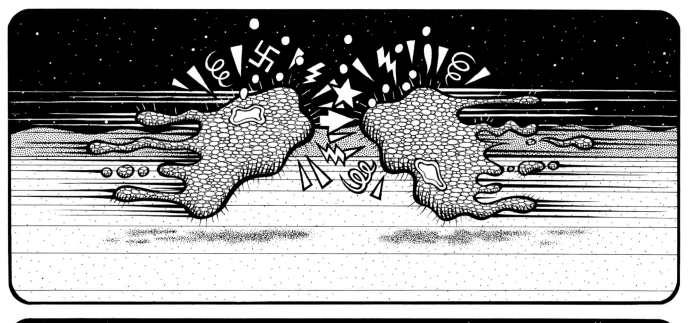

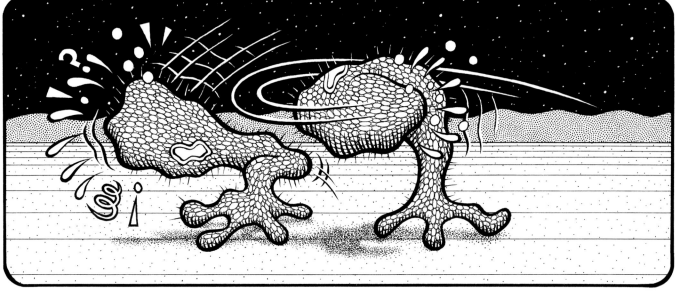

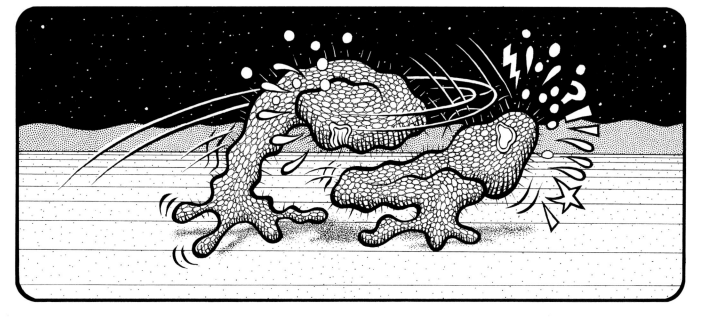

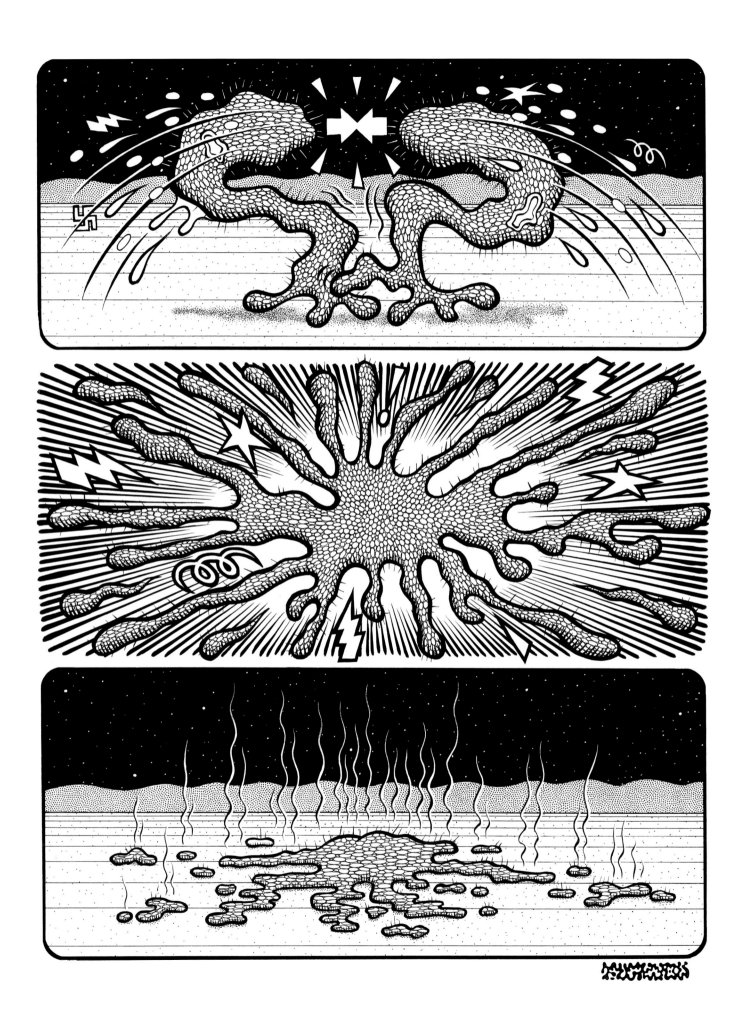

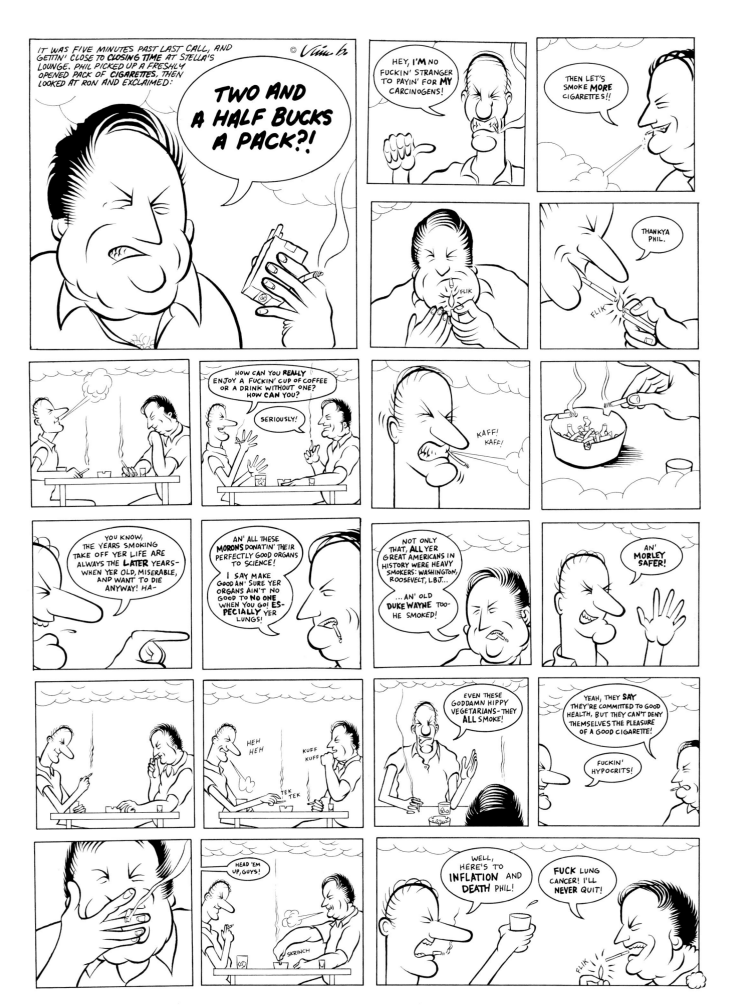

TWO AND A HALF BUCKS A PACK?!- from *Cruel World* No. 1, 1993.

¡ME OLVIDÉ QUE EL AMOR ECESTIA!- from *Bad Meat* No.2, 1992.

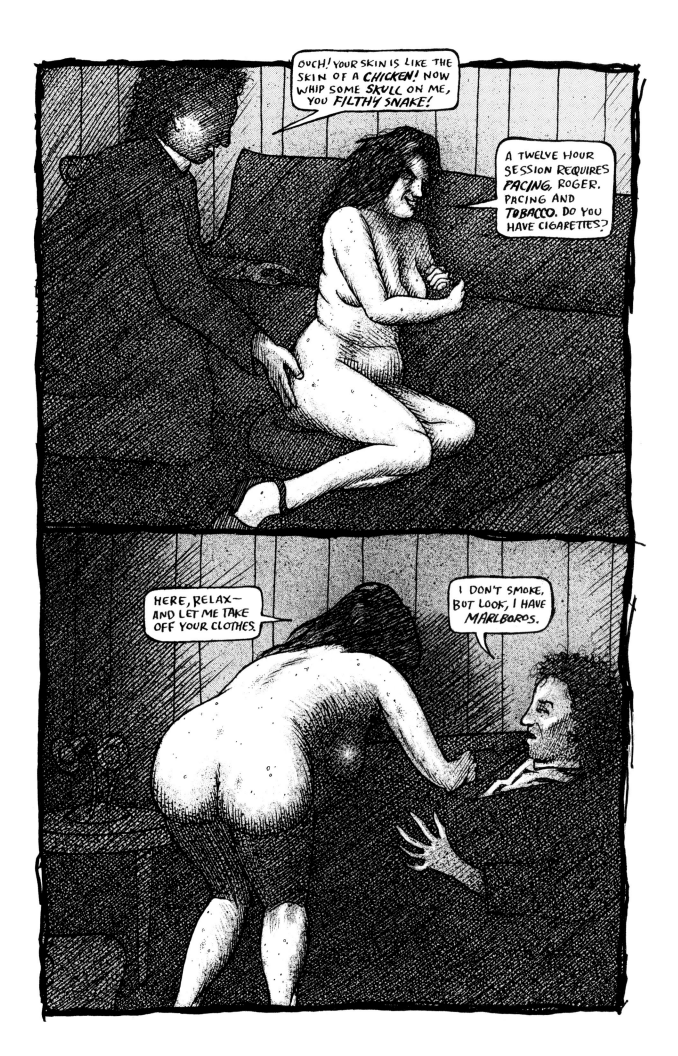

Eight hours later...

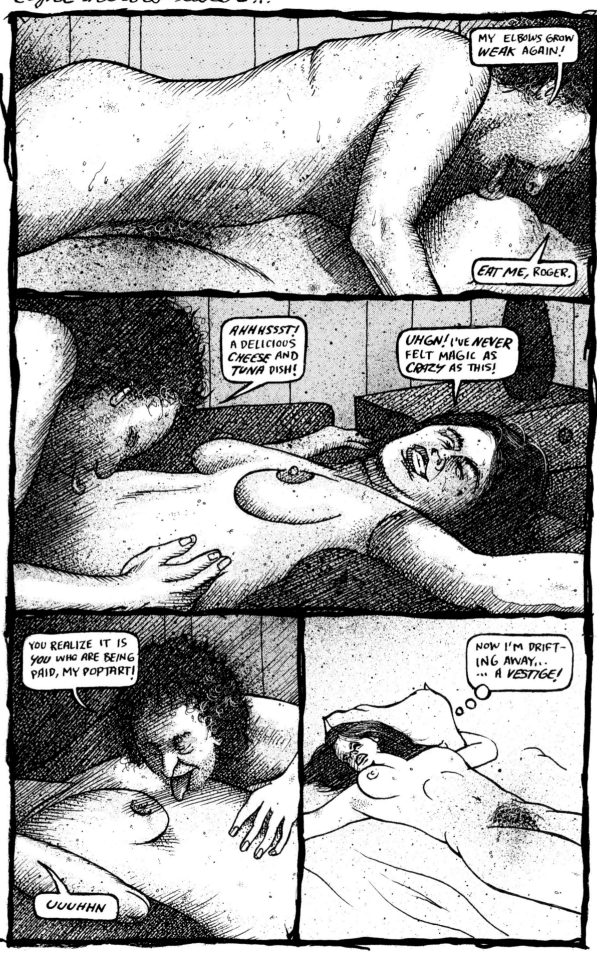

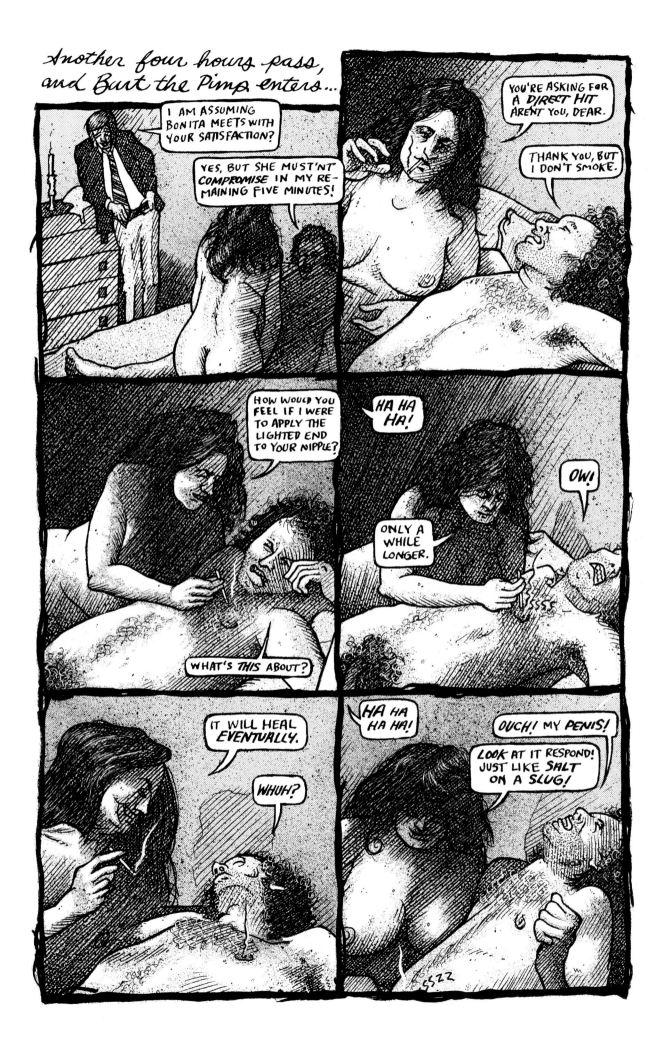

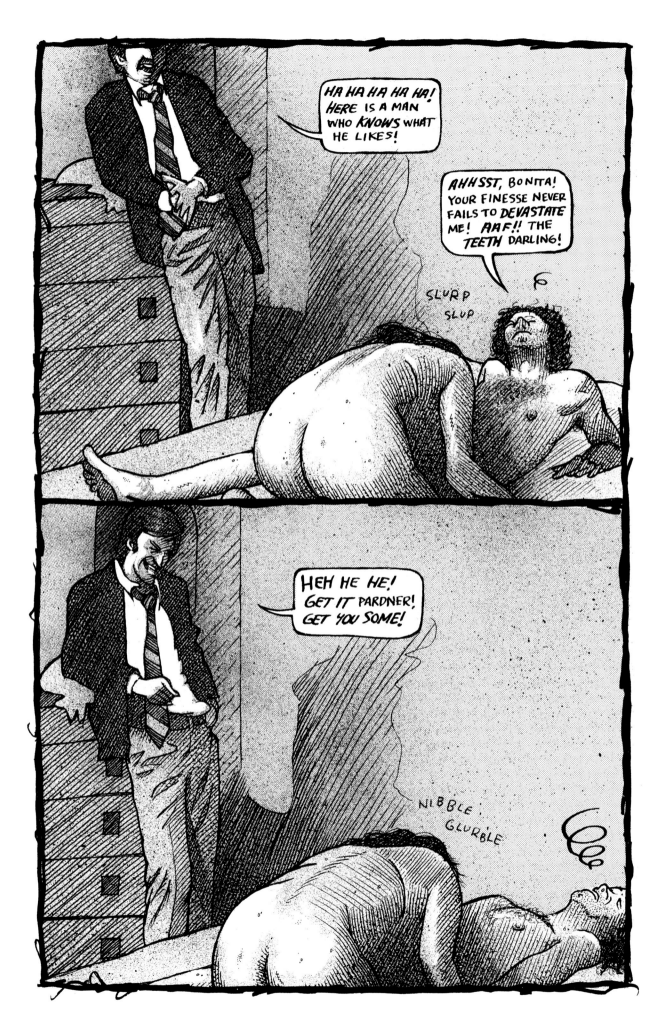

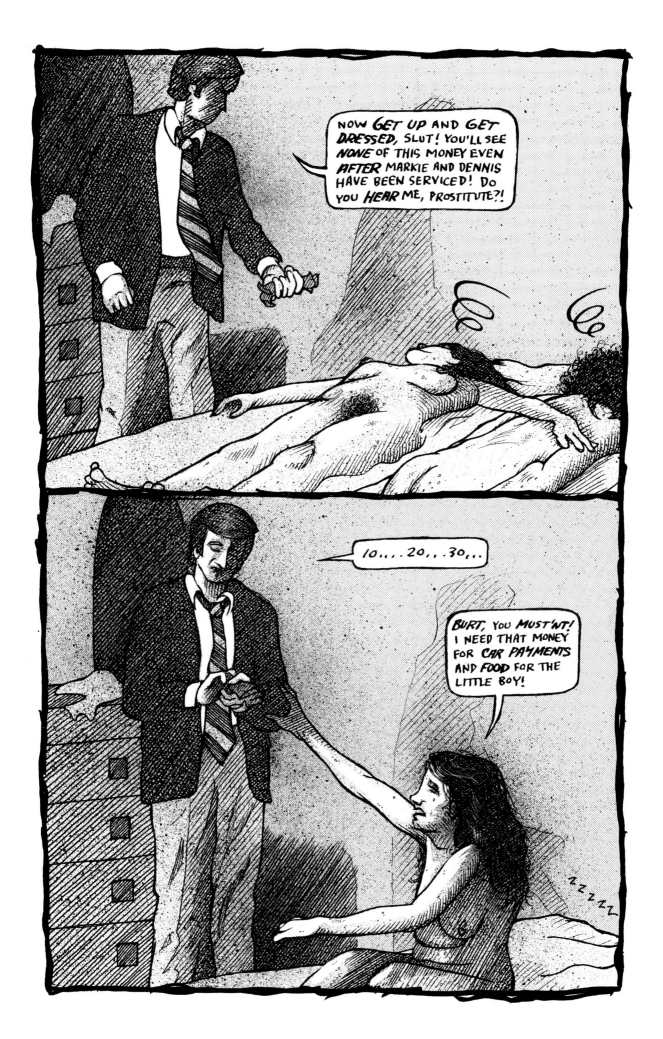

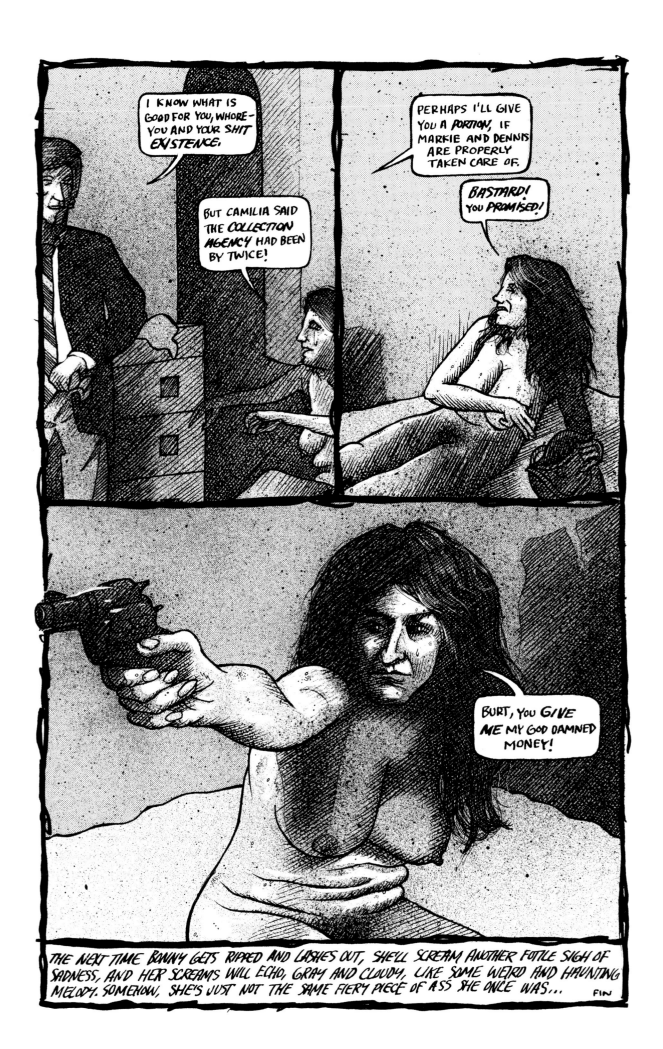

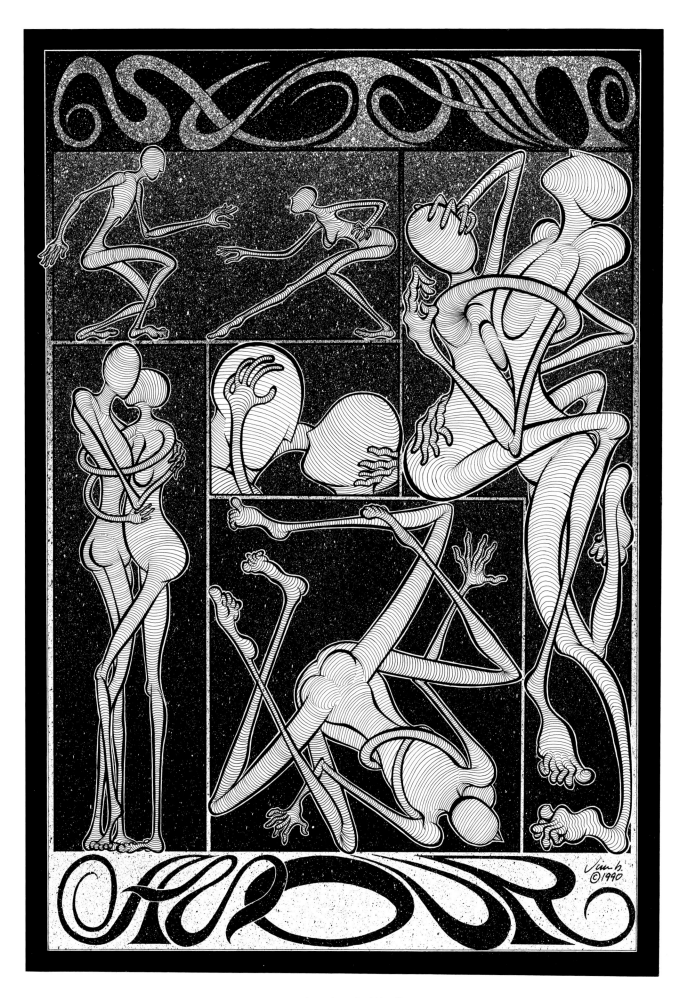

MUTANT AMOUR- from *Bad Meat* No. 2, 1992.

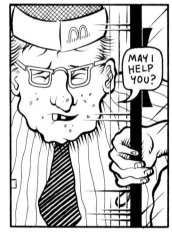

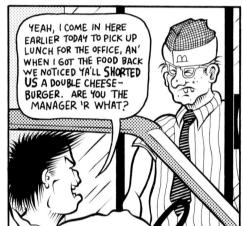

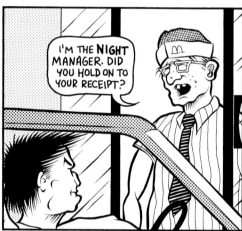

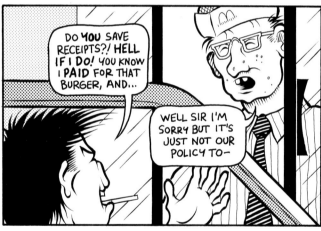

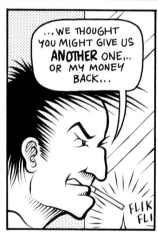

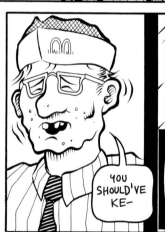

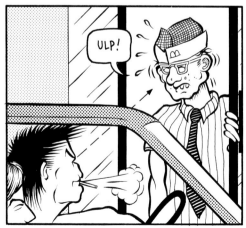

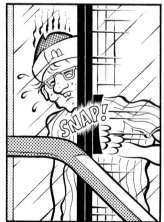

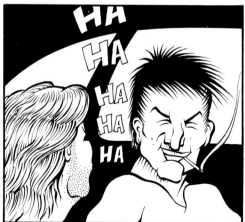

BORED, BROKE, HUNGRY, AND MEAN- from *Cruel World* No. 1, 1993.

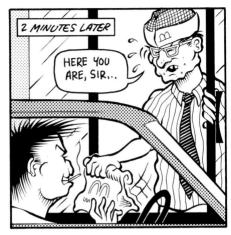

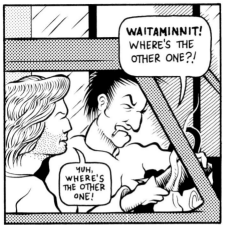

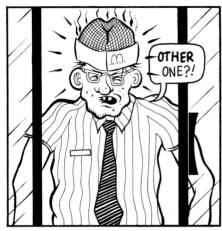

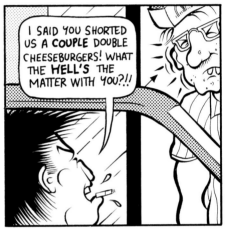

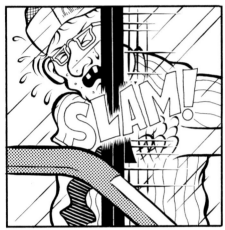

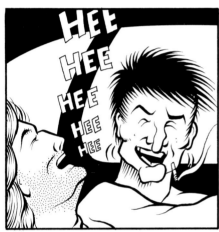

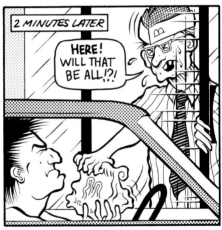

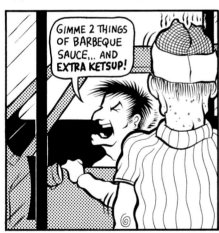

MORAL: The proper application of intimidation and lies can net you a stomach-full of fast food for free.

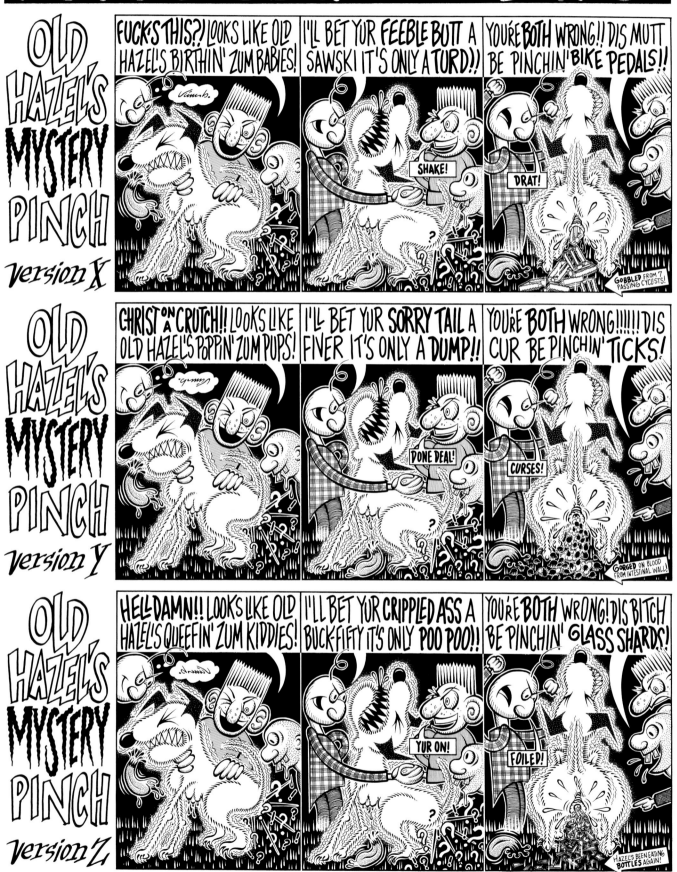

THIS PAGE: **OLD HAZEL'S MYSTERY PINCH**- from *Cruel World* No. 1, 1993. OPPOSITE PAGE: **A TEX-ASS PROVERB**- from *Bad Meat* No. 3, 1997.

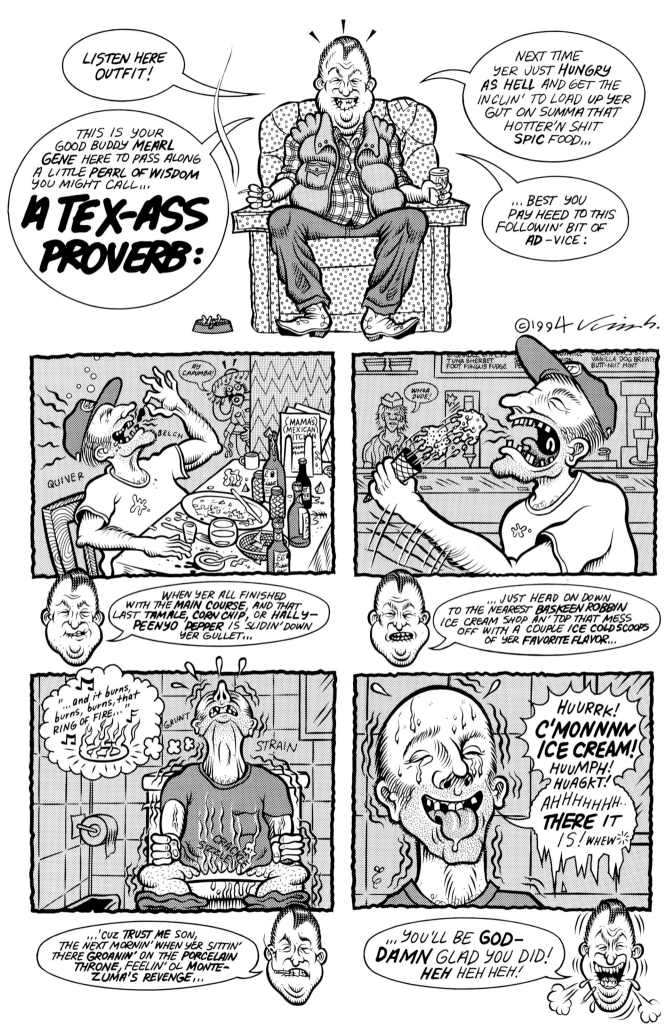

and now...
AN ABBREVIATED PICTO-HISTORY OF
BAD CRIME
IN THESE UNITED STATES

TONY NUBBS AND "CHEEKS" LARIZZO THOUGHT THEY WERE BIG TIME HOODS BUT THEY WEREN'T! THEY WERE FUCK UPS!

"OKAY KID, WE'RE GONNA KILL YOU NOW, AND THEN TELL YOUR PARENTS THAT WE KIDNAPPED YOU!" SAID TONY.

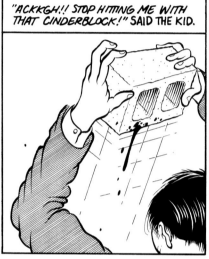

"ACKKGH!! STOP HITTING ME WITH THAT CINDERBLOCK!" SAID THE KID.

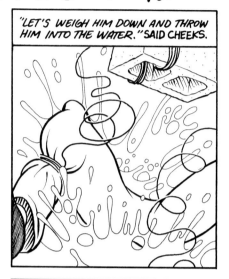

"LET'S WEIGH HIM DOWN AND THROW HIM INTO THE WATER." SAID CHEEKS.

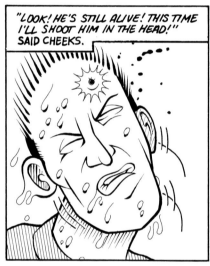

"LOOK! HE'S STILL ALIVE! THIS TIME I'LL SHOOT HIM IN THE HEAD!" SAID CHEEKS.

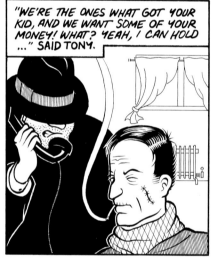

"WE'RE THE ONES WHAT GOT YOUR KID, AND WE WANT SOME OF YOUR MONEY! WHAT? YEAH, I CAN HOLD ..." SAID TONY.

"HOW WAS I SUPPOSED TO KNOW THEY WAS GONNA TRACE THE CALL?" SAID TONY.

"PEEEE-YOO.!! YEP, IT'S HIM— THE KID WHAT WAS KIDNAPPED!" SAID THE COP.

"LET'S ASSEMBLE A MOB AND STORM THE JAIL." SAID MOM. "GOOD IDEA, AND DURING THE FRACAS, I'LL PUT THEIR EYES OUT WITH MY AWL!" SAID DAD.

"THEN WE CAN HANG THEM FROM NEARBY TREES." SAID MOM.

THE END

BASED ON A TRUE STORY. (THE BROOKE HART KIDNAPPING, 1933)

AN ABBREVIATED PICTO-HISTORY OF BAD CRIME IN THESE UNITED STATES- from *Cruel World* No. 1, 1993.

Jim Blanchard's
MONDAY MORNING MISSY

©1989
All
Rights
Reserved

I WAKE UP EACH DAY TO THE SOUND OF CHIRPING BIRDS.

MONDAYS START OFF LIKE ANY OTHER DAY, BECAUSE I WORK ON WEEKENDS TOO.

EVERY MORNING I GET DRESSED, BRUSH MY TEETH, DRINK COFFEE, AND SMOKE A CIGARETTE.

THEN I ORGANIZE WHAT I NEED TO TAKE TO WORK WITH ME: KEYS, WALLET, HANKERCHEIF, CIGAR-ETTES, HAIRBRUSH, LIPSTICK, LIGHTER, AND ANY LOOSE CHANGE LYING AROUND.

ALL IN ALL IT TAKES ABOUT TWENTY MINUTES.

AS I'M LEAVING THE HOUSE I NOTICE A SMALL BOWL WITH CUBED BUTTER IN IT SITTING ON THE FRONT STEPS.

I PICK IT UP AND FOR SOME REASON IT'S COLD, EVEN THOUGH IT'S KIND OF WARM OUT TODAY.

THE MAN WHO LIVES ACROSS THE STREET IS SUDDENLY RUNNING TOWARDS ME AS FAST AS HE CAN, WITH AN ODD SMILE ON HIS FACE.

HE'S WEARING BOXER SHORTS AND A BATHROBE, BUT NO SHOES.

HALF THE WAY TO ME, HE TRIPS ON THE CURB AND SKIDS TO A STOP RIGHT ON HIS CHINNY-CHIN-CHIN.

THE FALL NOT ONLY SHEARS A LAY-ER OF SKIN OFF HIS CHIN, BUT ALSO LOBS OFF A PORTION OF THE SKIN ON HIS RIGHT BIG TOE.

MONDAY MORNING MISSY- from *Cruel World* No. 1, 1993.

INSTEAD OF CRYING OUT OR SHOW-
ING ANY SIGN OF PAIN, HE PICKS
HIMSELF UP IMMEDIATELY AND CON-
TINUES TOWARDS ME, SMILING.

WHEN HE REACHES ME, HE GRIPS
MY ARMS, THEN HESITATES.

HE IS BREATHING HARD.

SLOWLY HE LOWERS HIS HEAD TO
THE BOWL IN MY HANDS.

HIS EYES LOOK DEEPLY INTO MINE
AS HE BEGINS POKING HIS TONGUE
INTO THE BOWL OF BUTTER.

THIS SEEMS TO EXCITE HIM TO NO
END.

HE IS OBLIVIOUS TO THE BLOODY
WOUNDS.

I'M STARTLED AND SICKENED BY
THIS STRANGE DISPLAY AND DROP
THE BOWL.

THE BOWL HITS THE CONCRETE
UNDERNEATH IT AND BREAKS.

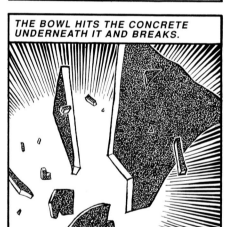

THE BUTTER STICKS, AND MUTES
THE SOUND OF THE BREAKING BOWL.

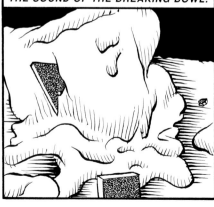

I PROCEED TO GRASP THE MAN'S
HEAD WITH BOTH MY HANDS AND
PULL HIS FACE UP TO MINE.

I SPIT IN HIS FACE.

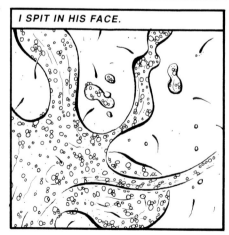

HE SMILES AND MAKES A CIRCULAR MOTION WITH HIS TONGUE, LICKING THE SPIT OFF THE AREA AROUND HIS MOUTH.

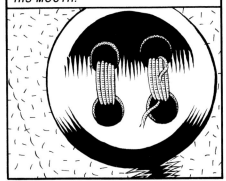

HE TAKES MY SPIT INTO HIS MOUTH AND SWALLOWS IT.

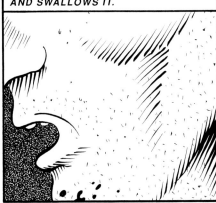

I SPIT ON HIM AGAIN, LANDING IT ON HIS ROBE.

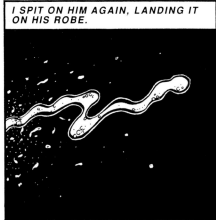

THIS TIME HE REACTS VIOLENTLY.

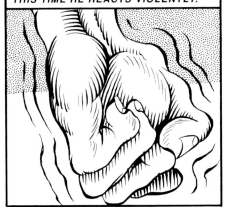

A NASTY FROWN REPLACES HIS SMILE.

HE GRITS HIS TEETH AND HIS SWEATY FACE FLUSHES RED, FORC- ING A PIMPLE UNDER HIS EYE TO GLEAM.

HE STARTS TO QUIVER AND MOAN. HE LOOKS BEWILDERED.

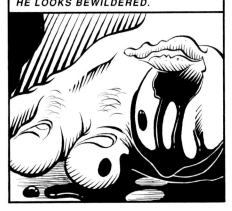

HIS QUIVERING TURNS INTO A RUMBLING SPASM AND HE DROPS TO MY FEET- DEAD, I ASSUME.

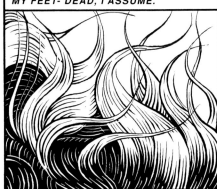

I'M LATE FOR WORK, SO I CLOSE THE DOOR AND BRUSH MY NEIGH- BOR, AS WELL AS THE BUTTER AND PORCELIN FRAGMENTS, OFF THE STEPS WITH MY FOOT.

I HATE MEN.

I REALLY HATE BEING LATE FOR WORK.

THE EXECUTION OF CARL JUNG

Text by George Petros (and Carl Jung) • Illustrations by Jim Blanchard • Research by Robert N. Taylor

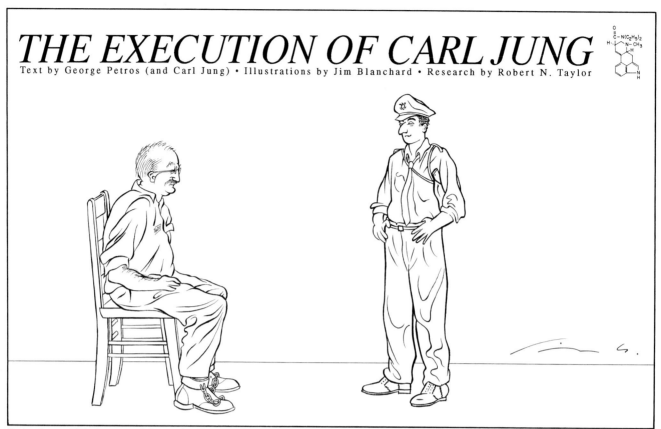

During the year 1938, there occured the amazing discovery of Lysergic Acid Diethylamide. It is now post-war 1946 and humanity is at a crossroads; LSD is on the verge of being made available for scientific study, while, conversely, the Nuremberg Trials have ushered in a climate of self-righteous hysteria. LSD is ready to be used as a key to open new doors of perception, but all eyes are instead focused on the victorious Allied Powers' witchhunt for Nazis: be they real or imagined, alledged or otherwise, supposed collaborators, or those who "inadequately" oppossed them.

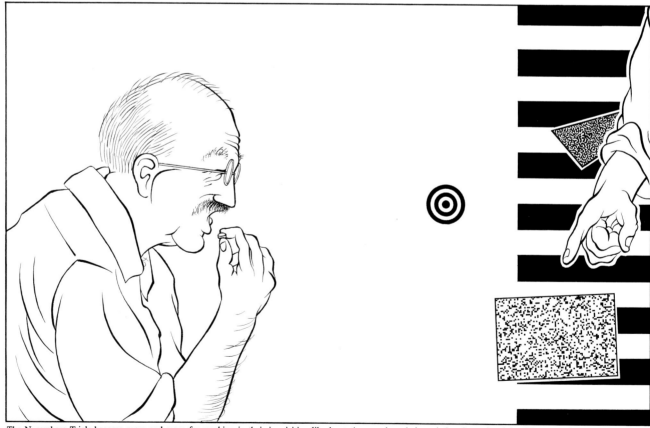

The Nuremberg Trials become more and more far-reaching in their inquisition-like hunt. Among those being tried and convicted for Crimes Against Humanity is the eminent Psychologist and philosopher Carl Gustav Jung, whose work concerning the 'collective unconscious' have done much to open the doorway for self-reflection and understanding. Despite Jung's incarceration, admiring colleagues have smuggled him some of the new found psychoactive miracle drug, LSD-25. Jung sits facing a lone interrogator for a final questioning. Knowing that these may well be his last moments, he decides to administer himself the dose of LSD in a final act of experimentation, just as his interrogation is about to commence.

THE EXECUTION OF CARL JUNG- text by George Petros, research by Robert N. Taylor, featuring Carl Jung's actual words. From *Exit* #5, 1991.

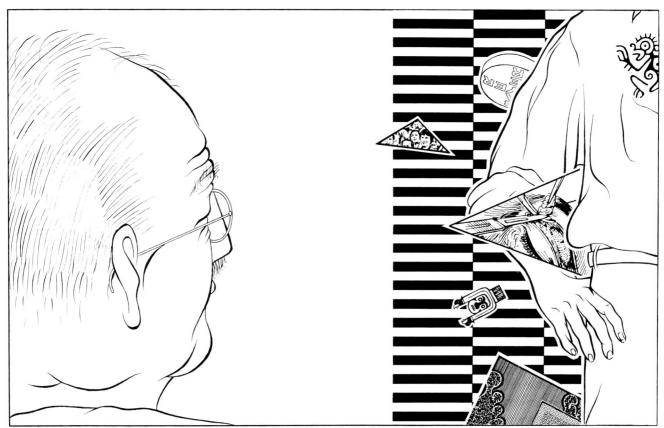

Interrogator: "We know that in 1933, you accepted the Nazi invitation to take over as President of the German Association for Psych-therapy. Their Nazified paper, *Zentralblatt fur Pschotherapie*, declared: 'Thanks to the fact Dr. C.G. Jung accepted the presidency, it has been possible to continue the scientific activity of the Association and its periodical.' And, Dr. Jung, we all know just what this "scientific activity" came to be, don't we doctor! Medical experimentation of an inhuman and disgusting nature, crimes against humanity!"

Jung: "This is a gross distortion..."

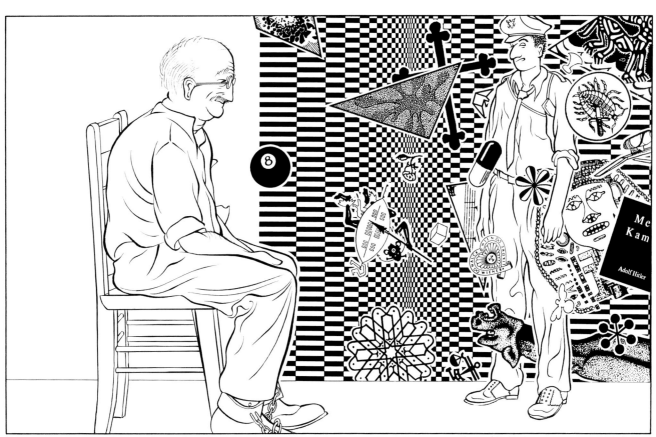

Interrogator: "So we find a Swiss citizen editing the official organ of a society which, according to the statement of one of its leading members, Dr. M. H. Goring, requires of all its actively writing and speaking members that they shall have studied Adolf Hitler's fundamental book *Mein Kampf* with full scientific thoroughness and shall recognize it as a basis for their activity."

Jung: "But, but, surely you cannot equate my work with..."

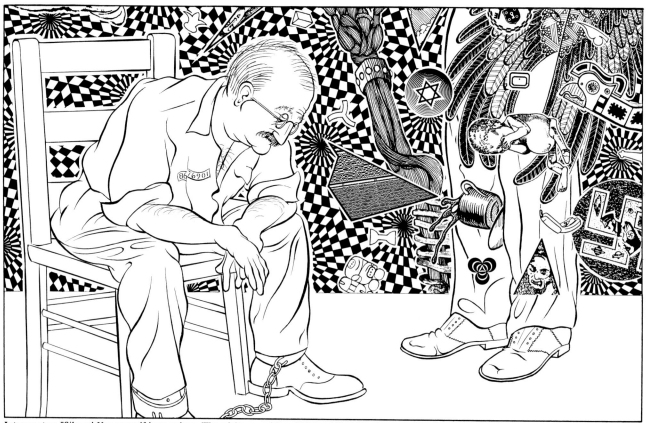

Interrogator: "Silence! You yourself have written, 'The mighty apparition of National Socialism has something better to teach us' – something better, perhaps, like the concentration camps, the gas ovens, the bulldozing of bodies for burning and butchering, the machine-gunning of innocent women and children, the genocide of a people – is this what we are to learn, Dr. Jung, from this 'Mighty Apparition' of death! Your contemporary followers always try to ignore or minimize your extensive collaboration with the German National Socialist regime, a collaboration carried on since the 1930's!"

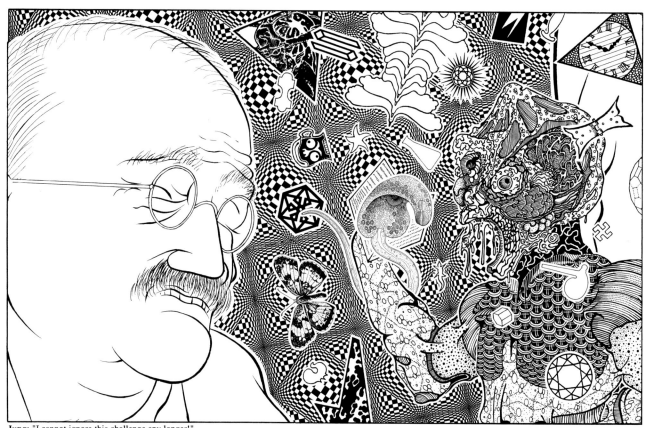

Jung: "I cannot ignore this challenge any longer!"

Interrogator: "Yes, yes, explain yourself!"

Jung: "I found myself faced with a moral conflict... should I as a prudent neutral withdraw into security on this side of the frontier, live and wash my hands in innocence, or should I – as I was well aware – lay myself open to attack and the unavoidable misunderstanding which no one can escape who, out of a higher necessity, has to come to terms with the political powers that be in Germany? Should I sacrifice the interests of science, of loyalty to my colleagues, of the friendship which binds me to many German physicians, and the living community of German language and intellectual culture, to my egoistic comfort and different political outlook? So I had no alternative but to lend the weight of my name and of my independent position for the benefit of my friends."

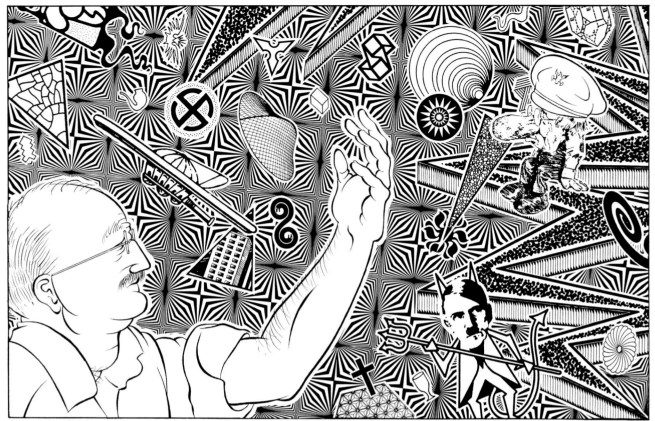

Interrogator: "It is impossible any longer to have any kind of association with Germany without becoming politically suspect on one side or the other! Indeed, Dr. Jung, things have reached a stage where you are personally regarded as a 'blood-boltered anti-semite' that 'helped the German doctors to consolidate their Psychotherapeutic society.' Why did you not resign at once?!"

Jung: "I challenge this! My German colleagues were not responsible for the Nazi revolution, its politics, or persecutions! I have done nothing against the Jews, our regulations allowed the participation of everyone, quite apart from political or religious convictions."

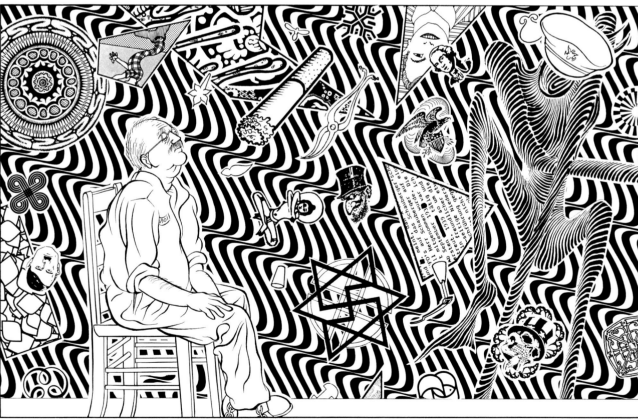

Interrogator: "But I quote you: 'The factual differences between Germanic and Jewish psychology which has long been known to intelligent people shall no longer be wiped out and that can only be helpful to science.' Dr. Jung, in any normal atmosphere these words may be innocuous enough, but against the blazing context of Nazi anti-semitism and the proclaimed intention of Hitler to obliterate the Jews, they could be distorted to endorse philosophic assumptions of a dangerous kind!"

The LSD has now fully entered Dr. Jung's bloodstream and he speaks his racing thoughts out loud.

Jung: "The 'Aryan' unconscious contains explosive forces and seeds of a future yet to be born, and these may not be developed as nursery romanticism without psychic danger. The still youthful Germanic peoples are fully capable of creating new cultural forms that still lie dormant in the darkness of the unconscious of every individual – seeds bursting with energy and capable of mighty expansion."

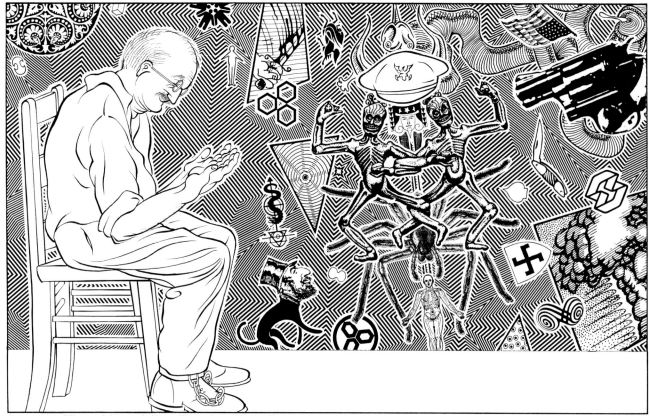

Interrogator: "These anti-democratic ideas will never leave this room!"

Jung: "The Jew who is something of a nomad, has never yet created a cultural form of his own and as far as we can see never will, since all his instincts and talents require a more or less civilized nation to act as host for their development. The Jewish race as a whole – at least this is my experience – possesses an unconscious which can be compared with the 'Aryan' only with reserve. Creative individuals apart, the average Jew is far too conscious and differenciated to go about pregnant with the tensions on unborn futures. The 'Aryan' unconscious has a higher potential than the Jewish... The most precious secret of the Germanic people – their creative and intuitive depth of soul – has been explained as a morass of banal infantilism, while my own warning voice has for decades been suspected of anti-semitism. This suspicion emanated from Freud..."

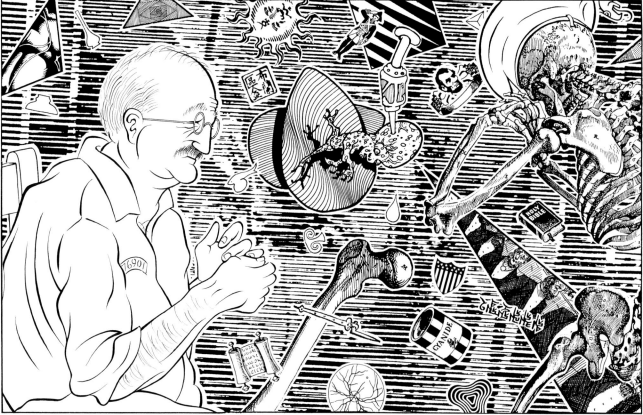

Interrogator: "Now you speak nonsense with your pontifications! Are you to refute the great master of psychology - Sigmund Freud?"

Jung: "It is quite unpardonable to accept the conclusions of a Jewish psychology as generally valid. Nobody would dream of taking Chinese or Indian psychology as binding upon ourselves. The cheap accusation of anti-semitism that has been leveled at me on the ground of this criticism is about as intelligent as accusing me of anti-Chinese prejudice!"

Interrogator: "But, but this cannot be!"

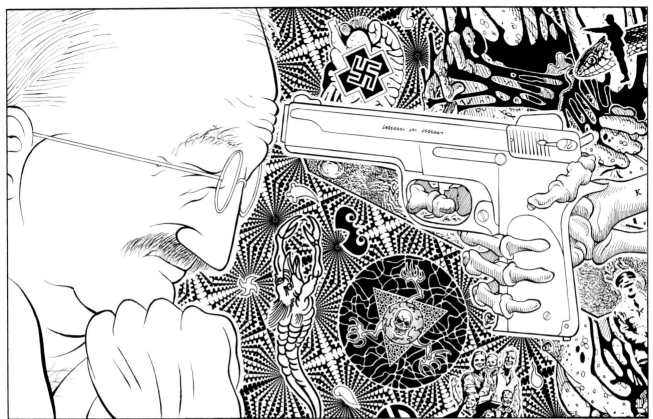

Jung: "The 'Aryan' unconscious has a higher potential than the Jewish; this is the advantage and the disadvantage of a youthfulness not yet fully escaped from babarism. In my opinion, it has been a great mistake of all previous medical psychology to apply Jewish catagories which are not even binding for all Jews, indiscriminately to Christians, Germans, and Slavs. In so doing, medical psychology has declared the most precious secret of the Germanic peoples – the creatively prophetic depth of soul – to be a childishly banal morass, while for decades my warning voice has been suspected of anti-semitism. The source of this suspicion is Freud. He did not know the Germanic soul any more than did all his Germanic imitators. Yes, the mighty apparition of National Socialism which the whole world watches with astonished eyes has taught them something better..."

Interrogator: "Enough of your opinion!"

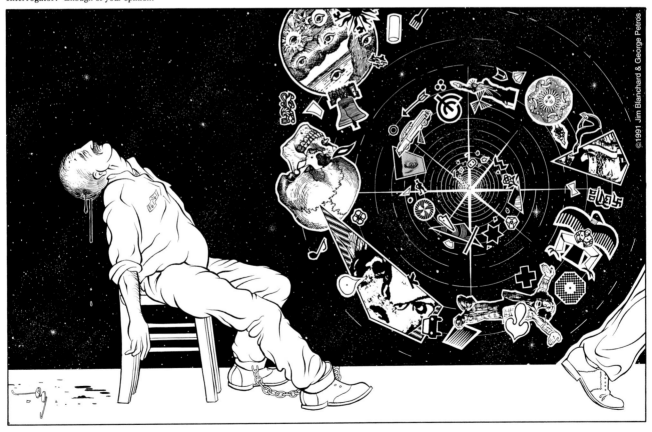

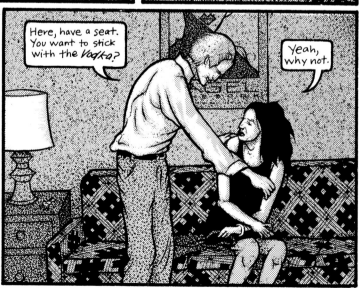

NOTHING HAPPENED- from *Bad Meat* No. 3, 1997.

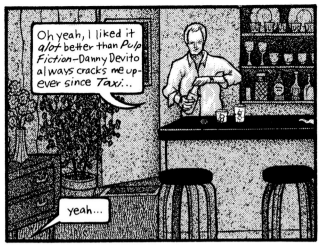

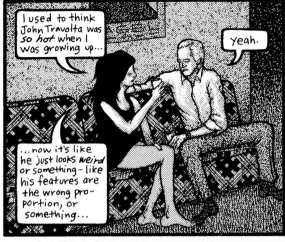

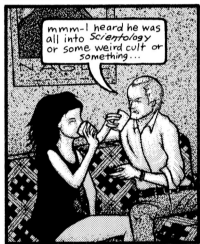

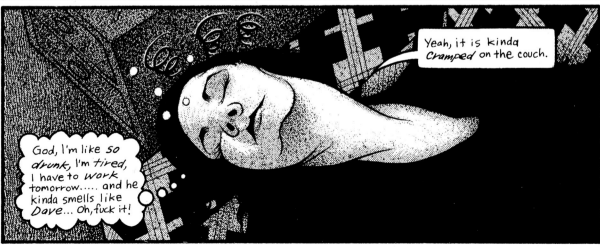

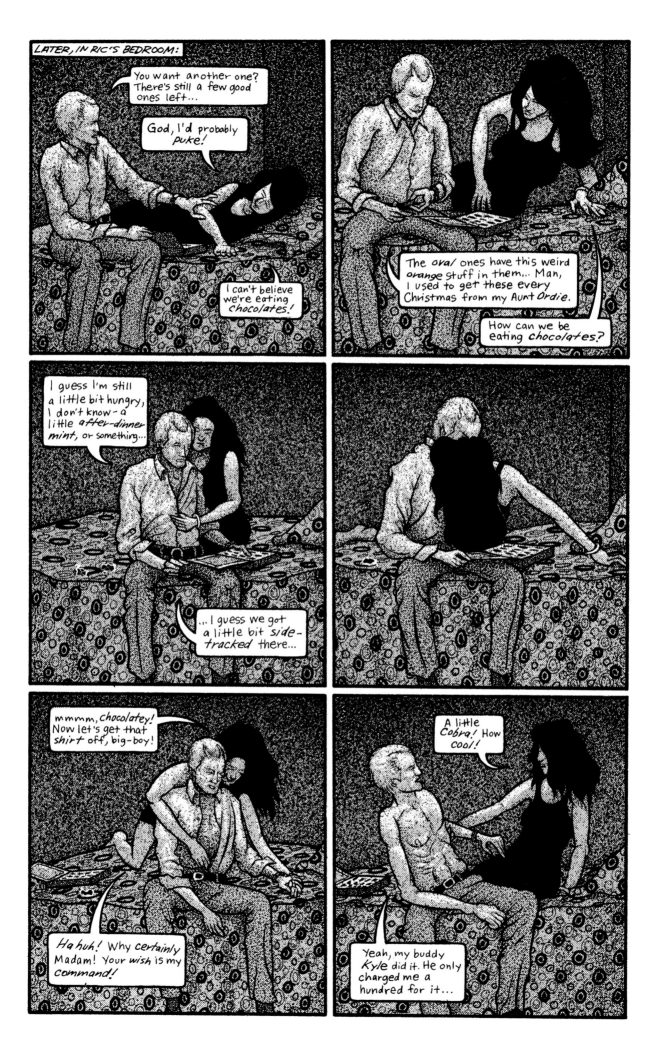

128

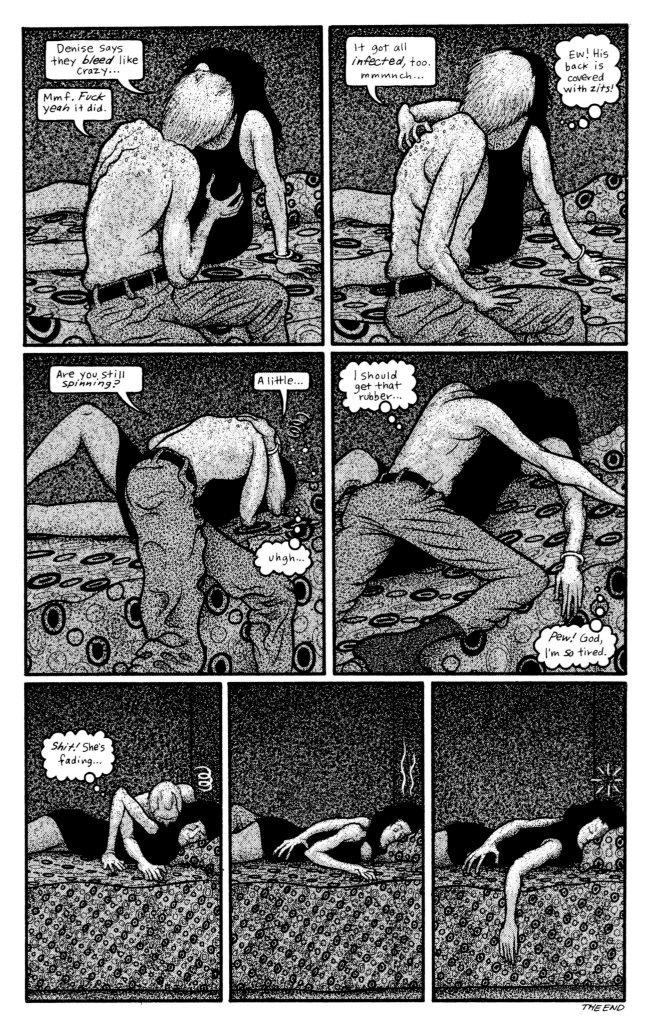

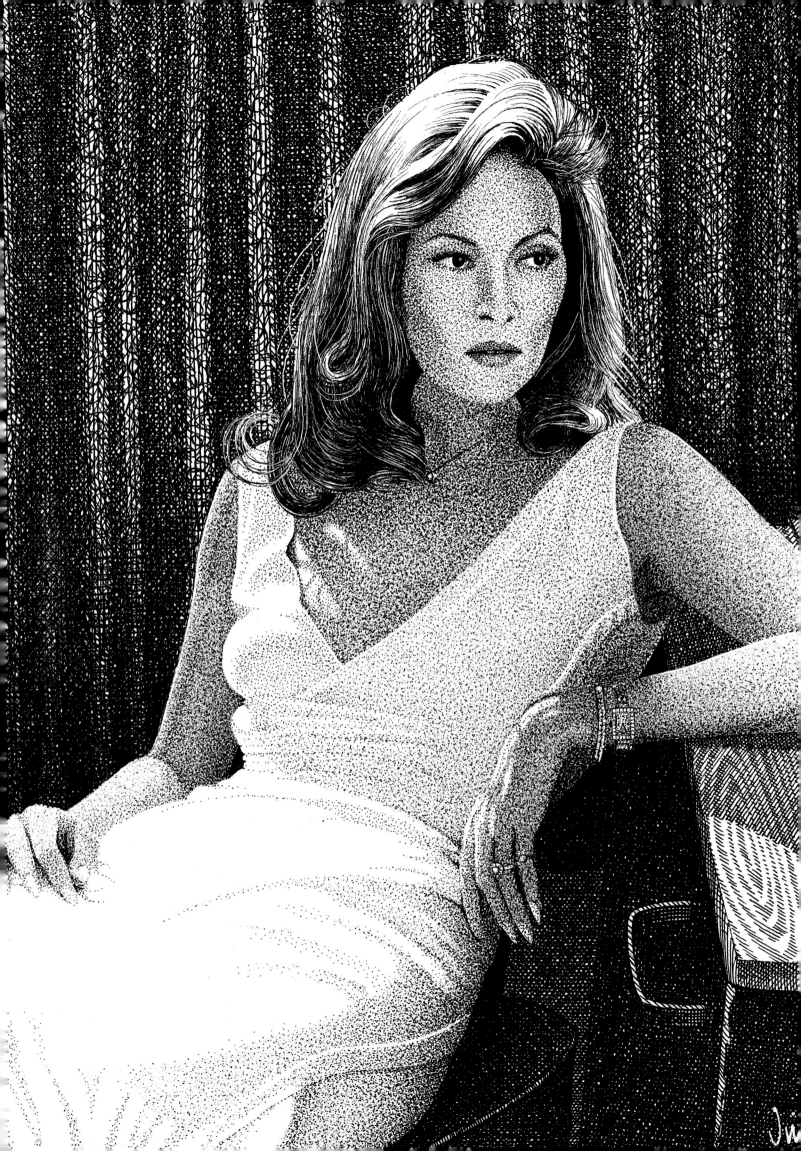

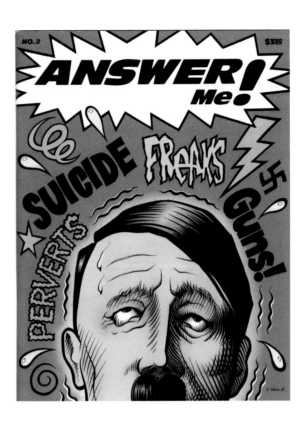

PORTRAITS / ART FOR HIRE

In graphic designer Art Chantry's introduction to my 2006 portraits book *Beasts And Priests*, he states "After many years as an art director hiring professional illustrators to do portraits to accompany magazine articles, I come to think that it is actually a talent that you are born with rather than one you can learn. I think it's actually a genetic trait to be able to do portaits well." These days, ninety percent of the art I make is portraits. I'm not exactly sure how it ended up that way. Perhaps Art Chantry is right and it's something I was born with. I know for a fact that it's partially due to artistic laziness, as my portrait work is done with the use of photographic references. Artist Jim Woodring suggested that my portraits were "...*masks* through which [Blanchard is] coldly staring you down". I was born with a lazy eye and have forever had a problem with eye contact, so maybe Jim is on to something, too. I think the main reason I ended up a portrait jockey is because I got paid for it. For years I was a dedicated "psycho-delic underground cartoonist," and I pretty much didn't make squat. Only when I

started inking Peter Bagge's comics and doing portraiture did the freelance cash start to flow my way. A labor of love is all well and good, until you no longer have a day job and bills need to be paid.

In the mid-1980s, Jimmy Johnson, editor for corrosive Boston music mag *Forced Exposure*, asked me to do a portrait of writer William S. Burroughs after he saw my high-contrast portrait of Karl Marx in *Blatch* #12. This would mark the beginning of a career of rendering famous and infamous faces. After Burroughs, I did a triad of tough guy writers, Charles Bukowski, Jim Thompson, and Charles Willeford for *Forced Exposure*. When *Forced Exposure* ceased publication in 1993, I continued doing portraits of writers and musicians for other opinionated music and culture magazines, such as *Your Flesh, Motorbooty, Cool & Strange Music,* and *The Oxford American*.

One of the first things you learn when you're a freelance magazine illustrator is the importance of your relationship with the Art Director. I was lucky to be good friends with Joe Newton when he art directed the Seattle alternative newsweekly

OPPOSITE PAGE: **FAYE DUNAWAY**- commissioned portrait, 2001. THIS PAGE, ABOVE: **ANSWER ME! No. 3**- magazine cover art, 1993.

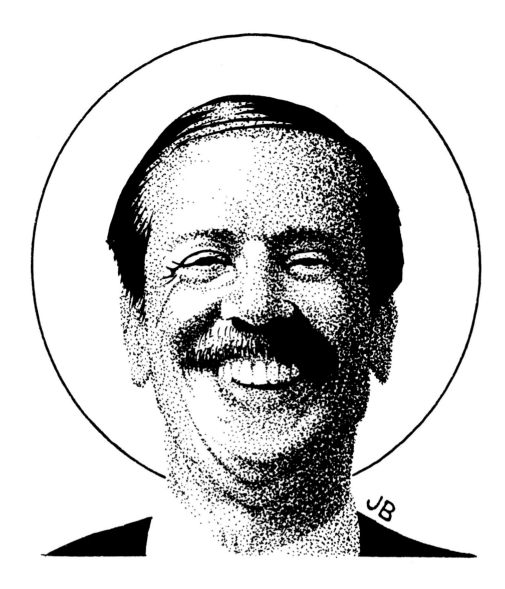

The Stranger from 1999-2004. Previous to Joe, the art director at *The Stranger* was Dale Yarger, who I had worked with at Fantagraphics. Joe and Dale fed me tons of illustration work. It didn't pay much, but I was a bachelor who lived cheaply, so it helped keep me afloat. Since *The Stranger* was well circulated, it was also "good exposure" and got my name and handiwork under people's noses, which led to more jobs, including commissioned portraits from individuals. Another important art director connection was Bill Nelson at *Hustler* magazine. *Hustler* made a point to hire illustators and writers from the punk/comix underground, and because the pay was above average, it was a coveted gig, especially for a broke-ass cartoonist/illustator like me.

In 2000, just for the hell of it, I made a four foot by four foot painting of Telly Savalas as Kojak, using black acrylic paint with rows of burnished adhesive stickers for color. The gigantic portrait was for a group show at Seattle's Roq La Rue gallery, and even though it was more or less done as a joke, it sold for eight hundred dollars. The lightbulb in my head switched on, and I began creating a series of large-scale celebrity visages that would become known as my "stickerpaintings." Kirsten Anderson

and her Roq La Rue gallery hosted two shows of the stickerpaintings, *Stickershock I & II*, and they were a categorical success. I would ultimately create and sell twenty nine stickerpaintings, and they helped solidify my reputation as a portrait artist.

The last portion of this chapter is work I did for "hardcore libertarian" publisher Loompanics Books from Port Townsend, Washington. Loompanics owner Michael Hoy liked my art and before he retired and quit publishing in 2006, I did a dozen book covers and over a hundred editorial illustrations and technical illustrations for his company. Working for Loompanics was never boring, I illustrated books on everything from backyard meat production, to building your own deadly catapult, to making crystal meth and armor-piercing bullets. Hoy paid his artists a decent wage and the check always arrived immediately after I submitted the artwork.

Since the advent of the internet, my freelance illustration work has gradually slowed to a trickle. Print editions of magazines and newspapers are dropping like flies, and the web-based versions are now more likely to use photographs or art from a low-cost online clip art library than they are to hire a bonafide illustrator. What a revoltin' development!

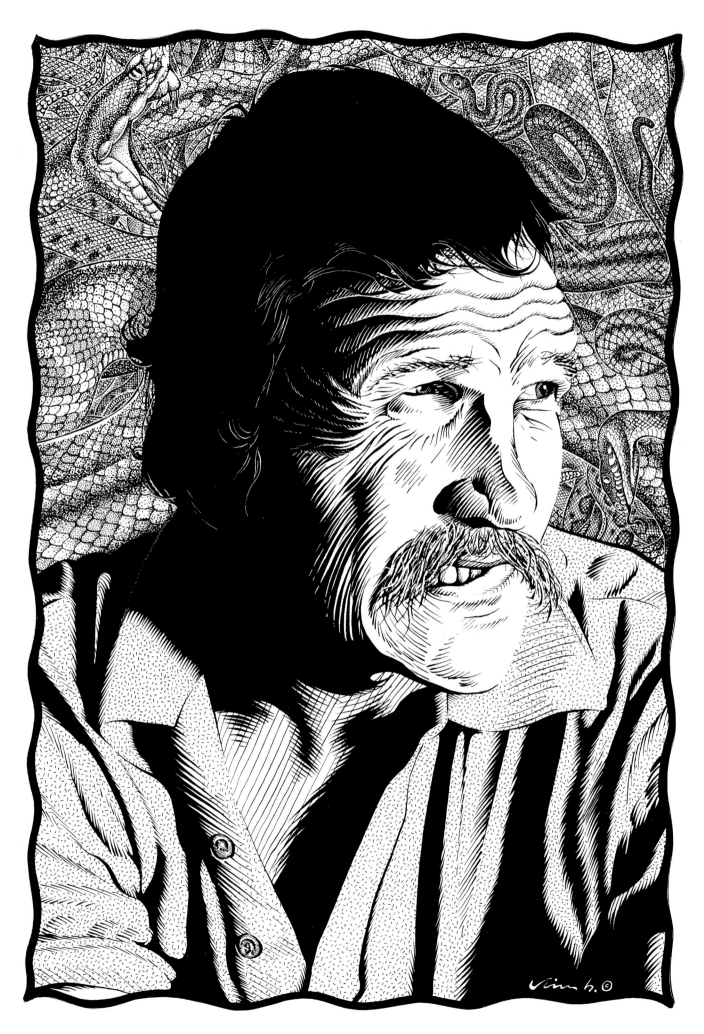

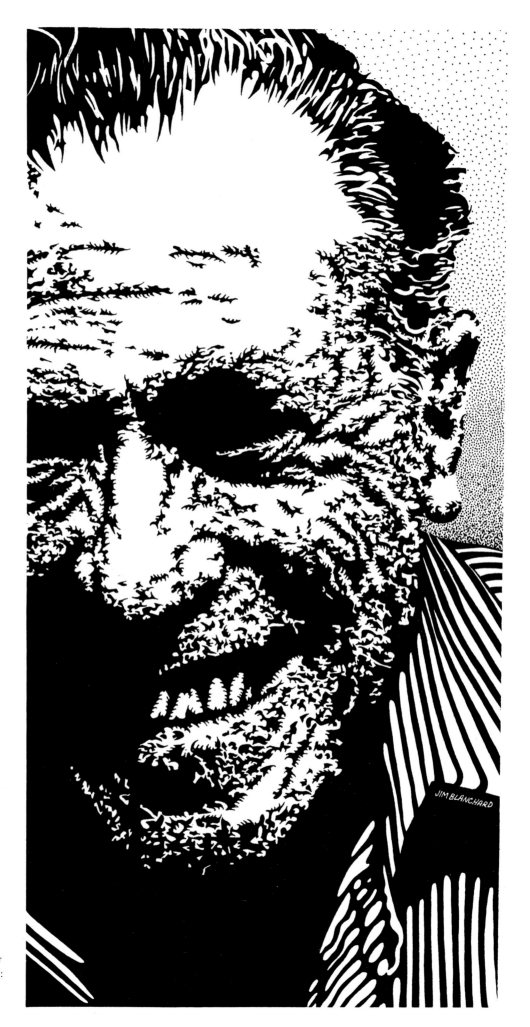

OPPOSITE PAGE: **HARRY CREWS**- for
Your Flesh magazine, 1988. THIS PAGE:
CHARLES BUKOWSKI- for *Forced
Exposure* magazine, 1985.

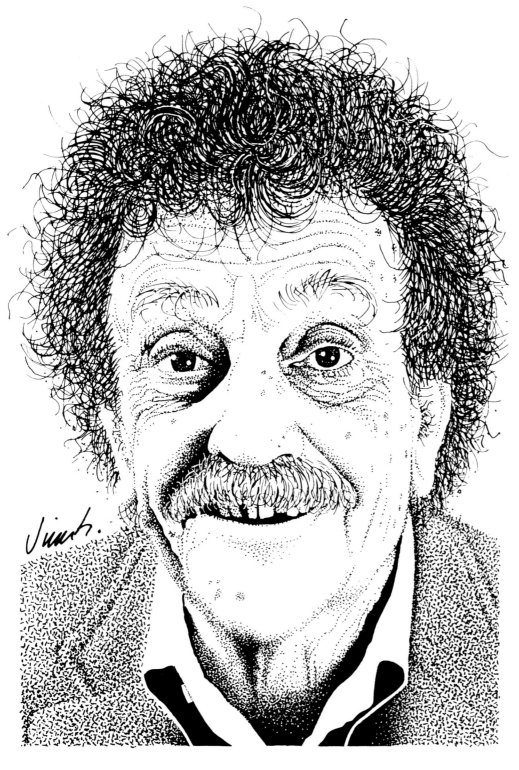

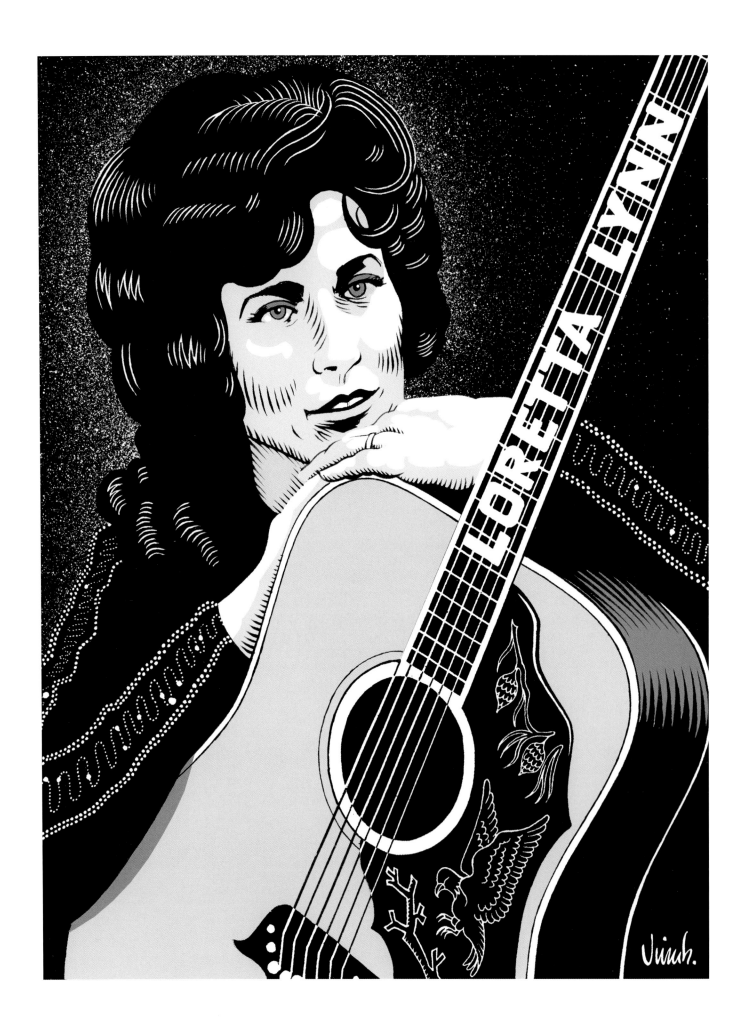

LORETTA LYNN- mixed-media portrait for a proposed book of biographies of Country and Western artists.

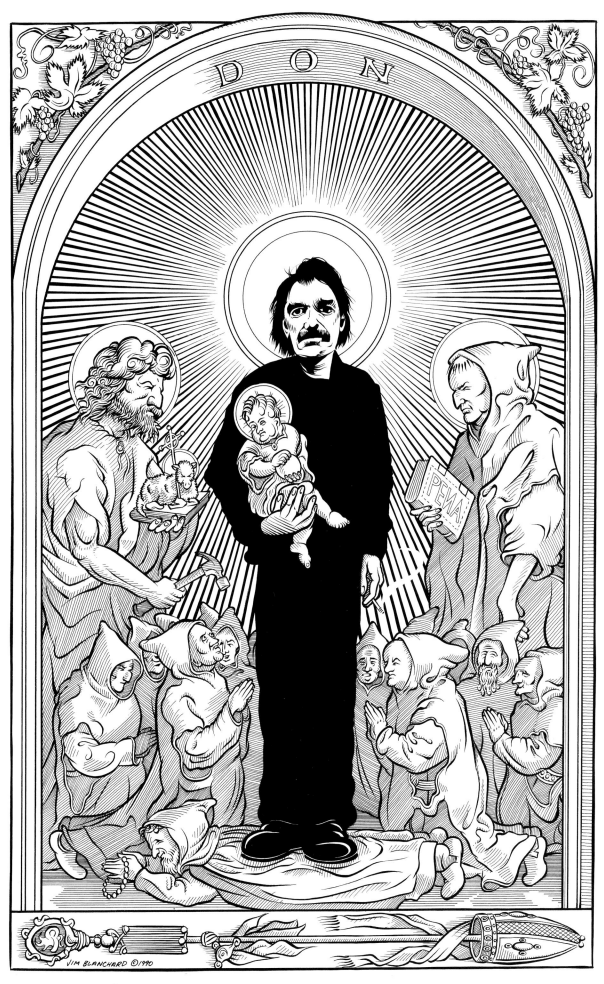

DON VAN VLIET aka CAPTAIN BEEFHEART- for *Your Flesh* magazine, 1990. Background imagery by way of Albrecht Dürer.

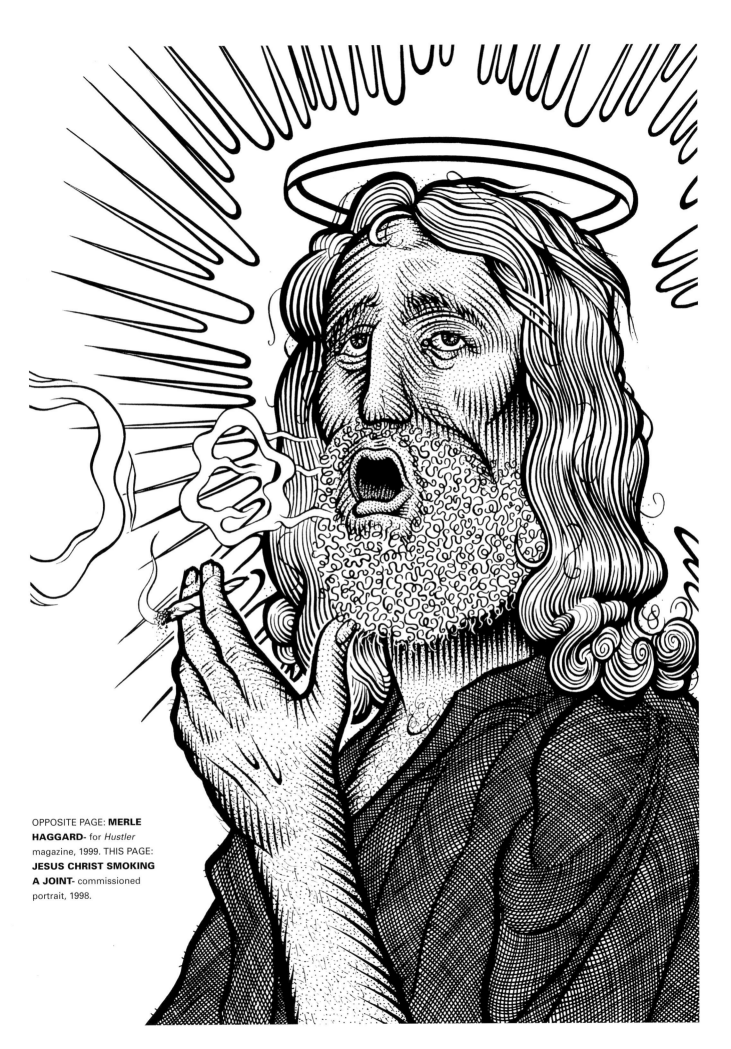

OPPOSITE PAGE: **MERLE HAGGARD-** for *Hustler* magazine, 1999. THIS PAGE: **JESUS CHRIST SMOKING A JOINT-** commissioned portrait, 1998.

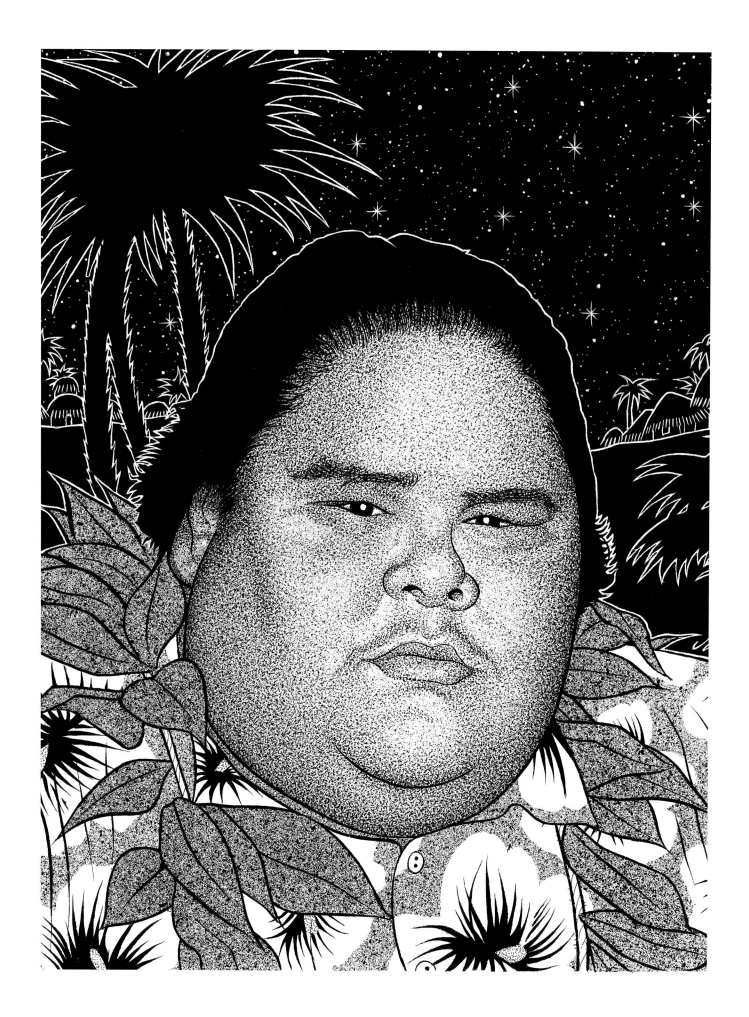

ISREAL KAMAKAWIWO'OLE O- for *Cool & Strange Music* magazine, 2002.

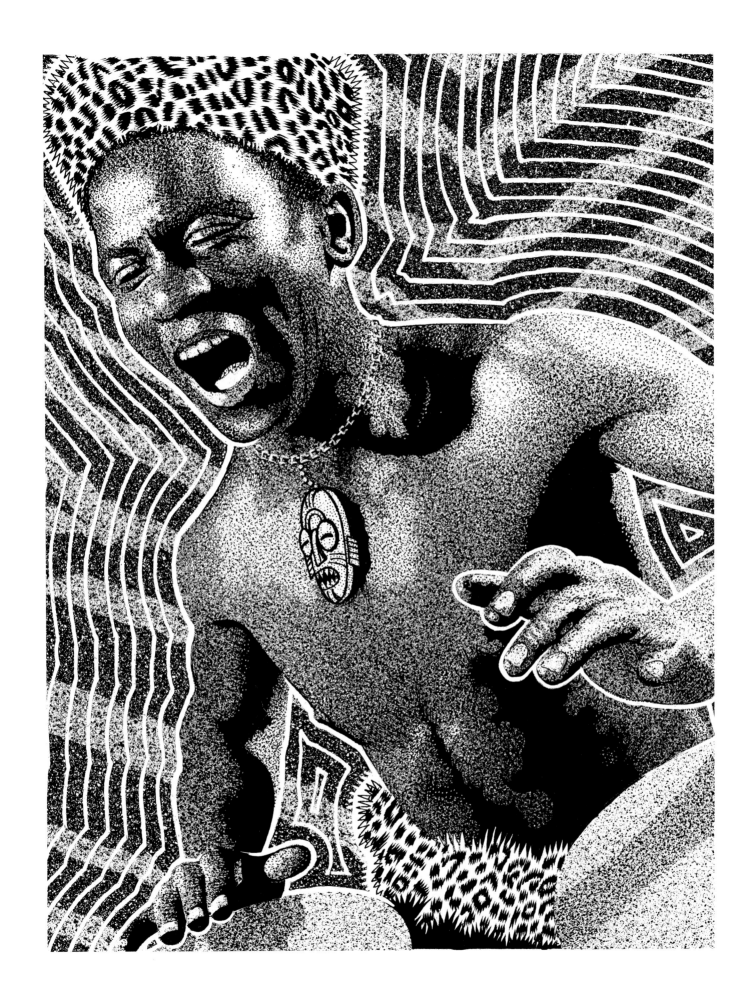

LEON "CHAINO" JOHNSON- for *Cool & Strange Music* magazine, 2001.

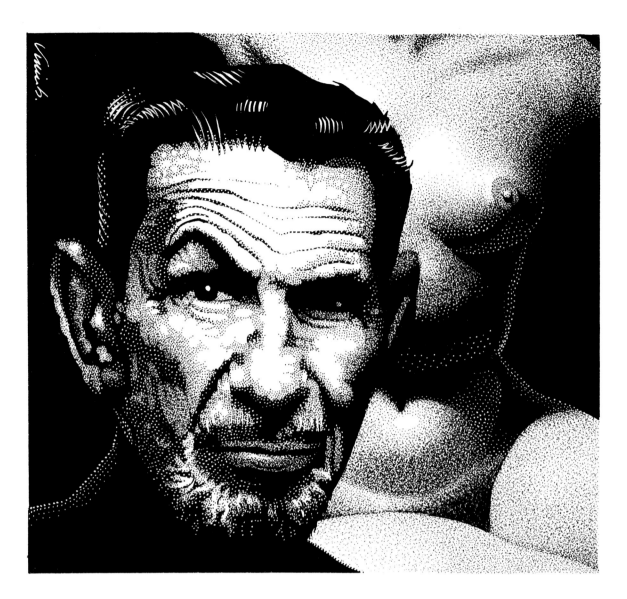

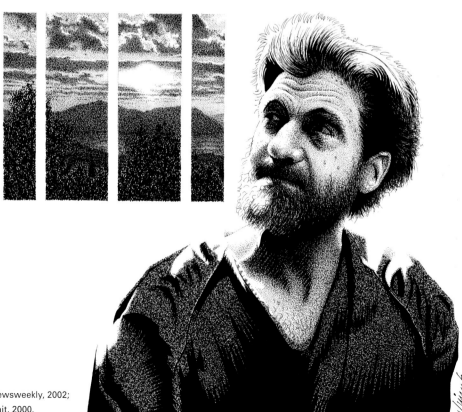

ABOVE: **LEONARD NIMOY**- for *The Stranger* newsweekly, 2002;
RIGHT: **TED KACZYNSKI**- commissioned portrait, 2000.

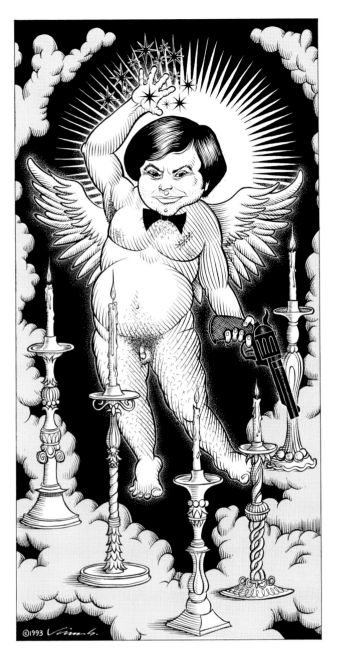

SAINT ED

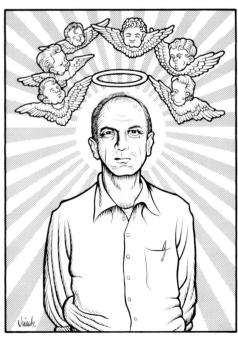

ABOVE LEFT: **HERVÉ VILLECHAIZE**- for *Your Flesh* magazine, 1994; ABOVE RIGHT: **EDDIE VEDDER**- for *Your Flesh* magazine, 1995; LEFT: **THE JESUS OF BURIEN**- for *The Stranger* newsweekly, 1999.

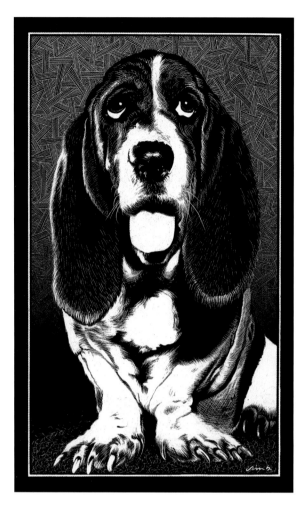

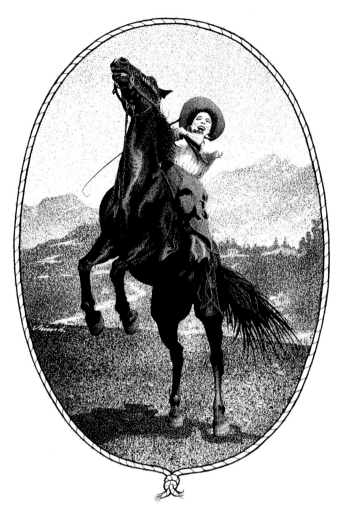

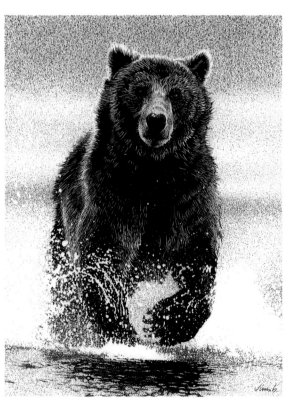

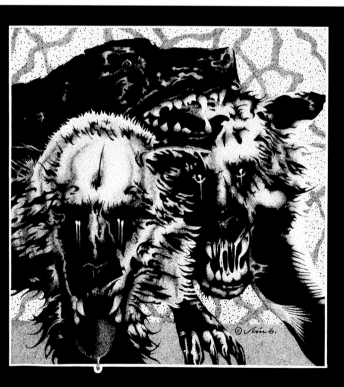

ABOVE LEFT: **BASSETT HOUND**- scratchboard self-promotional illustration, 1987; ABOVE RIGHT: **MAY LILLIE & HORSE**- commissioned portrait, 2002; LOWER LEFT: **BEAR IN WATER**- self-promotional illustration, 2000; LOWER RIGHT: **WILD DOGS**- self-promotional illustration, 1985.

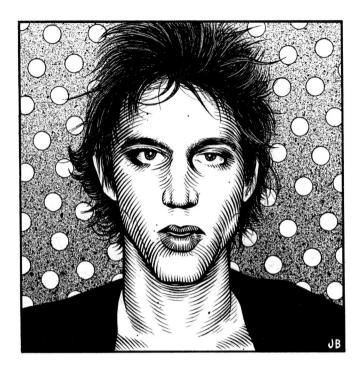

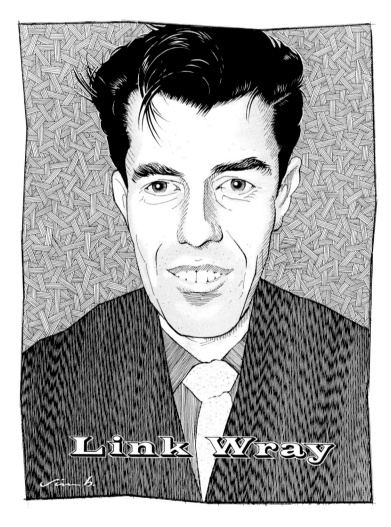

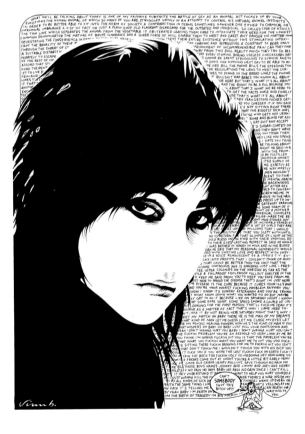

ABOVE LEFT: **RICHARD HELL**- for *The Stranger* newsweekly, 2002; ABOVE RIGHT: **MICK COLLINS**- for *The Stranger* newsweekly, 2001; LOWER LEFT: **LINK WRAY**- for *Your Flesh* magazine, 1990; LOWER RIGHT: **LYDIA LUNCH**- for *Your Flesh* magazine, 1990.

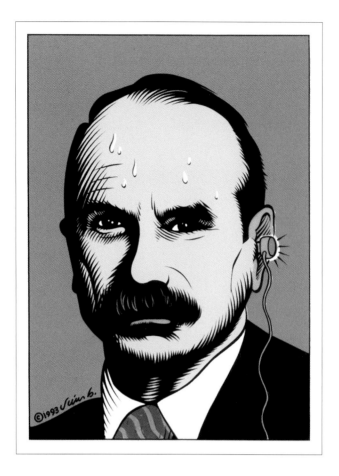

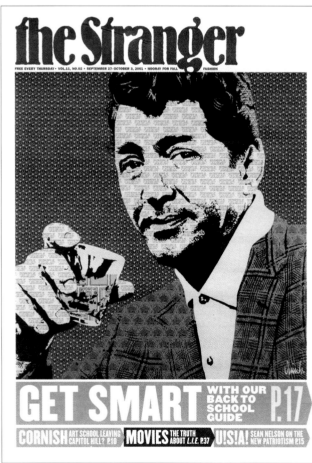

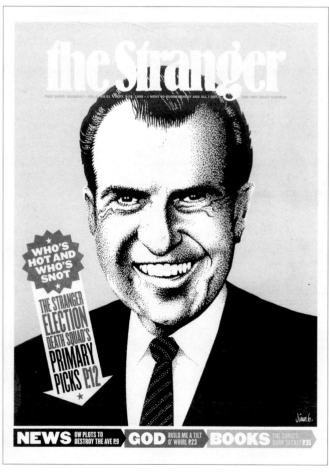

ABOVE: **G. GORDON LIDDY**- trading card art for WFMU's *Crackpots & Visionaries* card set, 1994; LOWER LEFT: **DEAN MARTIN**- cover for *The Stranger* newsweekly, 2001; LOWER RIGHT: **RICHARD NIXON**- cover for *The Stranger* newsweekly, 1999. OPPOSITE PAGE: **JOHNNY CASH**- detail from commissioned portrait, 1999.

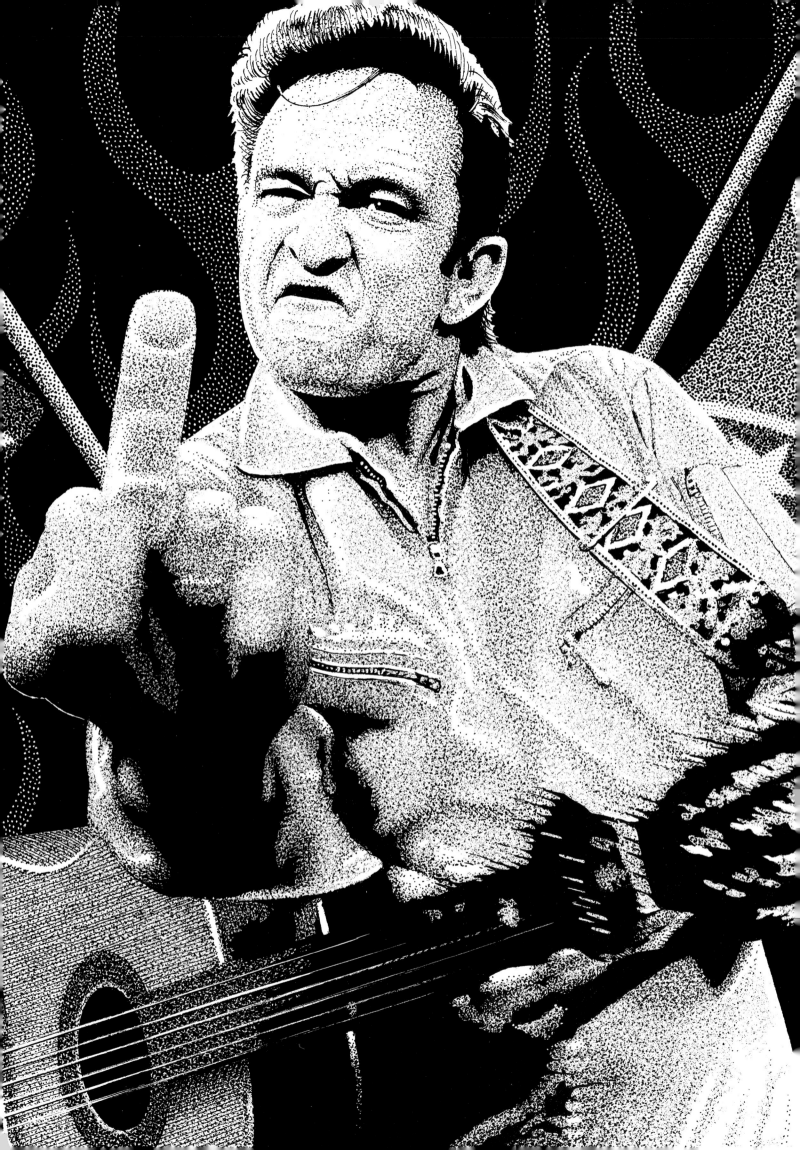

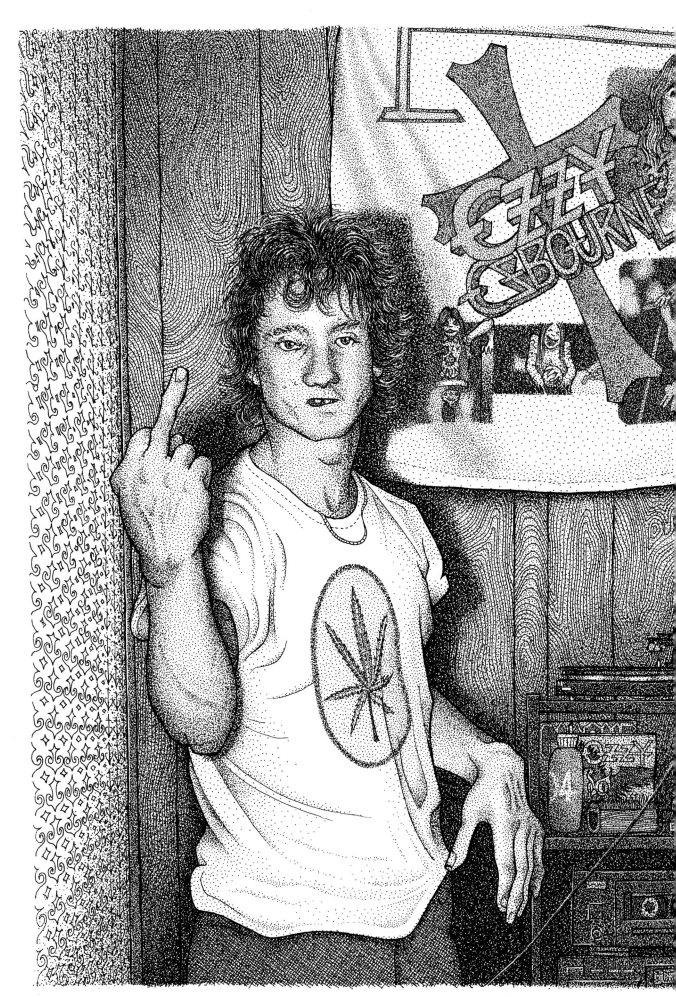

NEW TRINTY (FROM A PHOTO OF A FRIEND OF ROB'S)- self-promotional illustration, 1993.

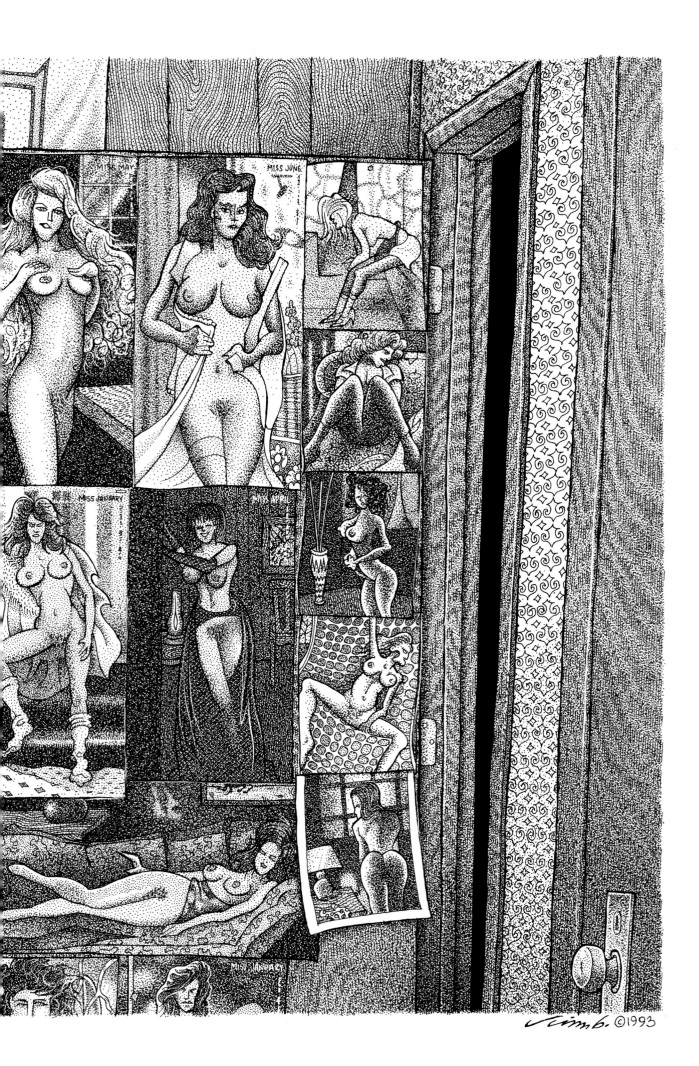

THIS PAGE: **MAN WITH GUN**- self-promotional illustration,1984. OPPOSITE PAGE: **BOY WITH GUN**- self-promotional illustration based on found photograph, 1993.

HITLERAMBO- hybrid of Adolf Hitler and Sylvester Stallone's John Rambo. Idea conceived by Jim Goad. Illustration for *Answer Me!* magazine, 1993.

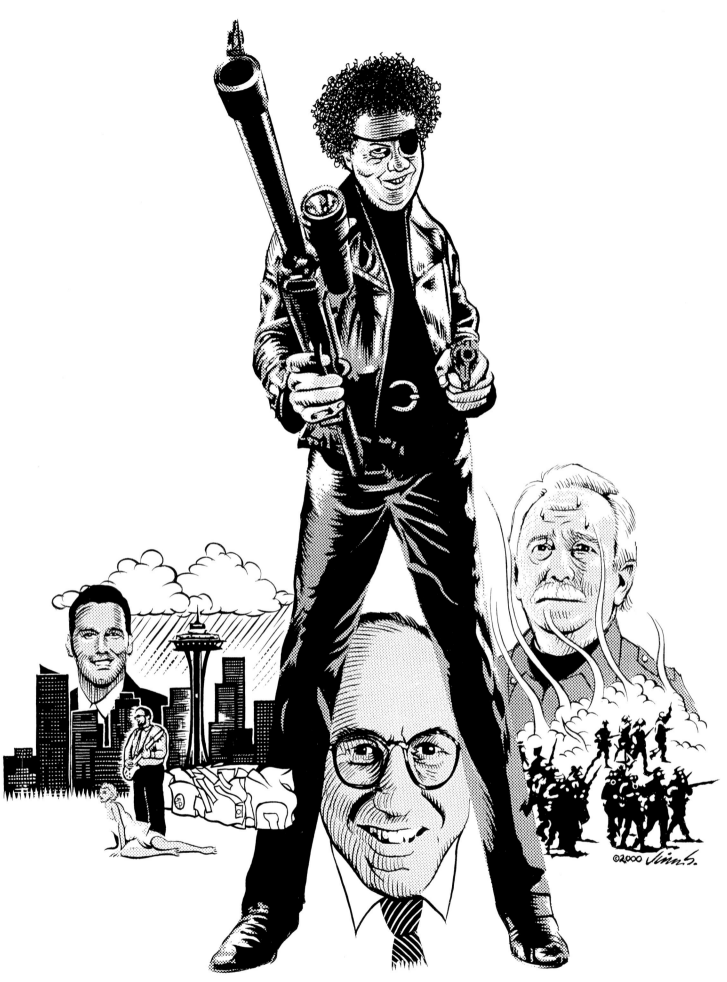

CLOCKWISE FROM TOP: **DALE CHIHULY AS SHAFT**, Seattle Police Chief **NORM STAMPER**, Seattle City Attorney **MARK SIDRAN** (between legs),
PAUL ALLEN and his EMP Museum, Q13 Fox weatherman **JIM CASTILLO**. For *The Stranger* newsweekly, 2000.

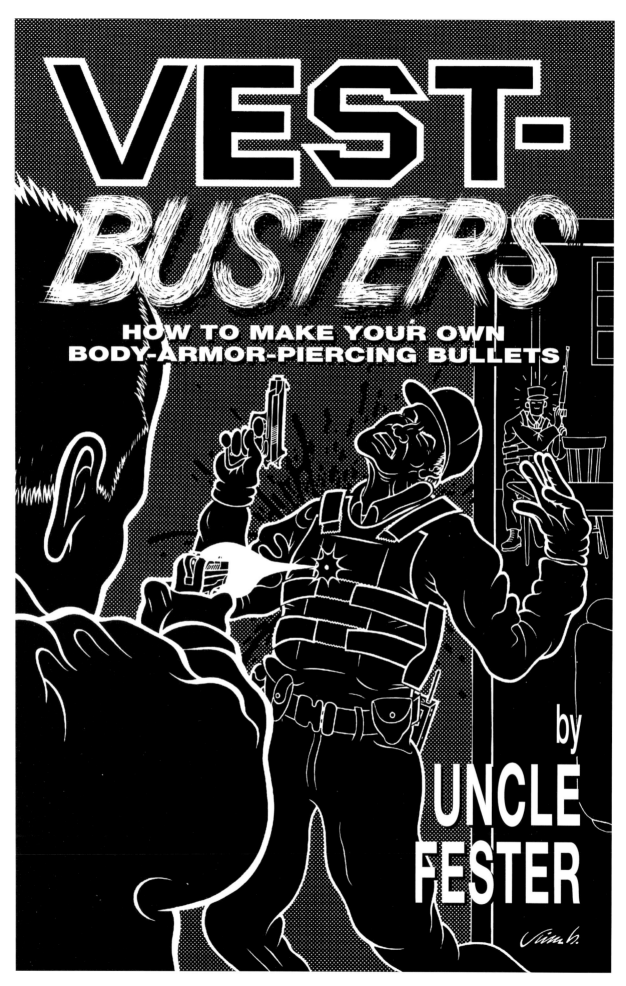

VEST-BUSTERS: HOW TO MAKE YOUR OWN BODY-ARMOR-PIERCING BULLETS- cover art for Loompanics Books, 2000.

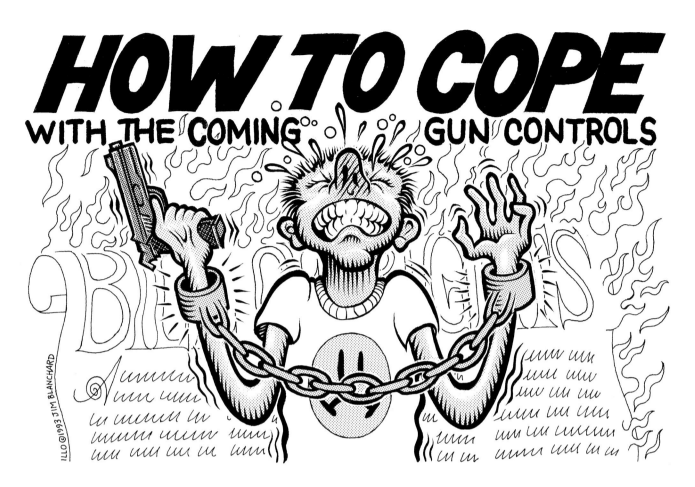

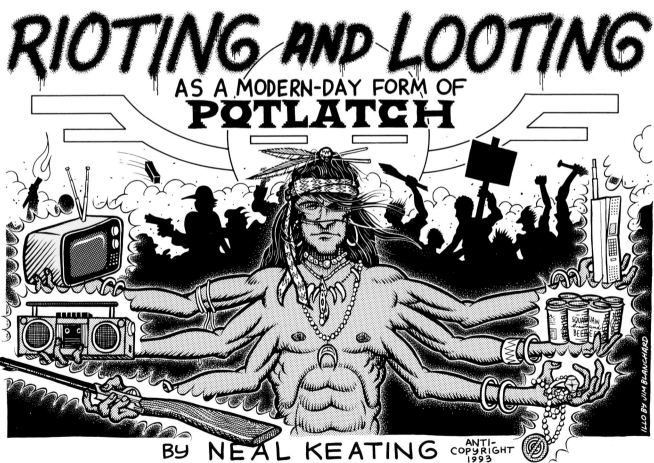

HOW TO COPE WITH THE COMING GUN CONTROLS, RIOTING AND LOOTING AS A MODERN-DAY FORM OF POTLATCH- Loompanics Books catalog supplement illustartions, 1993.

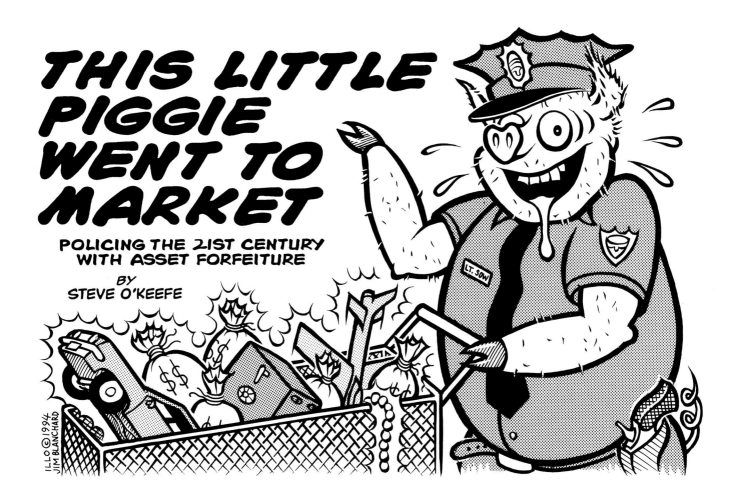

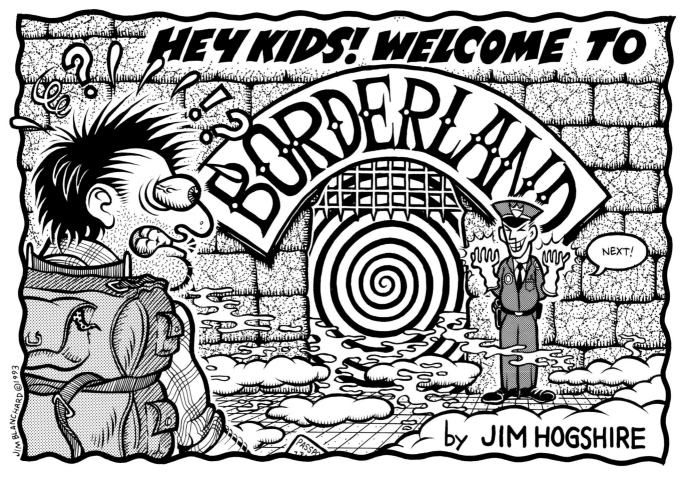

THIS LITTLE PIGGIE WENT TO MARKET, HEY KIDS! WELCOME TO BORDERLAND- Loompanics Books catalog supplement illustartions, 1993-1994.

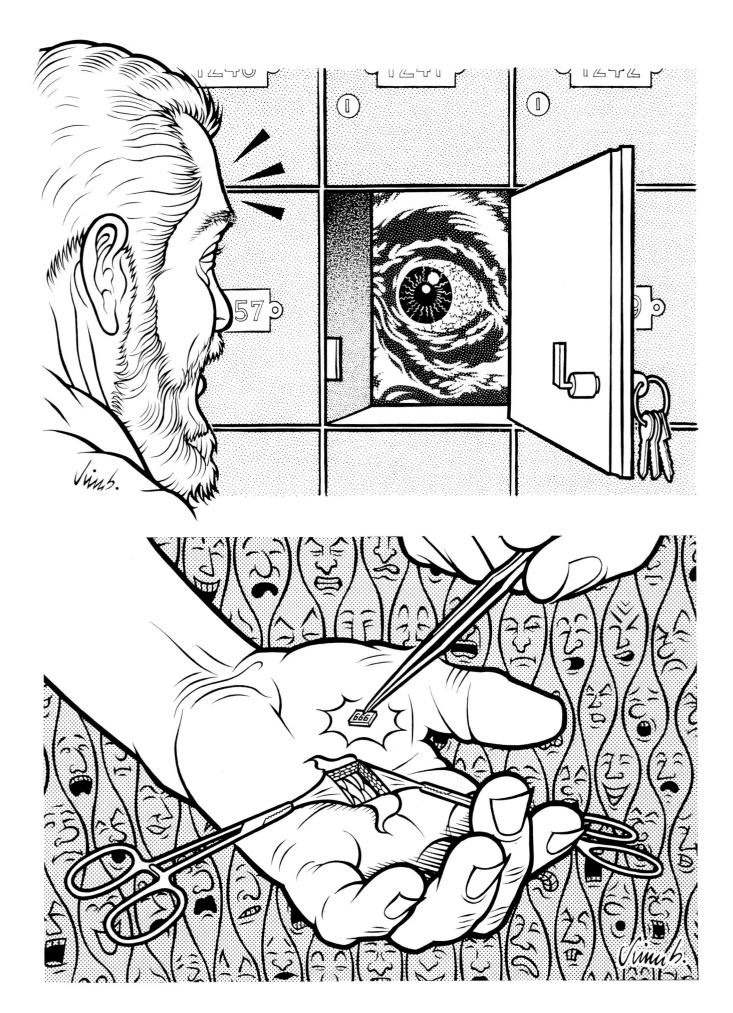

POST OFFICE PARANOIA, THE GREAT ID CHIP HO-HO-HOAX- Loompanics Books catalog supplement illustartions, 1999-2000.

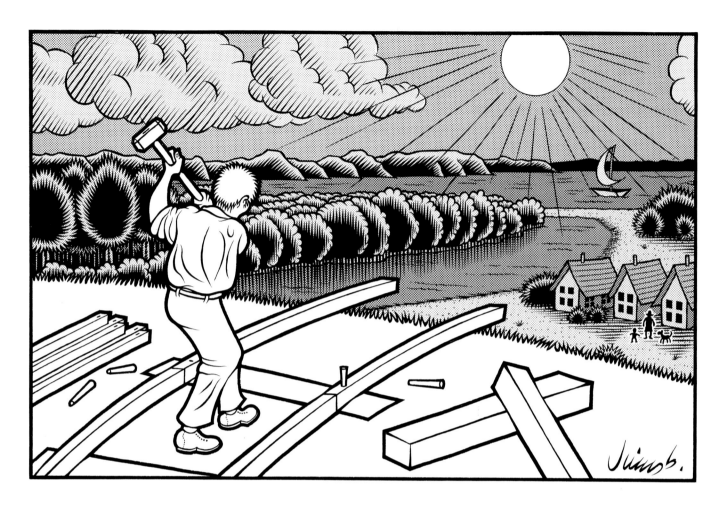

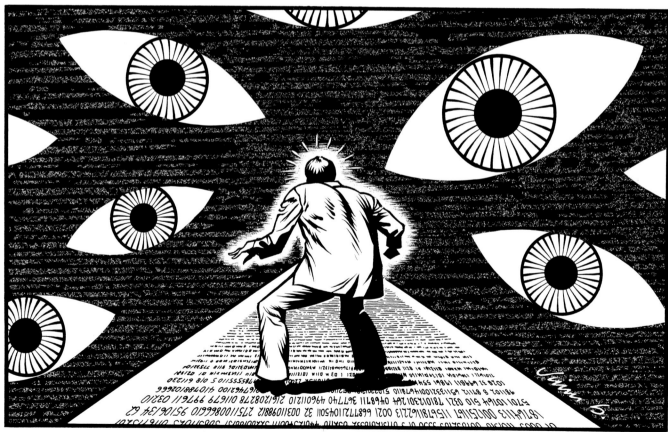

BUILDING RAILS TO FREEDOM, BIG BROTHER IN A DATA-RICH AGE- Loompanics Books catalog supplement illustartions, 2000.

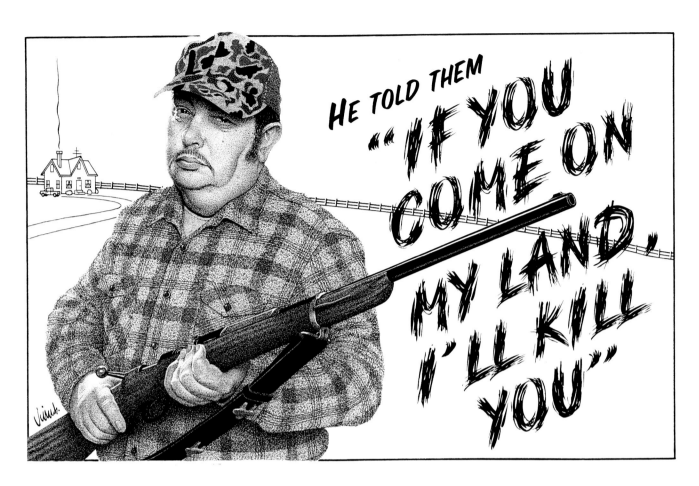

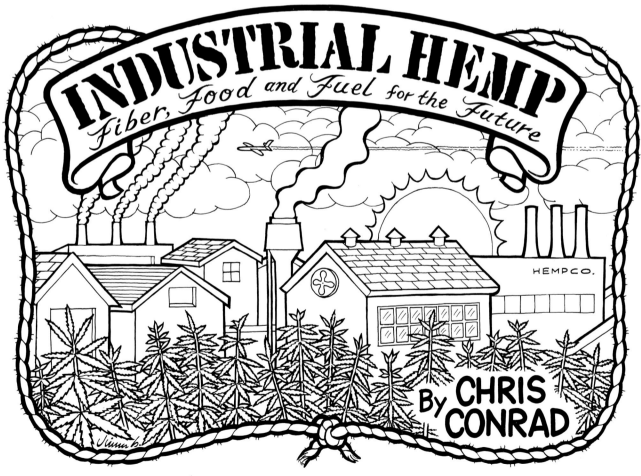

HE TOLD THEM "IF YOU COME ON MY LAND, I'LL KILL YOU", INDUSTRIAL HEMP- Loompanics Books catalog supplement illustartions, 1998-1999.

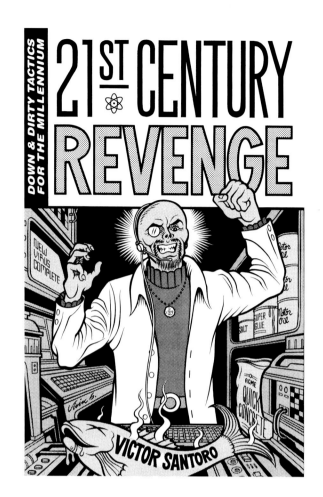

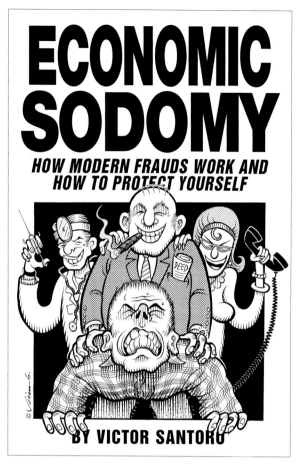

THIS PAGE: **21ST CENTURY REVENGE, ECONOMIC SODOMY, HOW TO HIDE THINGS IN PUBLIC PLACES, OUT OF BUSINESS**. OPPOSITE PAGE: **ADVANCED TECHNIQUES OF CLANDESTINE PSYCHEDELIC & AMPHETAMINE MANUFACTURE**- cover art for Loompanics Books, 1994-2001.

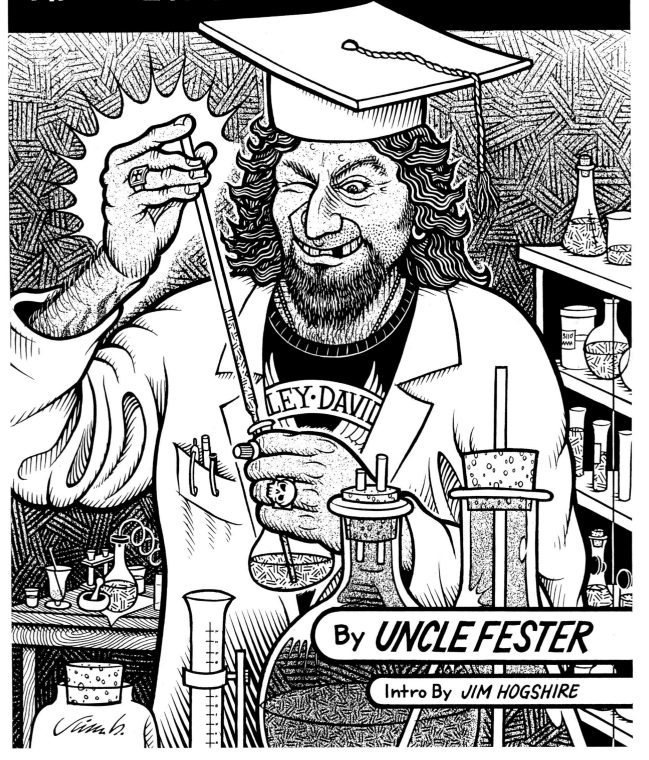

ADVANCED TECHNIQUES
OF CLANDESTINE PSYCHEDELIC & AMPHETAMINE MANUFACTURE

By *UNCLE FESTER*

Intro By *JIM HOGSHIRE*

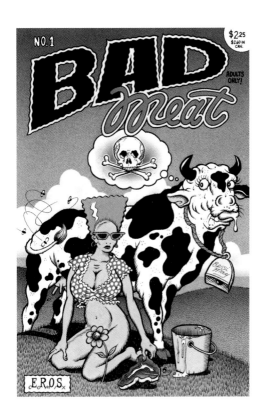

WEIRD WIMMEN

The bulk of the art in this chapter is from *Glam Warp*, a large-format, black & white art book published by Fantagraphics in 2001 (now out of print). These bizarre drawings of women were originally slated to make up the fourth issue of *Bad Meat*, a willfully depraved surrealo-porno comic I did from 1991-1997. However, the pages I was producing at that time—oddly situated females juxtaposed with some sort of advertising typography—turned out more "refined" than standard *Bad Meat* fare, so I thought it best to package them as a separate entity. The format and tone of *Glam Warp* was inspired by R. Crumb's *Art & Beauty* magazine, and Rick Griffin's *Man From Utopia*, both oversized books, and both with an elusive quality, sort of a combination of comic art and classical "fine" art.

The initial response to seeing the ladies of *Glam Warp* might be repulsion, but my aim was not to degrade women, only to satirize/subvert the unimaginative way they are sometimes utilized. It's obvious to me that *Glam Warp* wimmen may be funky and deformed, but they remain power figures. During the late '90s, half-assed vintage pin-up imagery, and uninspired "glamour girl" art was all the rage in pop and alternative culture, and it pissed me off that so many people found such sterile artwork satisfying. So the impetus of this art was to create a far-out personal version of otherwise stale *de rigueur* glamour girl art, and turn "glamorous" female art on its head, perhaps shocking the viewer into re-examinining the way sexy women are used in advertising and packaging. Believe it or not, *Glam Warp* is a pro-woman's lib book.

One of my original titles for the monograph you hold in your hands was *No Relief In Sight*, which came to me as I thumbed through a printed prototype and was struck by how there was no let-up to the visual bombardment, and some ungodly eyeball-violating image was around every corner. It would have been nice to wrap this book up on more of an uplifting, life-affirming note, but I'm afraid warped-out, wart-covered women will have to do. "Exterminate all the brutes!" And have a nice day.

OPPOSITE PAGE: **GLAM WARP**- cover artwork, 2001. THIS PAGE, ABOVE: **BAD MEAT No. 1**- cover artwork (collaboration with Chris Kegel), 1991.

WHAT KIND OF WOMEN READ BAD MEAT?

Well, certainly not any women who look like **this**. I mean, **come on**, they're obviously only here as an **easy** attention-getter. In fact, "Connie" and "Meg" (below) requested their identites be **obscured**. Nope, we're guessing most women who would be caught **dead** reading degrading, directionless **trash** like **BAD MEAT**, would be of a whole **different** variety. Perhaps she'd have **running sores**, or an enormous **sarcoma** on her buttock, something like that. (And, needless to say, **serious** psychological problems... like us.) Regardless of all this, we hope you'll still want to purchase several units of the products below. The **t-shirt** is **white**, has **four colors** on it (red, blue, yellow, and black), is high quality **100% cotton**, is available in **Large** and **X-tra Large** only, is **twelve dollars** postage-paid, is **stylish**, is **not** sexually explicit, and will confuse your friends. Send orders for that one to: Jim Blanchard, Box 20321 Seattle, WA 98102.

(Or save your money and just write and ask for a **free** catalog of books, posters, shirts, trading card sets, and postcards.) If your local book store isn't stocking the beautiful, sickening, and highly-praised **first issue** of BAD MEAT, **vast** quantities are available from EROS COMIX, and they're a **bargain** @ $3.00 per postage-paid copy. Send orders for that one to Eros Comix: P.O. Box 25070 Seattle, WA 98125. (Don't send orders for BAD MEAT #1 to the Jim Blanchard address, or orders for the t-shirt to the Eros Comix address, or we'll find you and kill you.)

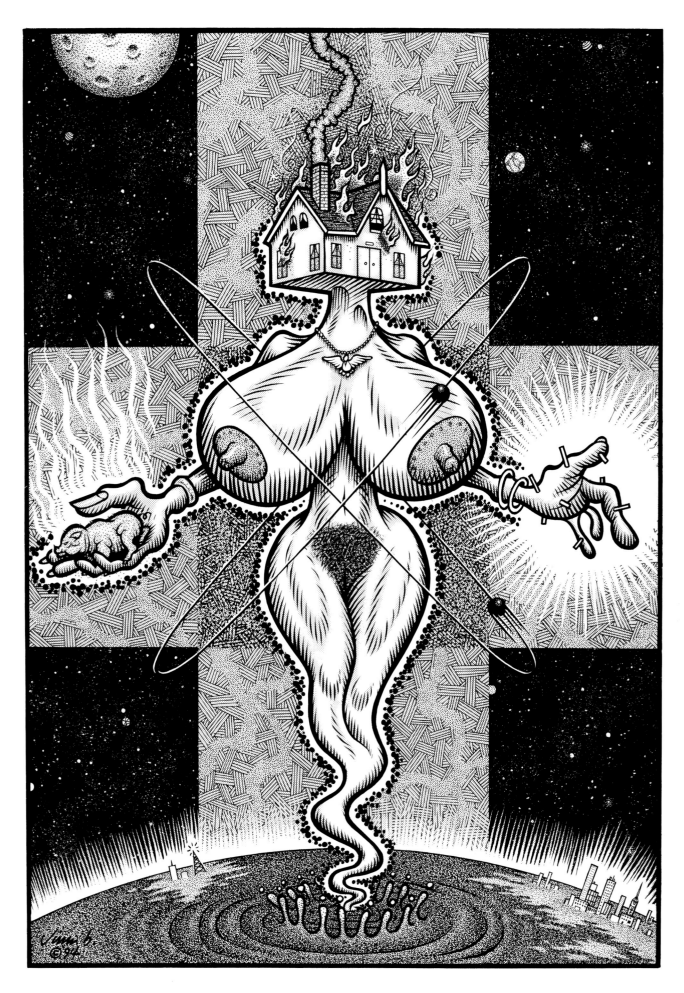

OPPOSITE PAGE: **T-SHIRT & BACK ISSUE ADVERTISEMENT**- from *Bad Meat* No. 2, 1992. THIS PAGE ABOVE: **ATOMIC VENUS**- from *Bad Meat* No.3, 1997.

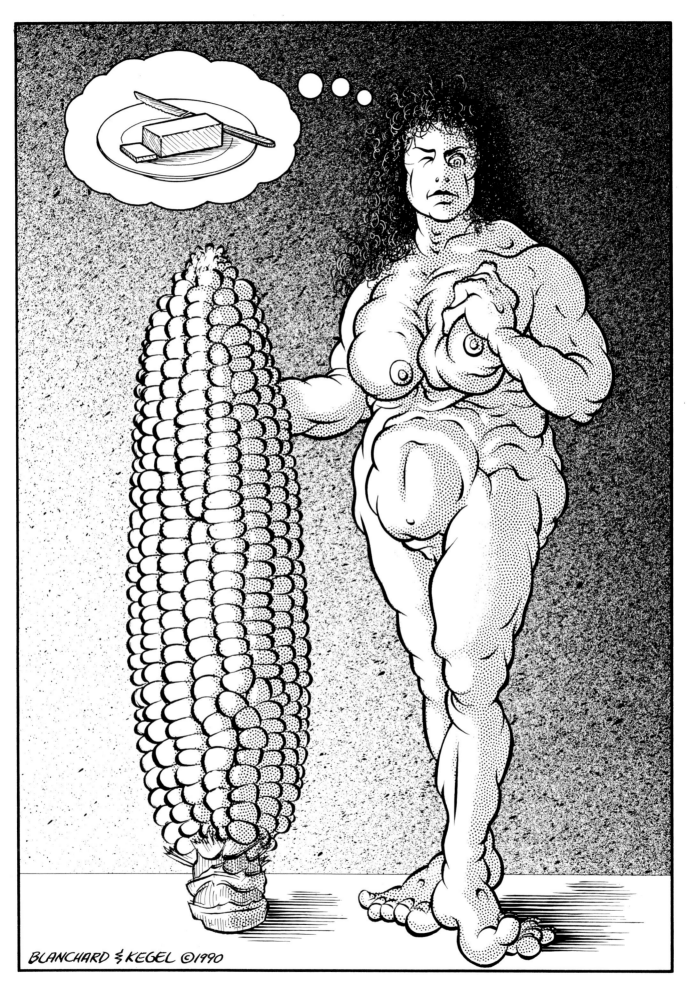

WOMAN WITH LARGE EAR OF CORN- from *Bad Meat* No.1, 1991 (collaboration with Chris Kegel).

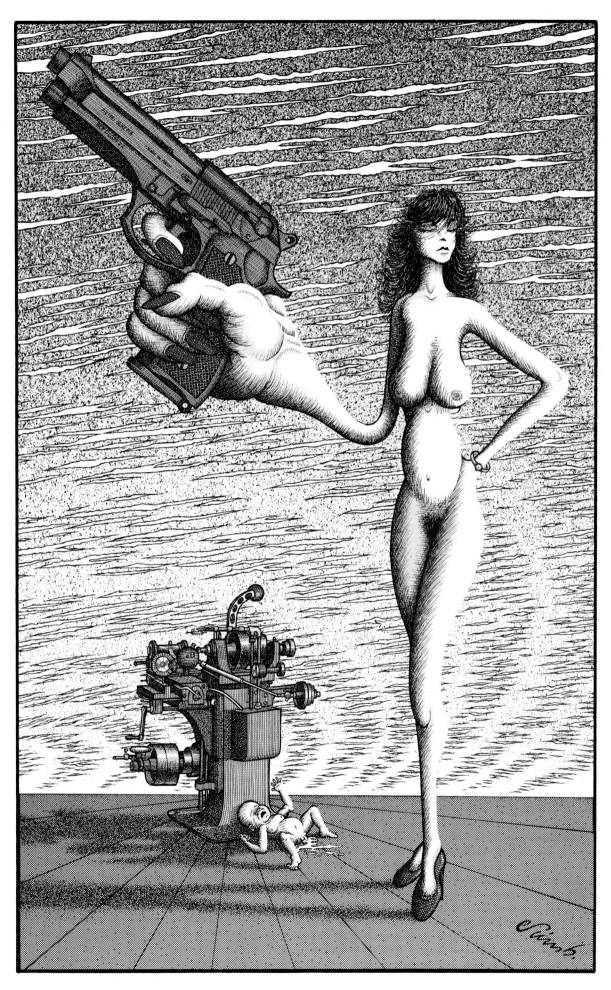

WOMAN WITH LARGE GUN- from *Bad Meat* No.3, 1997.

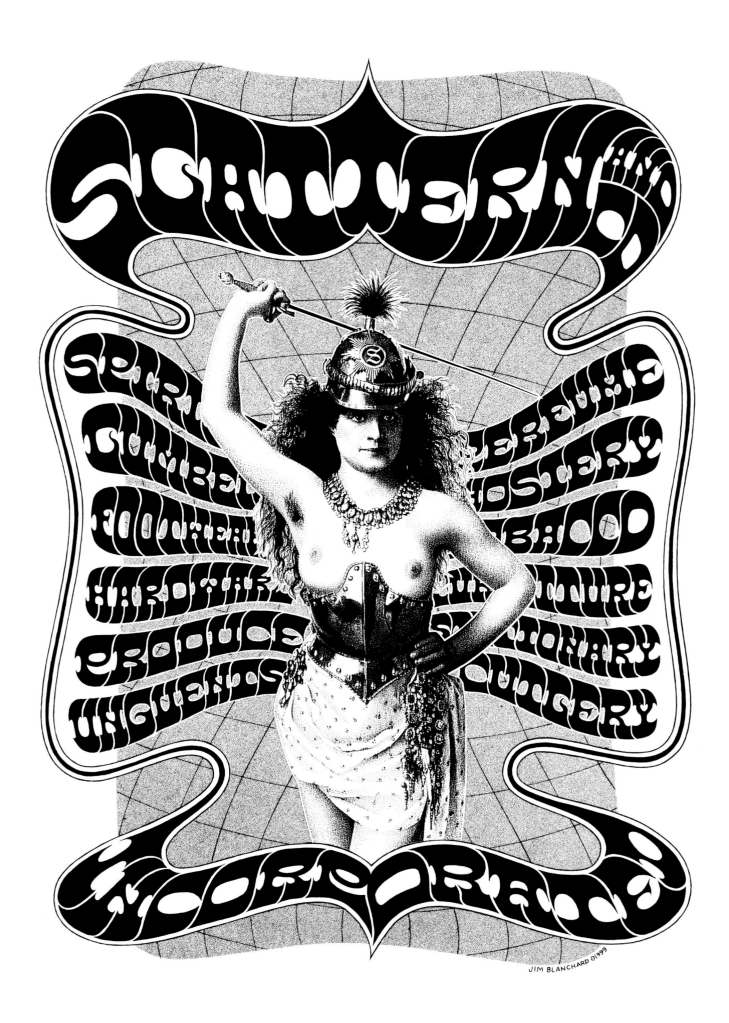

SCHWERN AND NOORDORADD

SPIRIT PERFUME

GUMBELI HOSIERY

FOOTHEAL TABACCO

HARDWARE CULTURE

PRODUCE STATIONARY

UNGUENTS CUTLERY

SCHWERN INCORPORATED

JIM BLANCHARD ©1999

PP. 170-191: **PAGES FROM GLAM WARP**- 1998-2001.

170

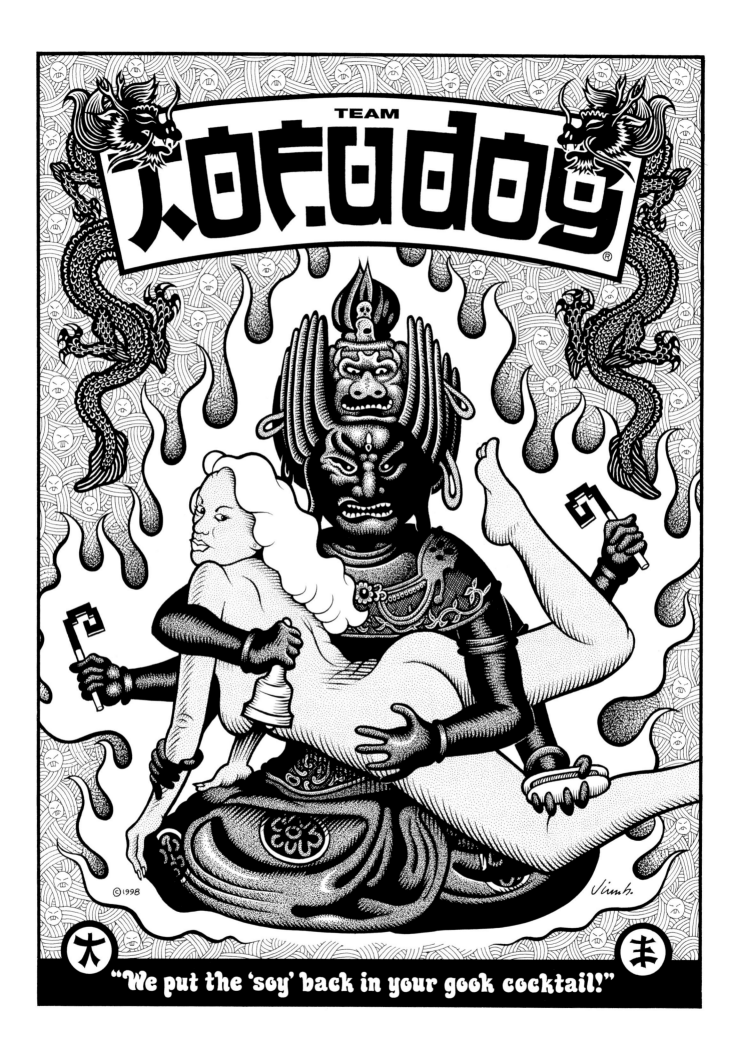

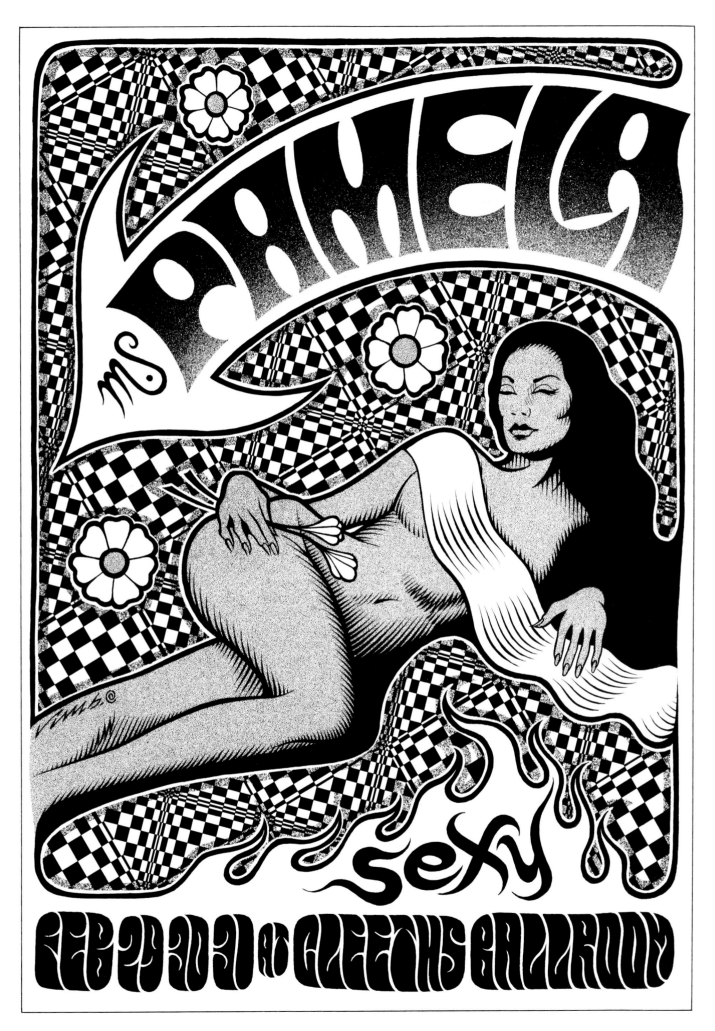

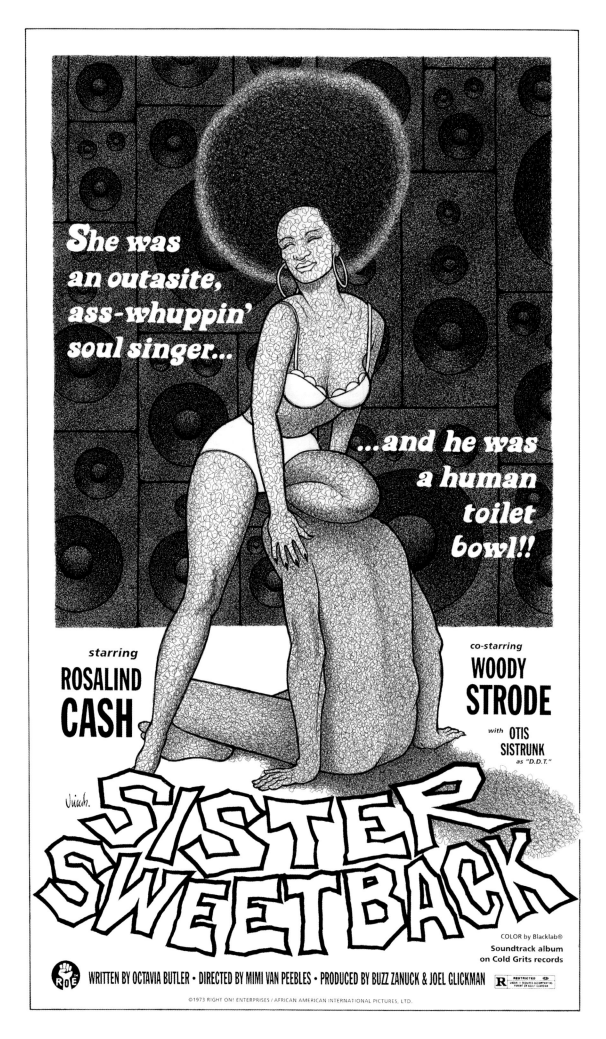

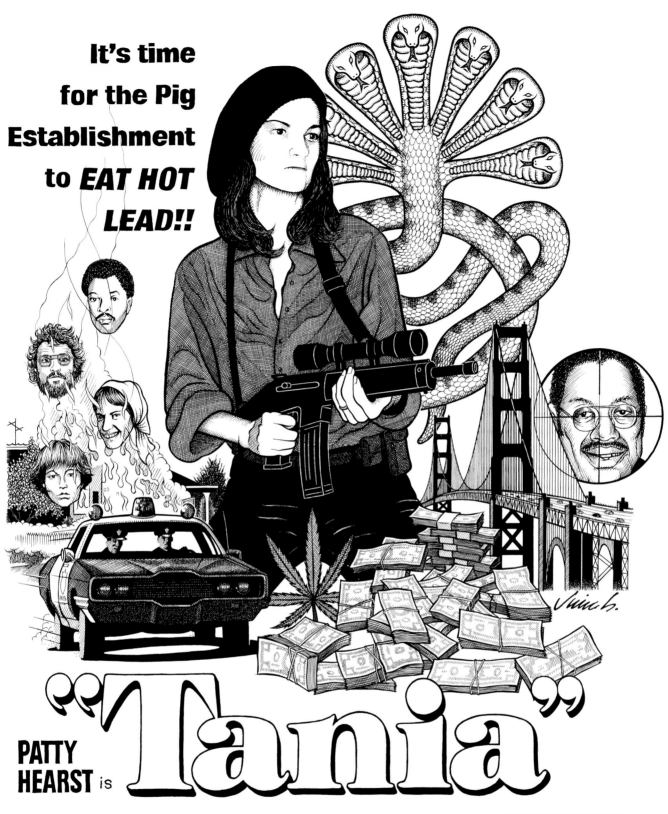

It's time
for the Pig
Establishment
to *EAT HOT
LEAD!!*

PATTY HEARST is "Tania"

The People's Revolutionary Strike Force presents a Symbionese Liberation Army "release"

"TANIA"

starring
DONALD DeFREEZE as "Cinque" · NANCY LING PERRY as "Fahizah" · WILLIAM WOLFE as "Cujo" · PATRICIA SOLTYSIK as "Mizmoon" · and BILL HARRIS as "Teko"

Produced by The William Randolph Hearst Foundation · Written & Directed by L. Patrick Gray · Filmed in GUEVARASCOPE®

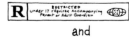

73/152

"TANIA"

175

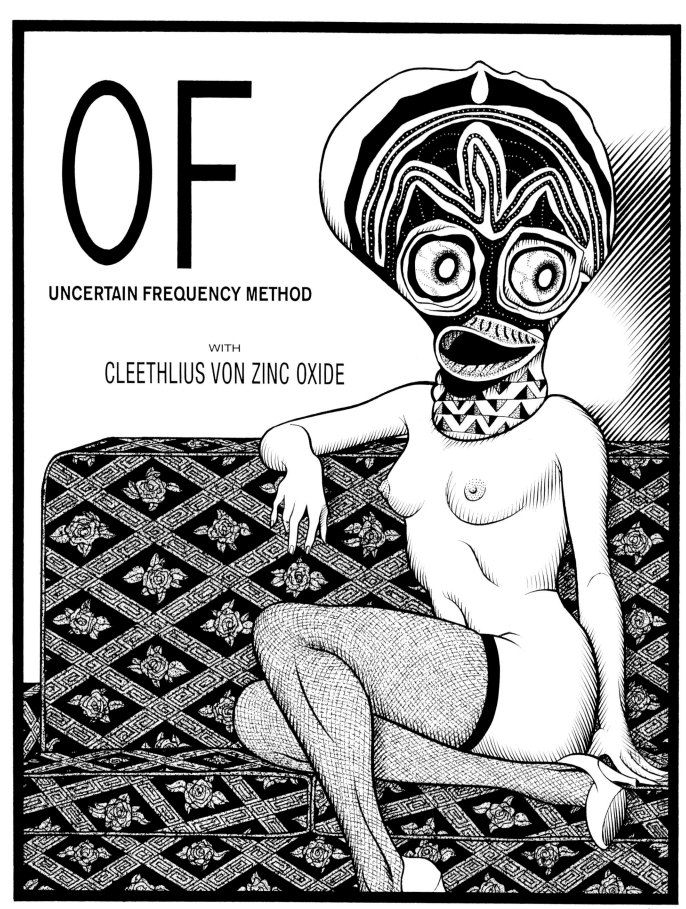

OF

UNCERTAIN FREQUENCY METHOD

WITH

CLEETHLIUS VON ZINC OXIDE

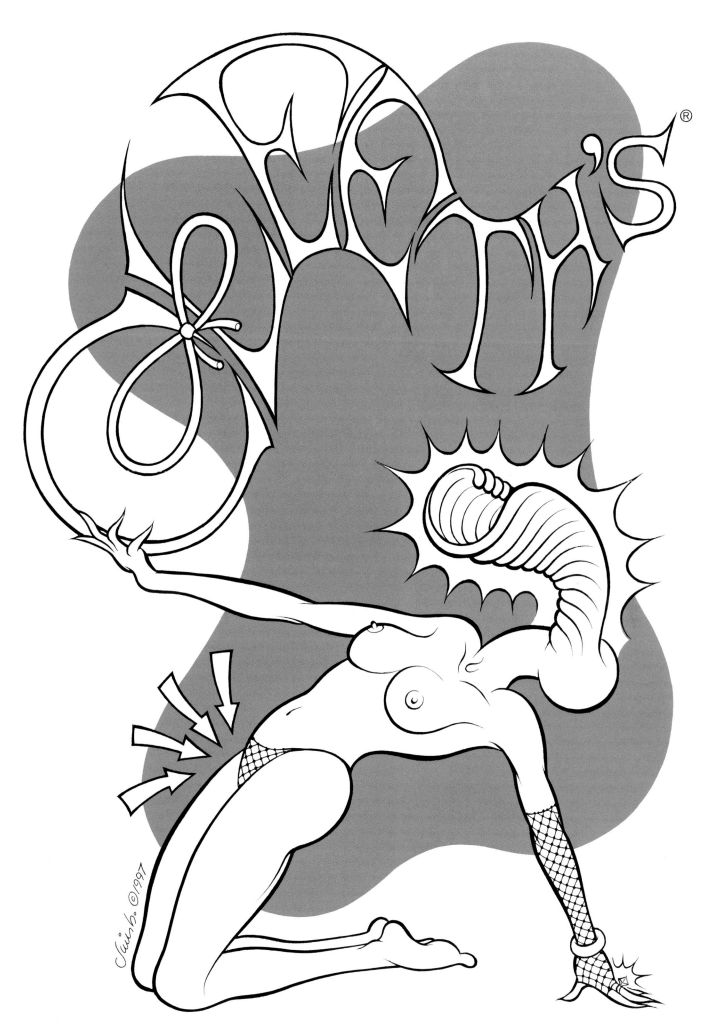

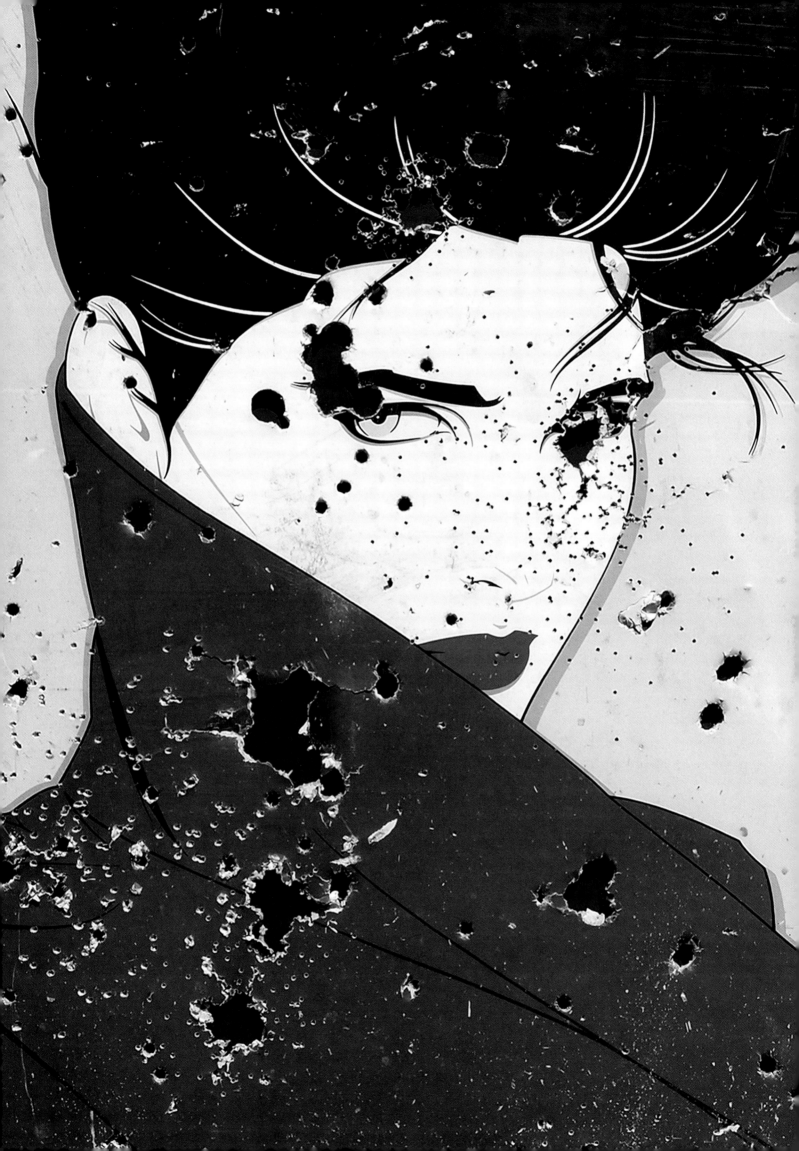

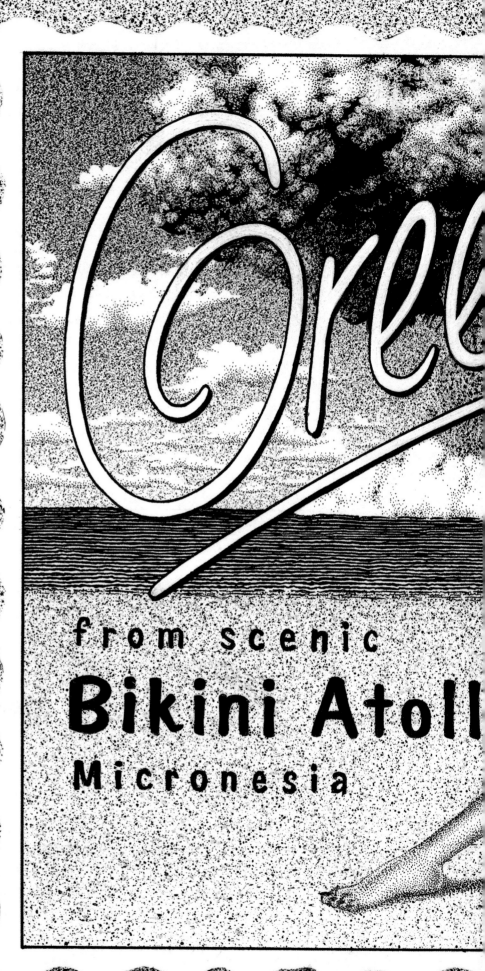

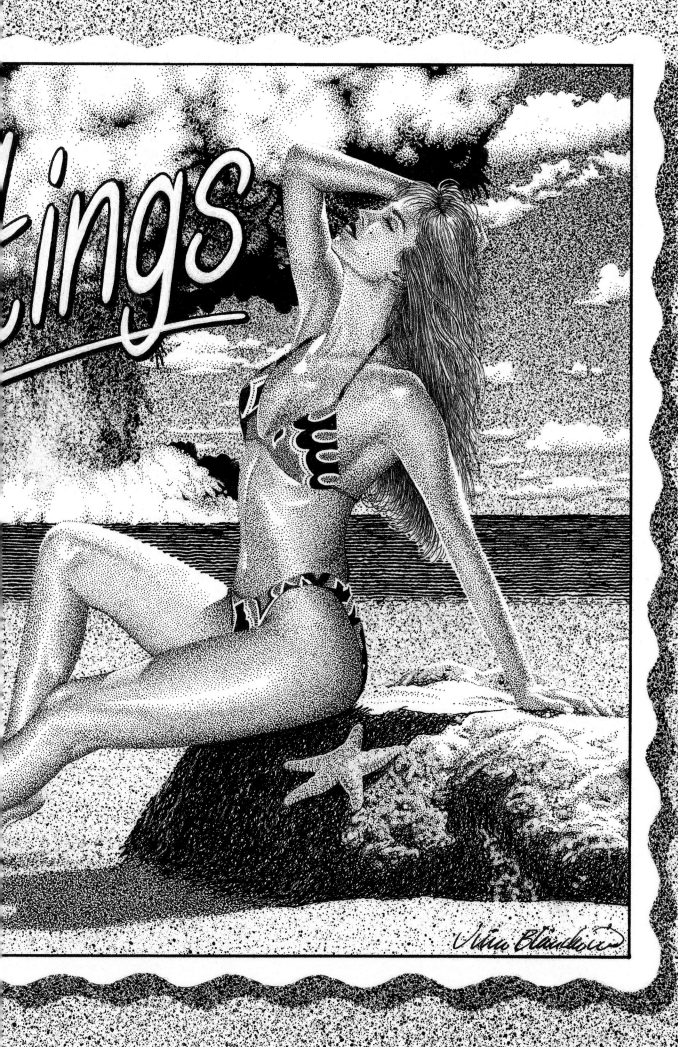

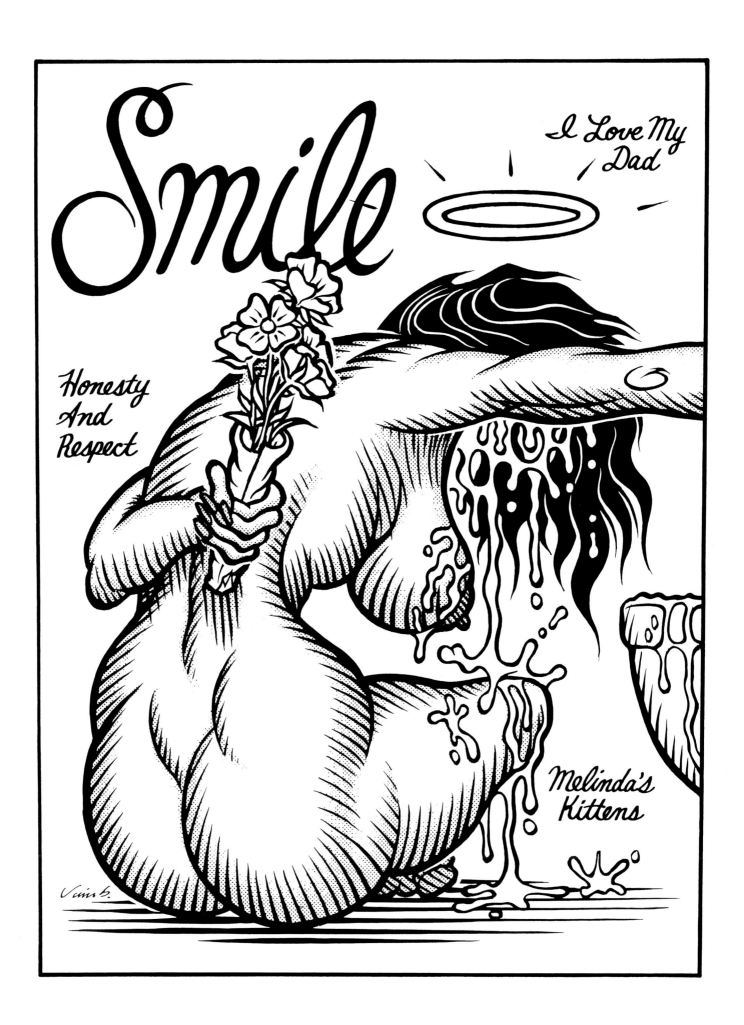

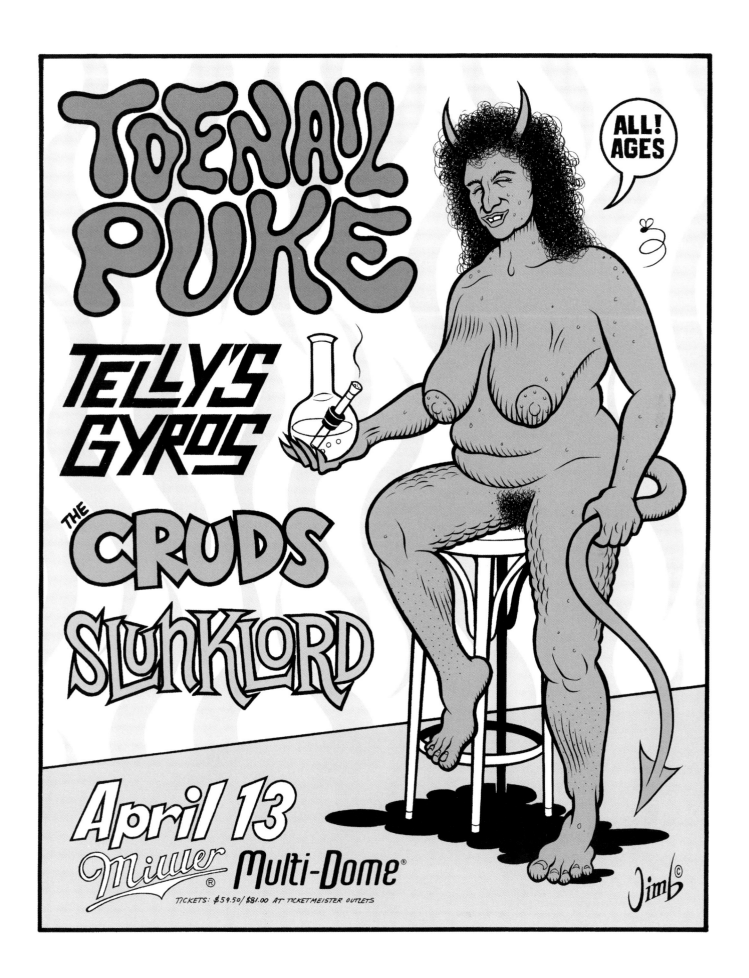

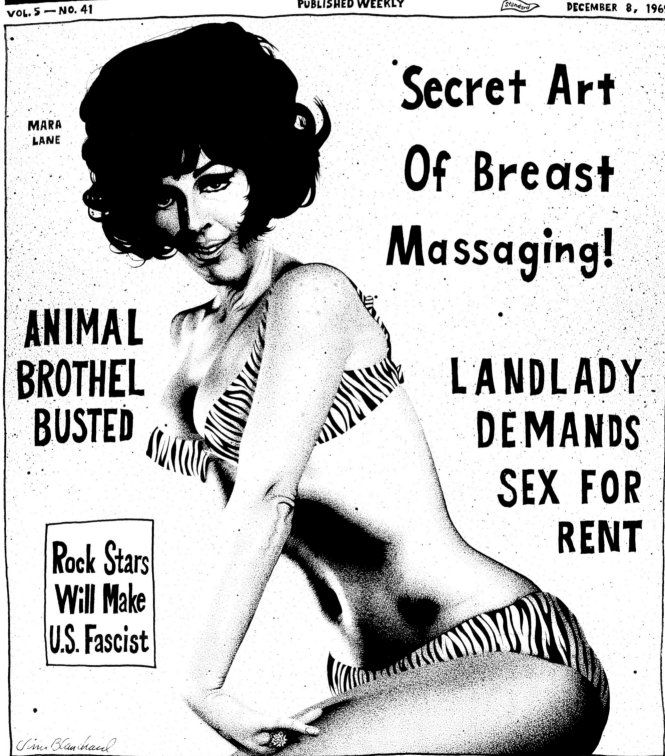

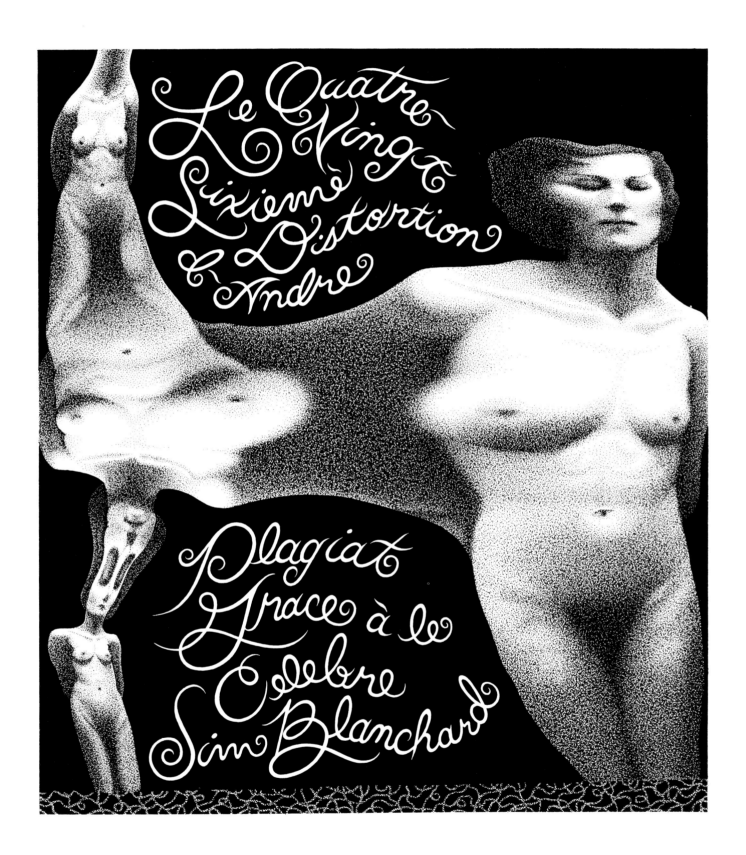

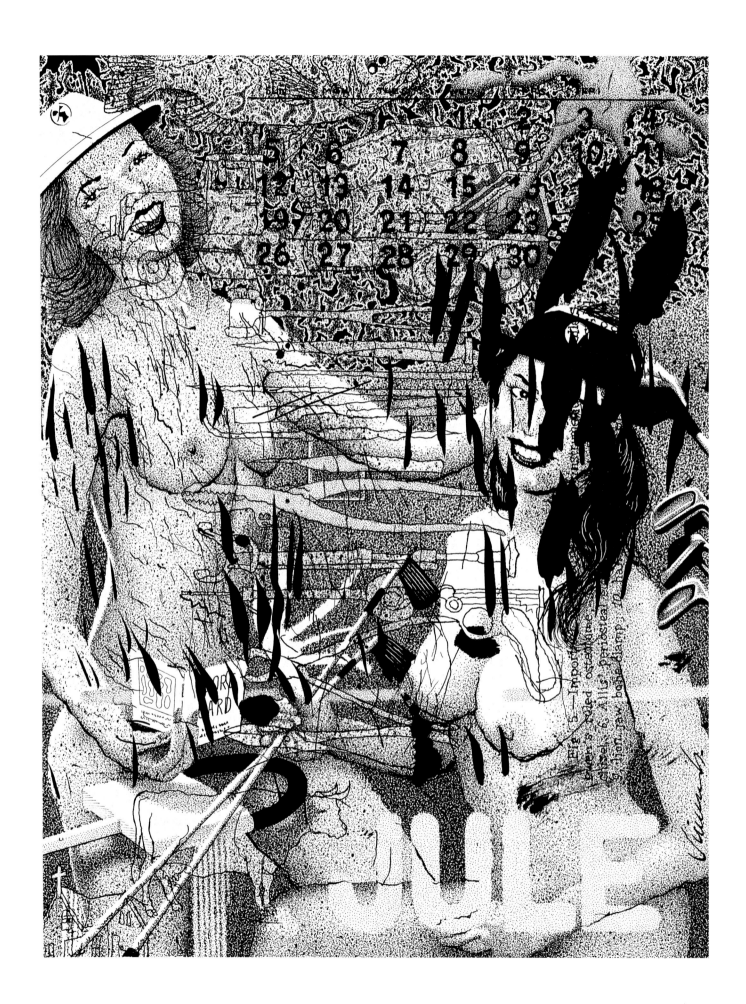

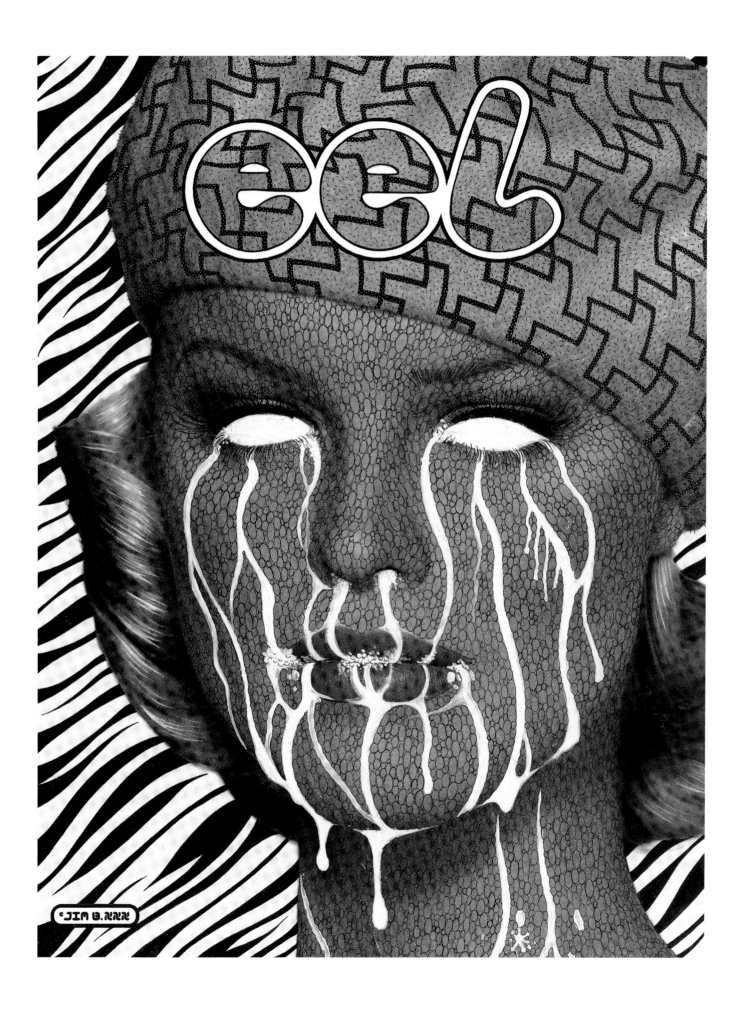

187

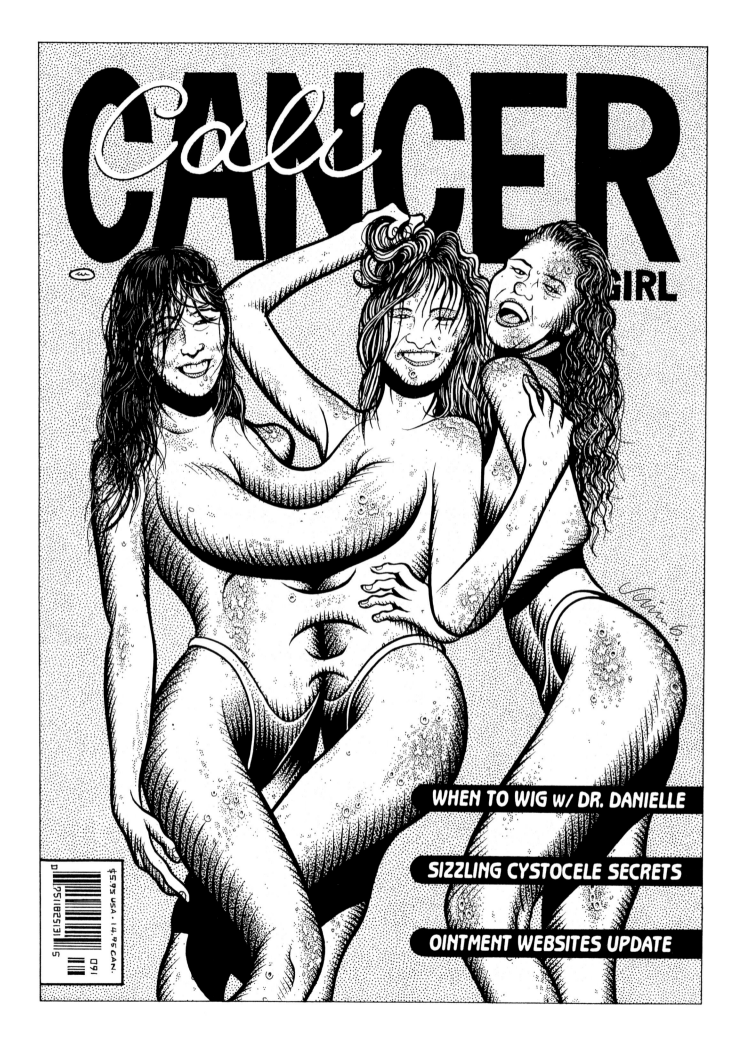

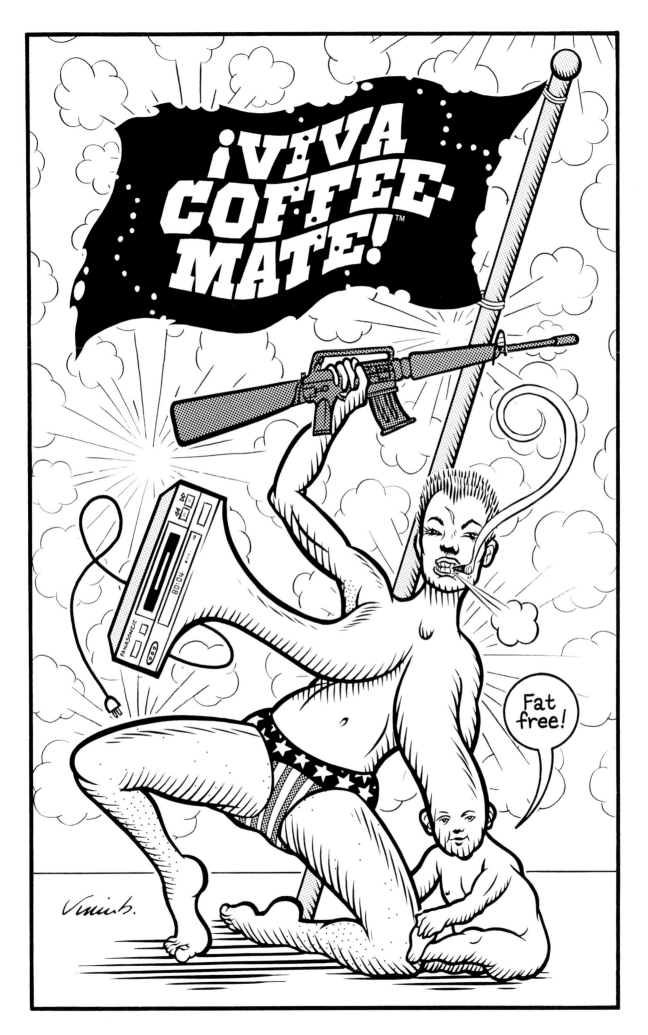

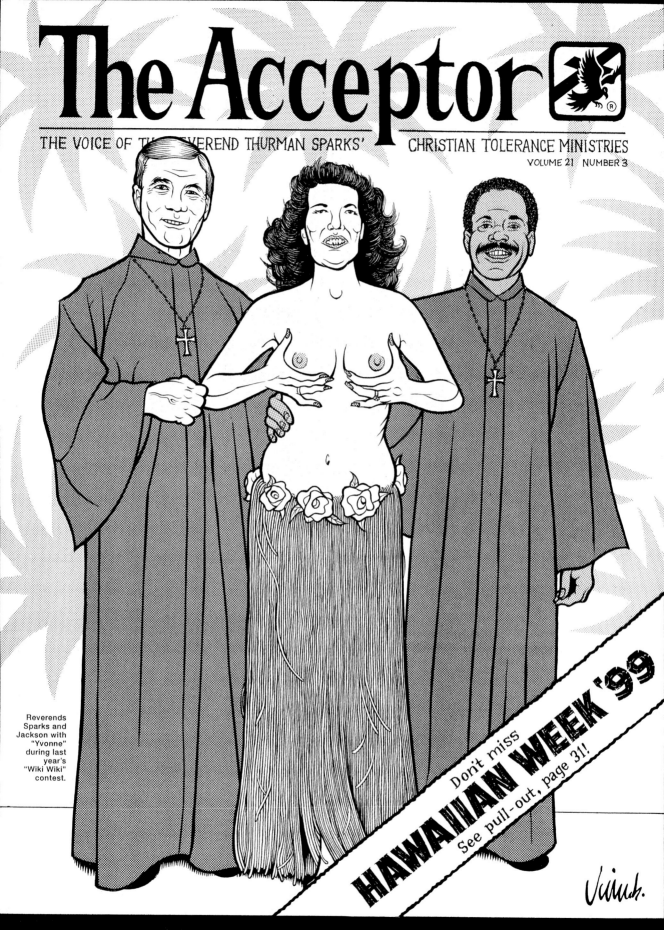

The Acceptor ®

THE VOICE OF THE REVEREND THURMAN SPARKS' CHRISTIAN TOLERANCE MINISTRIES

VOLUME 21 NUMBER 3

Reverends Sparks and Jackson with "Yvonne" during last year's "Wiki Wiki" contest.

Don't miss HAWAIIAN WEEK '99
See pull-out, page 31!

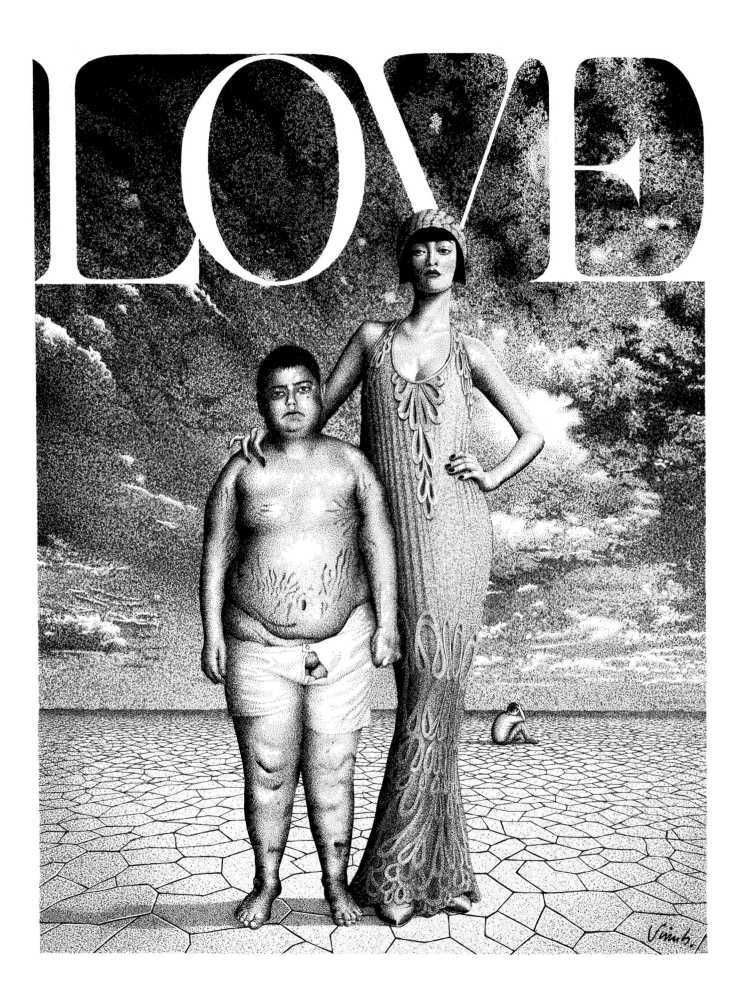

THANK YOU:

Steve Abrams, John Aes-Nihil, Steve Albini, Grant Alden, Barry Alfonso, Rick Altergott, Dawn Anderson, Kirsten Anderson, Tom Anderson, Brad Angell, Mark Arm, Arlington Ashby, Dale Ashmun, Arthur Aubrey, Natasha Avery, Cynthia Bach, Bill Badgley, Mike Baehr, Joanne Bagge, Peter Bagge, Ron Bally, Ron Bandor, Jim Banner, Russ Battaglia, Scott Beale, Steve Beaupre, James Bender, Mark Bendix, Jello Biafra, John Bigley, Alan Bishop, Rick Bishop, Don Blackstone, Blanchard Family, Martin Bland, Ben Blankenship, Steven Blush, Jim Bodoia, Django Bohren, Ariel Bordeaux, Bill Bored, Charles Boucher, Nick Bougas, Mitch Boulanger, Robert Boyd, Richy Boyer, Jacques Boyreau, Braimes Family, Dave Brooks, Bill Brown, Richard Bruhn, Jamie Burton, Charles Burns, Mary Byrd, Michelle Byrd, Len Callo, Mike Campbell, Mark Campos, Joe Carducci, Carl Carlson, Howie Chackowicz, Art Chantry, Celeste Cleary, Daniel Clowes, Clare Cloutier, Jacq Cohen, Joe Coleman, Byron Coley, Charms Conrad, Kenwick Cook, Chris Cooper, Dave Cooper, Dana Countryman, Matt Counts, Jacob Covey, Russell Cowser, Wayne Coyne, R.L. Crabb, Del Cranford, Layne Cranford, John Crawford, Alan Crider, Bekki Crider, Dave Crider, Tim Cridland, Tom Crites, Laura Croteau, Matt Crowley, Mark Dancey, Joe Danger, Eric Davidson, Peter Davis, Mike Decker, Monica Dee, Mark Dillon, Stefan Dinter, Don Donahue, Julie Doucet, Michael Dougan, Michael Dowers, Tad Doyle, Chuck Dukowski, Jeremy Eaton, Damon Eaves, Dennis Eichhorn, El Rotringo, Drew Elliott, Jack Endino, Greg Escalante, Eric Eye, Dave Fallis, Gene Fama, Dan Faught, Todd Felker, Jake Fennell, Uncle Fester, The Fightsters, Kirk Fillmore, Ruth Fillmore, Carol Ann Fitzgerald, Mary Fleener, Shary Flenniken, Eddie Flowers, Ellen Forney, Cameron Forsley, Charley Foster, Chuck Foster, Terry Foster, Claudia Frank, Carl Franzoni, Renée French, Drew Friedman, Jeff Gaither, Javier Gallegos, Art Garcia, Steve Gilbert, Sandy Glaze, Jim Goad, Tony Godbehere, Lia Golzinski, Dave Goodrich, Chris Goodwin, Tim Goodyear, Mary Gregory, Roberta Gregory, Gary Groth, Jerry Haasch, Jason Hadley, Jake Hamilton, Robb Hamilton, Justin Hampton, John Hart, Helena Harvilicz, Tim Hayes, Tom Hazlemyer, Dan Heidebrecht, Sam Henderson, Bruce Hendrickson, John Hensley, Mario Hernandez, Rebecka Hernandez, Paul Herring, Jim Hogshire, Gordon Holmes, Todd Homer, Daniel House, Jaynee Howe, Michael Hoy, Aaron Huffman, Scott Huffines, Clark Humphrey, Daryl Hutchinson, Shane Ibrahim, Chris Jacobs, Penn Jillette, Brad Johnson, Jess Johnson, Jimmy Johnson, Matt Johnston, Kent Joyce, Lester K., Kika Kane, Jacaeber Kastor, Chris Kegel, Tim Kerr, Dan Kiacz, Terry Kim, Annabella Kirby, Jeff Klein, Rick Klu, Ken Koch, Basille Kolliopoulos, Charles Krafft, Paul Krassner, Terry Laban, Steve Lafler, Reese Lamb, David Lasky, Peter Litwin, Long Gone John, Russell Love, Todd Lovering, Mikey Lucas, Greg Lundgren, Jason Lutes, Allan MacDonell, Ian MacKaye, Greg Macon, Michael Maker, Seth Malice, Amy Marchegiani, Marina Marioni, Barrett Martin, Gabe Martinez, Allison Maryatt, Robert Mashlan, Paul Mavrides, J. Michael McCarthy, Tara McDonald, Jacob McMurray, Tyson Meade, David Melton, Jason Miles, Dave Miller, Otis Miller, Robert Millis, Phil Milstein, Mike Mitchell, Tom Moffat, Keith Monsey, Jon Mooneyham, Marty Moore, Thurston Moore, Jamie Morgan Heath, Pat Moriarity, Lori Moriarity, John Mortensen, Paul Murphy, Steve Murrell, Scott Musgrove, Cliff Neal, Nehls Family, Bill Nelson, Joe Newton, Kevin O'Brien, John Ohannesian, Martin Ontiveros, Gary Panter, Adam Parfrey, John Parker, Dave Parks, Rhea Patton, Dan Paulus, Bruce Pavitt, Charles Peterson, Naomi Petersen, Scott Peterson, George Petros, Lisa Petrucci, Ray Pettibon, Phlegm Pets, Jim Pink, Eric Predoehl, Gary

Pressman, Tom Price, Anthony Pulsipher, Bobby Purdon, Pushead, Jen Ralston, Vince Rancid, Everett Rand, Steve Rapacz, David Rapaport, Carl Ratliff, Jane Rebelowski, Larry Reid, Marshall Stack Reid, Rev. Nørb, Brian Riedel, Zoogz Rift, Eugene Robinson, Greg Robinson, Larri Robinson, Aaron Roeder, Neil Rogers, Henry Rollins, Darby Romeo, Tim Root, Cynthia Rose, Patrick Rosenkranz, Jeff Roysdon, Mark Rubin, Johnny Ryan, Joe Sacco, Matt Sapero, Bill Sassenberger, Andy Schmidt, Michelle Schutte, Brian Sendelbach, Greg Sewell, John Sev, Dan Shahin, Stan Shaw, Rob Shealy, Rusty Short, Matt Silvie, Josh Simmons, Tommy Simpson, Gianluca Sirri, Rob Skinner, Denny Sloane, R.K. Sloane, Joe Smallkowski, Marc Smirnoff, Gabe Soria, Jason Sprinkle, Tom Spurgeon, Rev. Ivan Stang, Jack Stevenson, Mats Stromberg, Greg Stump, Greg Stumph, Barry Sublapse, Mark Sullo, Ashleigh Talbot, David Tatelman, Jeff Taylor, Robert Taylor, Sean Tejaratchi, Randal Tin-ear, Lori Theis, Paul Therio, Kim Thompson, Frank Thorne, Laura Box Thurmond, Elise Tissot, Mariellen Tissot, Sabrina Tissot, Roy Tompkins, Hank Trotter, John Trubee, Jaime Trujillo, Gregg Turkington, Ron Turner, Carol Tyler, Mark Tyler, Val Vale, Mikey Van Buskirk, Daniel Vanneste, Tesco Vee, Dave Vorhees, Jeff Voris, Mike Vraney, Clark Walker, Todd Walker, John Wallace, John Wallen, Bryan Ward, Chris Ward, Tammy Watson, Wayno, Chet Weise, Niko Wenner, Mack White, Peppy White, Terrie White, J.R. Williams, Robert Williams, Suzanne Williams, Jason Willis, Rebecca Wilson, S. Clay Wilson, Stevo Winters, Jake Wisely, Shawn Wolfe, Jim Woodring, Mary Woodring, Dennis Worden, Gary Wray, Ryder Wyndam, Bob X, XNO, Dale Yarger, Frank Young, Stephen Young, Diana Young-Blanchard, David Yow, Matt Zielfelder, Mark Zingarelli, and Greg Zura.

A Companion volume to **VISUAL ABUSE** called **BEASTS AND PRIESTS** is available from Fantagraphics Books. Published in 2006, BEASTS AND PRIESTS collects the best of Jim Blanchard's pen & ink portraits, including Redd Foxx, Tom Jones, Duke Ellington, Lemmy Kilmister, Terry Southern, Jackie Gleason, Henry Kissinger, Ennio Morricone, Lenny Bruce, and many others. Also included is a 16-page full-color section featuring Blanchard's "sticker-painting" portraits. BEASTS AND PRIESTS contains 64 pages of artwork that does not appear in this book. $9.95 + shipping from www.fantagraphics.com